To Emily
With all m...
Helen
X

CW00797611

PERFORMING FOR THE CAMERA

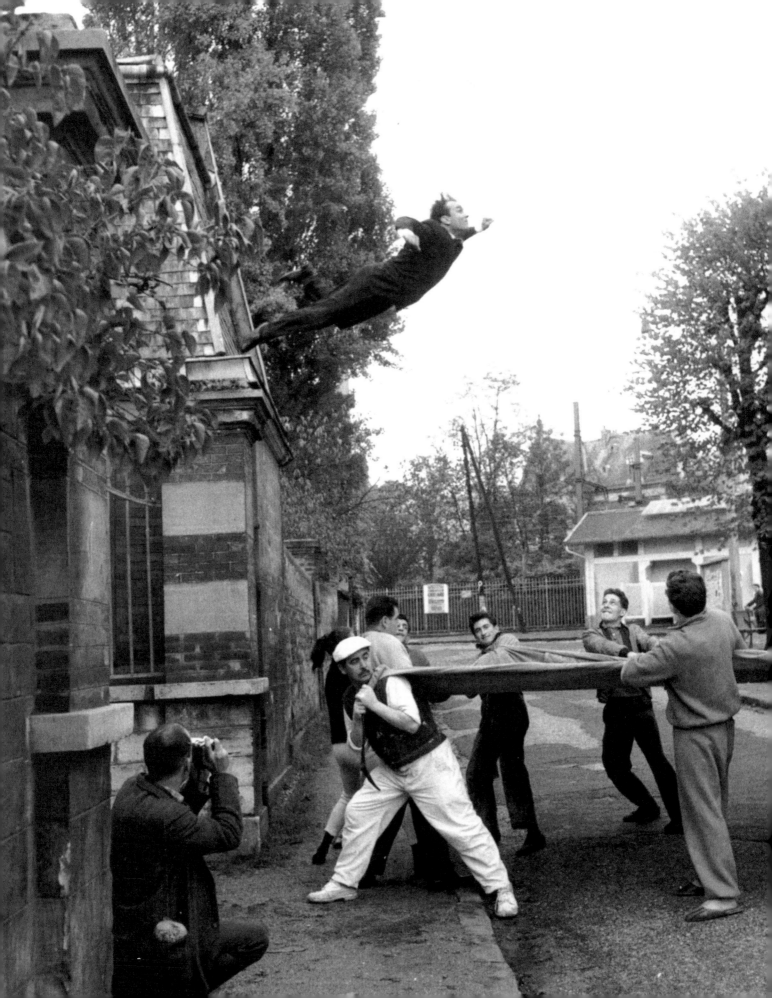

Edited by Simon Baker and Fiontán Moran
With an essay by Jonah Westerman

# PERFORMING FOR THE CAMERA

Tate Publishing

First published 2016 by order of the Tate Trustees
by Tate Publishing, a division of Tate Enterprises Ltd,
Millbank, London SW1P 4RG
www.tate.org.uk/publishing

on the occasion of the exhibition
*Performing for the Camera*

The Eyal Ofer Galleries, Tate Modern, London
18 February – 12 June 2016

The exhibition at Tate Modern is sponsored by Hyundai Card

**Hyundai Card**

A catalogue record for this book is available from the British Library

ISBN 978 1 84976 400 1

Distributed in the United States and Canada by ABRAMS, New York

Library of Congress Control Number applied for

Designed by Hoop Design
Colour reprographics by Altaimage, London
Printed and bound in Italy by Graphicom SPA

*Front cover*: Romain Mader, *Ekaterina: Marriage in Leukerbad* 2012 (see p.199)
*Back cover*: Masahisa Fukase *Bukubuku (Bubbling)* 1991 (see pp.26, 192–5)
*Inside front and back cover*: Yves Klein, *Yves Klein realising an 'Anthropometry' in his studio, 14 rue
Campagne Première, Paris 1960*. Photo: Shunk-Kender
*Frontispiece*: Yves Klein, Preparatory image for *Leap into the Void*, Fontenay-aux-Roses, France 1960.
Photo: Shunk-Kender

Measurements of artworks are given in centimetres, height before width

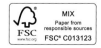

# Sponsor's Foreword

Hyundai Card is delighted to sponsor Tate Modern's groundbreaking exhibition *Performing for the Camera*.

This remarkable show sheds new light on the relationship between photography and performance, and the influence of both on today's art practices. We hope that visitors will be inspired and enlightened by the playful and pioneering spirits of the photographers and subjects.

As Korea's leading issuer of premium credit cards, Hyundai Card is committed to broadening public understanding of the positive effects that contemporary art and design have on our lives. Whether we are building libraries on music, design and travel, crafting concert experiences that are meticulous to the last detail, or designing credit cards as beautiful as they are functional, our most inventive endeavours all draw from the creative well that the arts provide.

We are proud to present this exhibition as the first of a three-year commitment to Tate Modern's expanding exploration of photography.

# Foreword

As performance increasingly becomes a prominent part of Tate's programme and collection, this exhibition looking at its relationship to the photographic image is especially timely. Throughout its history, live art has relied upon photography to provide records of transient events, but as this exhibition demonstrates, its connection to the photograph has in fact a longer and broader history. Since the invention of the photographic medium in the mid-nineteenth century, the camera has not only been used to document both theatrical and artistic actions, but also to create images that question dominant modes of representation, and the nature of identity.

Spanning 150 years and including over sixty artists, *Performing for the Camera* is not an attempt at a definitive history of the relationship between performance and photography, but instead offers a series of positions through which to consider how each has developed our understanding of the other. In opening up this subject, the exhibition will highlight the work of Harry Shunk and János Kender, two photographers who documented many of the most important artists of the 1960s and 1970s who were expanding the limits of painting and sculpture in new and exciting ways. Tate is fortunate to be able to exhibit a number of photographs by Shunk-Kender due to the generosity of the Roy Lichtenstein Foundation which, in 2014, donated a large number of prints jointly to Tate and Bibliotheque Kandinsky at the Centre Pompidou in Paris. Shunk-Kender's work provides an opportunity not only to view iconic works by the likes of Yves Klein and Yayoi Kusama, but also to consider anew the role that the photographer plays in the act of framing, cropping and processing such images.

The documentary role of photography forms only part of the story, as *Performing for the Camera* also considers the variety of ways that artists have engaged directly with the camera. Just as Allan Kaprow suggested that the space of the canvas, post-Pollock, might become an 'arena in which to act', so too did the photographic image. Instead of performing for a live audience,

**8** artists are increasingly choosing the privacy of the studio and now, with the invention of camera phones, public and domestic spaces. Since the nineteenth-century prints of Nadar, who brought the world of the theatre into the studio, the performative potential of the photograph has been a vital medium for artists to engage with serious, provocative and sensational topics, as well as humour, improvisation and irony. The exhibition will also dramatise the decision of artists to move from conventional uses of black-and-white photographs, to the embrace of colour and the full reprographic potential of the medium. As people both inside and outside the art world increasingly use the camera to create and express their own thoughts and identities, the exhibition and accompanying publication provide an opportunity to expand our understanding of what constitutes performance art, to reconsider the history of portraiture, and question what it means to perform for the camera.

The exhibition has been organised by Simon Baker, Senior Curator of International Art (Photography) and Fiontán Moran, Assistant Curator, Tate Modern. Carol Burnier Magno, Exhibition Registrar, has organised the transportation and insurance with grace and humour, and Samantha Manton, Exhibitions Administrator, has provided research and assistance on the project. Many thanks are due to Achim Borchardt-Hume, Director of Exhibitions at Tate Modern; Helen Sainsbury, Head of Programme Realisation; Catherine Wood, Senior Curator of International Art (Performance) who provided assistance in the early stages of the project; Rachel Kent, Programme Manager; Juliet Bingham, Curator, International Art; Natalia Sidlina, Adjunct Research Curator, Russian Art; and Morad Montazami, Adjunct Research Curator Middle East.

The exhibition design and installation was overseen by Phil Monk, with support from Rhona O'Brien, while Glenn Williams has ably managed the art handling team. Thanks are also due to our colleagues in the Tate Collection, Tate Library and Archive, the conservation department, press office, design studio and marketing teams, as well as Simon Bolitho and his colleagues in the interpretation team, Simon Armstrong, book buyer, and many other colleagues across Tate who have contributed to the exhibition. Thanks also to the Tate Publishing team, led by Jacky Klein, who worked to realise the catalogue. This would not have been possible without the patience, foresight and generosity of Judith Severne, Project Editor, along with her colleagues Emma O'Neill, Picture Researcher, and Bill Jones and Roanne Marner in Production. Adam Hooper at Hoop Design has perfectly realised the concept for the book with his elegant and considered design.

We are most grateful for the support of the Bibliothèque Kandinsky, Centre Pompidou, Paris, Musée national d'art moderne/Centre de création industrielle, Paris, with special thanks to Didier Schulmann and Catherine Tiraby at Bibliothèque Kandinsky. Many thanks are also due to Justin Brancato of the Roy Lichtenstein Foundation, New York, for his assistance with the Shunk-Kender archive; and Charlotte Ménard at the Yves Klein Archives, Paris.

In addition, we would like to acknowledge and express our thanks for the generosity of the following artists, lenders, galleries and institutions, who have provided essential loans and assistance to the exhibition: Ai Weiwei; Juana de Aizpura; Alison Jacques and Simona Pizzi at Alison Jacques Gallery, London; Eleanor Antin; Rózsa Farkas at Arcadia Missa, London; Matthew Arnatt at the Keith Arnatt Estate; Anthony d'Offay and ARTIST ROOMS; Lynda Benglis; Hicham Benohoud; Sylvie Aubenas, Thomas Cazentre and Jocelyn Monchamp at the Bibliothèque nationale de France, Paris; Stuart Brisley and Maya Brisley; Anke Kempkes and Lindsay Jarvis at BROADWAY 1602, New York; Trisha Brown; Yumiko Chiba and Yuki Miyanaka at Yumiko Chiba Associates, Tokyo; Merce Cunningham Trust; Judy Dater; Jimmy DeSana Trust; Hans Eijkelboom, Thomas Erben; VALIE EXPORT; Samuel Fosso; Lee Friedlander; Tomo Kosuga and Yoko Miyoshi

at Masahisa Fukase Archives, Tokyo; Jean-Kenta Gauthier; Dan Graham; Ivars Gravlejs; Stuart Morrison at Hales Gallery, London; Karin Seinsoth at Hauser & Wirth, Zurich; Minoru Hirata; Hirshhorn Museum and Sculpture Garden, Washington DC; Michael Hoppen; Norio Imai; Vitaly Komar; Jeff Koons; Les Krims; Yayoi Kusama; David Lamelas; Amy Cosier and Fionna Flaherty at Lehmann Maupin, New York; Rute Ventura at Lisson Gallery, London; Sarah Lucas; Romain Mader; Thomas Mailaender; Babette Mangolte; Estate of Robert Mapplethorpe; Dora Maurer; Paul McCarthy; Alexander Melamid; Boris Mikhailov and Vita Mikhailov; Marta Minujin; Jan Mot; Saburo Murakami; Thomas Galifot and Stéphane Bayard at Musée d'Orsay, Paris; Clement Cheroux at Musée national d'art moderne – Centre Pompidou, Paris; Akio Nagasawa; Kiyoji Otsuji; Paul Outerbridge; Giampaolo Paci and Federica Manfredini at Paci Contemporary Gallery, Brescia; Martin Parr, Jenni Smith and Louis Little at the Martin Parr Studio; Adrian Piper; Anneliis Beadnell at P.P.O.W Gallery, New York; Yvonne Rainer; Charles Ray; Martial Raysse; Marisa Bellani at Roman Road, London; Richard Saltoun and Niamh Coghlan at Richard Saltoun Gallery, London; Tokyo Rumando; Tomoko Sawada; Carolee Schneemann; Cindy Sherman; Bruce Silverstein; Estate of Aaron Siskind; Luce Lebart at Société française de photographie, Paris; Niccolo Sprovieri and Margherita Molinari at Sprovieri, London; Marie Krauss at Sprüth Magers, London; Jemima Stehli; Linder Sterling; Atsuko Tanaka Estate; Elisa Uematsu at Taka Ishii Gallery, Tokyo;  Keiji Uematsu; Amalia Ulman; Andy Warhol Foundation, New York; Michael Wilson and Polly Fleury at Wilson Centre for Photography; Estate of David Wojnarowicz; Hannah Wilke Collection & Archive, Los Angeles;  Amanda Wilkinson and Anthony Wilkinson at Wilkinson Gallery, London; Estate of Francesca Woodman; Erwin Wurm; Michael Xufu Huang at M WOODS Museum, Beijing; Amanda Lo at Zen Foto Gallery, Tokyo; and all those lenders who wish to remain anonymous.

This exhibition has been made possible by the provision of insurance through the Government Indemnity Scheme. Tate Modern would like to thank HM Government for providing Government Indemnity and the Department for Culture, Media and Sport and Arts Council England for arranging the indemnity.

This exhibition is the first in a new three year partnership with Hyundai Card to support acquisitions and exhibitions of photography. Their generous support will allow Tate Modern to stage a major photography exhibition in each of the next three years, and we are extremely grateful for their commitment to Tate.

**Chris Dercon**
Director, Tate Modern

# Performing for the Camera

SIMON BAKER

## PLEASURES AND TERRORS OF LEVITATION

In 1960, Yves Klein published his own newspaper *Sunday: The Newspaper of a Single Day*. Its front page featured *Leap into the Void*, a photograph that would become one of the most celebrated in the history of what is now commonly referred to as performance art: Klein's leap was, in every sense of the phrase, a photographic performance, an act, or event, conceived by the artist specifically for its photographic qualities.[1] Most obviously, Klein, suspended in mid-air, is frozen by the camera's split-second recording capacity. But as a fait accompli, *Leap into the Void* engages another specific aspect of the photographic medium: for although Klein encourages his readers/viewers to buy into the legend that he might have survived his flight from gatepost to tarmac, in fact the image was produced in the darkroom. This photomontage was assembled, precisely and effectively, by Harry Shunk and János Kender, the photographic team that took the two pictures from which it is composed: one of Klein leaping from the pillar with a team of assistants holding a blanket below to catch his fall; and another of the empty street complete with its nonchalant and oblivious cyclist (borrowed from any number of photographic clichés) (frontispiece, p.12).[2] In common with many similar photographic acts, then, Klein's photographers, known collectively as Shunk-Kender, were less 'recording' a performance than producing it photographically; a performance, furthermore, that Klein can only have conceived in strictly photographic terms. For despite his attachment to the martial arts and his showmanship, a true 'Leap into the Void' was not something that Klein would ever have been willing or able to make. It is precisely this interface between the performative and the photographic that concerns *Performing for the Camera*, which takes as its starting point the intersection between what are understood to have been simply photographs of performances and what we might call performative photography.[3] For looking back at the histories of art and photography, it is as if, somehow, Klein's *Leap* and work like Aaron Siskind's series *Pleasures and Terrors of Levitation* (p.14) have been kept apart: suspended like flies in different pieces of amber.

YVES KLEIN, *LEAP INTO THE VOID* 1960

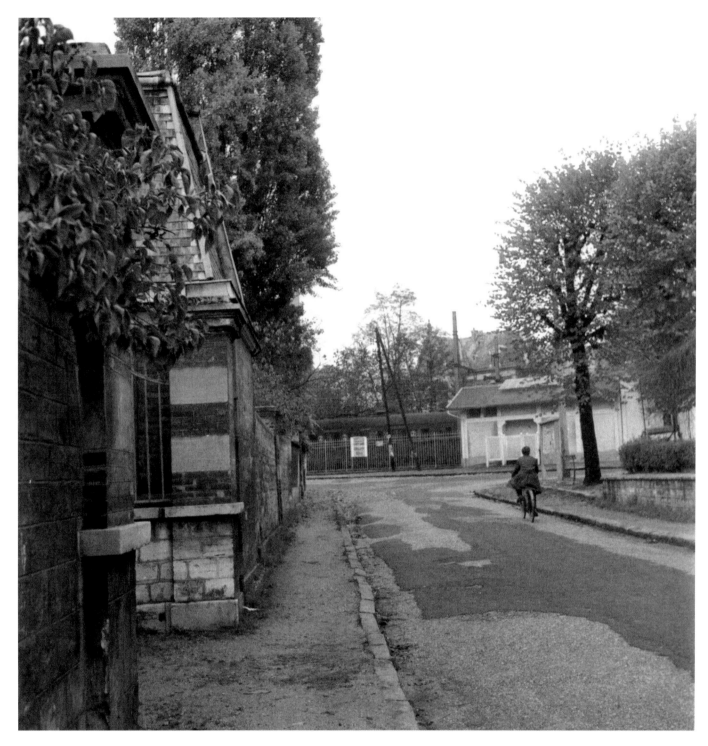

YVES KLEIN, PREPARATORY IMAGES FOR *LEAP INTO THE VOID*,
FONTENAY-AUX-ROSES, FRANCE 1960. PHOTOS: SHUNK-KENDER

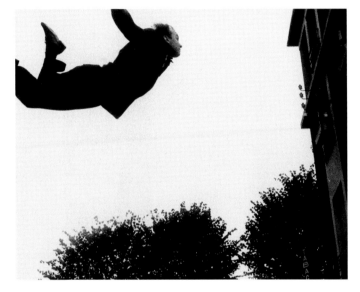 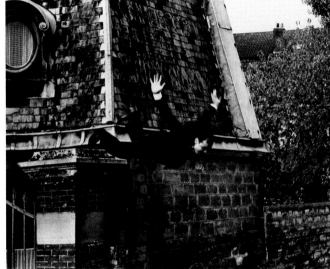

Siskind's practice predates Klein's *Leap*, and indeed his artistic career, by many years. He began as a documentary photographer, working on the streets of New York City in the 1930s, making portraits and capturing scenes of everyday life.[4] By the 1950s, however, Siskind was fully engaged with what we might call the 'specific qualities' of the photographic medium as they related to fine art more generally. He produced striking abstractions, responses to the rise of abstract expressionist painting, from carefully cropped close-ups of the most banal surfaces and textures, flaking paint and scuffed walls.[5] And in *Pleasures and Terrors of Levitation* he sought to reveal the formal capacity of the camera to transform actions into shapes. Having photographed acrobatic divers in mid-air, using a high-contrast aesthetic that reduced the bodies to black and the sky to white, Siskind also eliminated any background or context that might reveal either the starting points or destinations of the leaps and somersaults depicted. The results are frozen bodies of great poise, elegance and beauty that become simply 'forms' in black and white, not abstractions but transformations, sublimating speed and movement into controlled studies or compositions.

Both Klein and Siskind ask questions of the relationship between the veracity and credibility of the camera, in particular its promise of an indexical relationship to events in the real world (as a supposedly truthful and neutral recorder of reality, achieved by a technical process). We know, in a certain sense, that in order for these photographs to exist (before the infinite chaos of the digital image, at any rate), then at some point someone had to leap from something into something, whether gatepost, diving-board, blanket or water. And it is precisely the implication of the potential of the photograph to record actions, from the mundane to the spectacular, the implausible and even the impossible, that has brought the camera into the practice of so many artists whose first priorities lie outside the exploration of photography as such, especially in the field of conceptual art. Charles Ray, for example, best known as a sculptor, produced what could be described as sculptural performances for the camera: his brilliantly deadpan *Plank Pieces*.[6] Apparently the result of careful calculations about the potential of a plank to cantilever or counterbalance the weight of the artist's body, *Plank Piece I* and *Plank Piece II* are contrived to suggest the results of experimentation, trial and error. For each

14

AARON SISKIND, *PLEASURES AND TERRORS OF LEVITATION* 1956–65

CHARLES RAY, *PLANK PIECE I–II* 1973

precariously 'finished' photograph, we are encouraged to imagine countless alternative, less photographic iterations in which artist and plank have unceremoniously collapsed. But it is also part of the magic of Ray's use of the camera that it is only through its agency that he remains perfectly and permanently balanced, enjoying a state of perpetual equilibrium. In the photograph at least, his outstretched fingers will never touch the floor of his studio, just as Klein will never hit the ground, and Siskind's divers will never plunge into the waters of Lake Michigan.

## PERFORMANCE / ART / COLLABORATION

Photography itself has always been performative, and since the invention of the photographic medium, performance, whether in the practices of actors, choreographers or artists, has to a greater or lesser extent depended on photography. But what complicates the relation of performance to the camera is the degree to which photography is properly recognised for its translation of performative acts, beyond the limited sense of its being just documentation. There exists a notional sliding scale, along which we might measure the relationship of performance to its photographic image, after factoring in issues of intention, authorship, competence, aesthetic quality, conceptual integrity and many other elements. There are many issues involved in making such determinations. Did the performer wish to be photographed? Was the performance happening anyway, whether or not a photographer was present? Was the photographer a professional or just a friend of the artist? Were the photographs of the performance taken so that they could be published or exhibited? Who retains ownership or copyright of the images produced: the performer or the photographer, or both? Who is credited as the maker of the resulting work? However, rather than trying to find generic answers to these questions, it might instead be instructive to consider the ways in which photography has responded to performance aesthetically and conceptually, revealing the complexity of a symbiotic relationship in place of intractable value-laden arguments about priority and preeminence.[7]

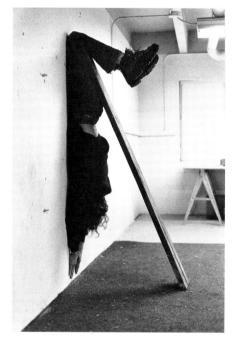

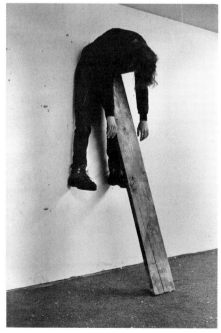

16

Once again the working relationship of Yves Klein and Shunk-Kender is an instructive place to start. Shunk-Kender photographed both the preparations for, and the performance of Klein's *Anthropometries of the Blue Period* 1960, in which Klein orchestrated a live painting event using the bodies of naked women before an invited audience at a Paris gallery (pp.28, 30–3).[8] What is surprising, however, is not that Klein should have invited or allowed Shunk-Kender to document the event; nor that, given its nature, and the reputation of the photographers, the resulting photographs would become the most iconic and permanent record of the evening. The surprises in this case lay in the way that Shunk-Kender employed the practice and language of photography in direct response to Klein's performance. Even in their photographs of a preliminary version of the live event, made in Klein's apartment, Shunk-Kender surpass the level of photographic activity necessary simply to 'document' Klein's actions. Not only are there posed, almost excerpted tableaux, but there are carefully composed, cropped close-ups of stages of the process, such as a naked torso, draped around and over a white, partially imprinted cloth. Such images, like many key works from the extensive archive of Shunk-Kender's work, were printed as enlargements on luxurious photographic paper and are, in every way, distinct from the kind of anecdotal recording, or mundane documentation for posterity, of an original event. Arguably, however, such images reflect the interests and ambitions of the photographers rather than those of Klein, on whose behalf the pictures were originally taken. In their responses to the public event itself, furthermore, there are numerous other images that are just as sophisticated and considered. For alongside the shots of Klein directing models, and those showing the

actions of the models as they paint and imprint themselves and one another – the expected 'evidence' of the event – we find Shunk-Kender ushering Klein's imagery, technically and creatively, towards photographic works in their own right. In one notable sequence that tells us much about the ambition and status of the photographers in the face of such a performance, Shunk-Kender zoomed in and enlarged the model seen between the backs of the heads of members of the audience, with Klein first visible and then excised from the scene. The resulting composition is almost classical in proportion and beguiling in the way it embodies the acts of attendance and spectatorship (pp.32–3).

All this is not to suggest that Shunk-Kender were in some sense making their own unique work distinct from Klein's, or that we need to rebalance the scales of creativity in favour of the photographers. Rather, the evidence suggests, both in formal and physical terms (in the ways that bigger and better quality paper was used for certain images, for example), we should acknowledge that there is more to the relationship of performer and photographer than initially meets the eye. This claim, moreover (more or less appropriate depending on the example), carries through from artists to choreographers and dancers, such as Shunk-Kender's darkroom interventions in their responses to Merce Cunningham's works *Nocturnes* and *Aeon* (pp.62–3).[9] Here, relatively straightforward images of Cunningham's dancers in specific poses have been frozen by the camera but then been deliberately distorted and blurred in the printing process, so that the figures lose their integrity and come almost to resemble elements of an abstract alphabet. Such an intervention on the part of the photographic team is clearly at odds with any conventional sense of 'documenting' performance. Yet although it flies in the face of the commonplace conception of photography as an exemplary means of objective picture-making, in fact what Shunk-Kender did was simply to shift the home ground of the medium towards that occupied by experimental modernists in the 1920s and 1930s: a photographic approach in which close-up,

cropping, rotation, solarisation and all the other kinds of deliberate defamiliarisations were recognised and celebrated as fundamental to photography as an art form in its own right.

The real shift in performing for the camera, however, occurs not with the elevation of performance documentation towards a discrete artistic practice in its own right but with the implicit realisation of a deep interconnectedness between performance and photography at many levels. For, arguably, the absolute necessity of the complicity of both artist and photographer, and their shared interest in photographic practices and techniques in works like *Leap into the Void*, or Babette Mangolte's visualisation of Trisha Brown's *Woman Walking Down a Ladder* 1973 (pp.58–9), speak less the language of 'documentation', and more eloquently of close collaboration, however the finished works are officially authored.[10]

Perhaps unique in the context of this shifting emphasis, or rebalancing of photographer and performer is the practice of Eikoh Hosoe, whose interest in, and complete absorption by, avant-garde practices in Japan across a range of media (from literature to music, acting and dance) would result in some of the most radical collaborative photographic work of the postwar period. Hosoe made several related bodies of work, beginning with his contributions to *Dance Experience* (the publication based on Tatsumi Hijikata's first Butoh events in 1960 and 1961; pp.76–7), and including *Ordeal by Roses* (in which Hosoe photographed the writer and bodybuilder Yukio Mishima). This part of his practice culminates in the striking photobook *Kamaitachi,* which is credited, perhaps uniquely, 'Photographs Eikoh Hosoe, Dance Tatsumi Hijikata' (pp.78–81).[11] *Kamaitachi* comprises a series of scenes or tableaux in which Hijikata, founder of the Butoh movement, responds physically to a Japanese folk legend about a mischievous spirit that lives in the countryside. By according the subject of his photographic work an equal authorial status, and working to produce a sequence

18 of photographic images that offers Hijikata a voice alongside his own, Hosoe accepted more completely and honestly than any other artist of his generation the absolute equilibrium at the heart of the relationship between photography and performance. Hosoe's openness to performances staged purely for the camera transformed both his own practice as a photographer and the way in which his collaborators were able to conceive and deliver their performances. *Simmon: A Private Landscape*, for example, made in 1971, sees the actor Simmon Yotsuya take his transgressive, deeply emotional characterisations of an androgynous alter-ego out of the theatre and into the streets: from the application of make-up in the first scene, through a range of intense poses and expressions that conclude with the character's collapse and disappearance on the outskirts of the city (pp.82–5). What Hosoe contributes to the performance, through the accumulation of scenes and sequencing of images is almost cinematic; framing and reframing, moving towards and away from his subject so that the final work is less a single performance than a layering of multiple facets of the story that Yotsuya presents to the camera.

Photography, in a sense then, has the capacity both to record and displace performances, shifting them from their origins in time and space, isolating and preserving individual acts (the pose or expression of an actor in a scene), but also allowing them to be rearranged as serial images that exist in relation to one another. Almost unbelievably, however, these characteristics of the photographic medium were identified and deployed almost from the very first photographs, with the camera's ability to respond creatively and positively to theatrical performance being quickly recognised and exploited. The Nadar studio, in mid-nineteenth century Paris, for example, seized on the huge interest in the Pierrot character, performed by the mime artist Charles Deburau (a role he inherited from his father).[12] In 1853, Nadar (Gaspard-Félix Tournachon) and his brother Adrien invited the actor to collaborate with them by performing his signature poses and facial expressions against the neutral backdrop of their

studio, resulting in a portfolio of prints that could be displayed and exhibited as works of art in their own right (pp.68–9).[13] The silence of mime and the stillness of the photograph respond perfectly to one another in Nadar's vision of Deburau's Pierrot, not only foreshadowing the collaboration of Hosoe and Yotsuya, but offering the first example of a major contribution to the success and fame of the Nadar atelier. For throughout the second half of the nineteenth century, and into the first years of the twentieth (latterly under the direction of Nadar's son Paul), the finest Parisian actors would come to the studio to restage key scenes from the theatrical productions of the day, complete with costumes, props and painted backdrops. However, although in most cases, these strange 'production stills' seem more commercial than collaborative, there are many instances (among the many photographs of Sarah Bernhardt, for example), where the stage actor seems to work with and for the camera in a way that transcends the theatrical origins of the image, predicting instead the look and feel of the early years of cinema (pp.70–5). It is worth remembering, however, that Nadar's studio, like those

EIKOH HOSOE, *SIMMON: A PRIVATE LANDSCAPE* 1971

GASPARD-FÉLIX TOURNACHON (NADAR)
AND ADRIEN TOURNACHON, *PIERROT THE
PHOTOGRAPER* 1854

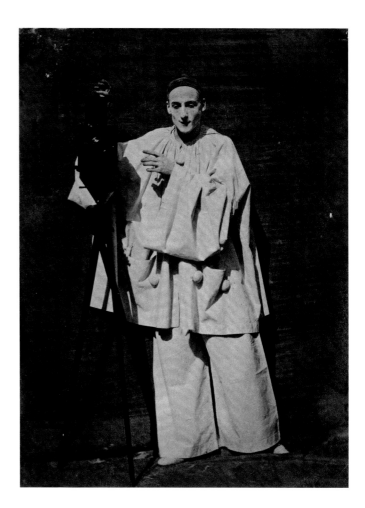

of many of the great portrait photographers who followed him, was itself a deeply theatrical environment, calculated to invite and incite the celebrities of his day to perform for his camera to maximum effect.

## I AM NOT I

It is clear that a strong relationship exists between performance and photography in those cases where the subject of the photograph is independently recognised as a performer of some sort, whether actor, dancer/choreographer, or latterly, an artist like Klein whose practice included performance. However, retracing this same trajectory in reverse, we find an even more persuasive formulation of performative photography, where the artist/photographer performs for their own camera; either physically, like Charles Ray, or more self-consciously and conceptually, acting out fantasies or alternative realities through their own self-image. And once again, although we may associate this kind of identity politics with modern and contemporary art, the ability of the camera to enable an artist to deliver a convincing performance purely as a photographic image can be traced back to the very first days of the medium.

Perhaps the most eloquent of these early examples of one-time performances destined only to exist as photographs is Hippolyte Bayard's work *Self-Portrait as a Drowned Man* of 1840 (p.20).[14] Bayard was the unlucky third inventor of photography, spectacularly outshone by Louis-Jacques-Mandé Daguerre in France and William Henry Fox Talbot in Great Britain. He was deeply depressed by the decision of the French authorities to announce, celebrate, support and buy for the nation the awkward metal daguerreotype, despite the fact that his own invention (positive photographic prints on paper) was cheaper, safer and easier to use. In response to having been, as he saw it, unfairly overlooked, Bayard staged an unusual visual protest: a self-portrait, naked from the waist up, slumped as if in death, in a pose reminiscent of Jacques-Louis David's painting *The Death of Marat*

1793, his work-stained hands a testimony to his wasted labour. Bayard's work, and its title, reveal not only the conceptual ingenuity of its author/inventor but also the fact that at its very outset, just one year after the first photograph was officially announced to the world, photography was already making itself the ideal partner for the staged actions of its pioneering practitioners.

Although it is unclear exactly who or what Bayard imagined the audience for his incredible self-portrait to be (or even whether he intended to circulate or publish it), it is evident that, from its inception, performance was an essential rather than peripheral element of photography. Beyond the ordinary necessity of 'extreme posing' for photographic portraits taken over long exposures, there were hybrid attempts at classical allegory and morality tales produced using directed, posed models: O.G. Rejlander's *The Two Ways of Life* 1857, for example, is a complex montage of different groups of actors reassembled into a kind of photographic 'history painting'. But perhaps more immediately engaging today are the stranger, more extreme examples of photo-realist mythology from the end of the nineteenth century. F. Holland Day's *The Seven Words*, for example, takes the radical potential suggested by Bayard's dramatic performance to an

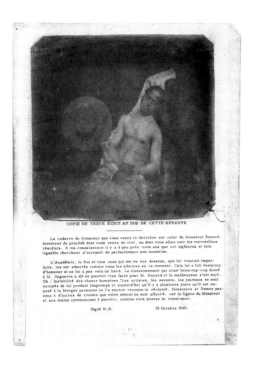

of Arthur Rimbaud: the author of the radical formulation 'Je est un autre', literally 'I is another'.[19] Ideas such as the mirror stage (concerning the role of self-recognition in psychological development), conceived by the psychoanalyst Jacques Lacan, grew alongside, and were nurtured by, surrealism, which saw Lacan's early research published in the pages of its magazine *Minotaure*.[20]

extreme conclusion in the form of seven self-portraits as a crucified, rather than drowned, man (pp.122–3). To pass himself off as a convincing Jesus Christ, Day not only grew a beard, but starved himself for the crucial climactic scene. Part of an ambitious plan to photographically depict the life of Christ, Day's decision to cast himself in the starring role was controversial not because Day had a heretical agenda (quite the contrary), but because the notion of an artist embodying Christ for a photograph was perceived as blasphemous.[15]

By the 1920s, the transgressive potential of posing as another person deliberately to confuse and provoke was well understood by the avant-garde artists associated with dada and surrealism. Marcel Duchamp, for example, always playing games of some kind, collaborated with Man Ray to produce several photographic versions of his female alter-ego Rrose Sélavy (pp.120, 124–5).[16] Claude Cahun produced a hugely influential body of work almost exclusively through the adoption of different variously androgynous versions of herself (including the adoption of a masculine name), playing with and against normative stereotypes of femininity that existed just for the length of time it took her to set up and take her own photograph (p.161).[17] Cahun's identity as a lesbian in the 1920s was troubling both for mainstream society and the surrealist group that claimed to espouse an emancipated attitude to sexual identity but never delivered on this promise with respect to homosexuality.[18] Her solitary and self-absorbing practice, performing facets of her self in the shadows of surrealism, suggests familiarity with that movement's co-option of both psychoanalysis and the poetry

The early promise of Cahun's practice, arguably however, would be made good by following generations of artists, working in the full awareness of the models of identity theorised and popularised through psychoanalysis. For example, feminist thinkers working in the 1970s drew radical conclusions about the social construction of gender roles and stereotypes, in particular in terms of the way that gender roles are learned and performed, that were not only engaged directly by feminist artists, but identified after the fact by feminist critics in the work of artists like Cindy Sherman.[21] Sherman's demonstration and deconstruction of cinematic and photographic clichés are the result of performances carefully calculated to mimic the tropes and signifiers of the kinds of image through which notions of femininity are constructed and perpetuated. Her *Untitled Film Stills* (pp.130–1), for example, are perfect equivalents for scenes from b-movies, although no single scene is a direct enough quote to appear to have come from a specific source. The uncanny effect of Sherman's work, however, comes not from her ability to construct plausible stills from non-existent films, but rather her use of herself as the actress for each scene, playing the gamut of potential roles twice; as the actress taking on a stereotypical female role; and as an artist taking on the role of the actress. Sherman's performances of herself as herself and another at one and the same time, reveal the artificial nature of what is taken on face value as normal or natural, thereby representing issues that were of central importance to feminist thought. At the same time, Sherman's work is determinedly photographic, resolutely concerned with what it is possible to imply and infer within the constraints of a posed, fixed image.

CINDY SHERMAN, *UNTITLED FILM STILL #53* 1980

The photomontage practice of the Japanese artist Tokyo Rumando openly acknowledges debts to Cahun and Sherman, parsing the work of her precursors in a serial performance that takes place both before and within a circular mirror: an object that not only symbolises and dramatises the act of self-reflection, but is itself analogous with the camera's lens (pp.22, 134–5). Rumando's double performance then, moving beyond Sherman's negation of her own identity (performing being an actress), is to picture versions of herself in the act of contemplating fantasies and fragmentary scenes in which she also appears. Rumando's

work, importantly, is concerned with the agency of spectatorship, or the 'gaze': what it means specifically for a woman to look at herself, and at the ways that women are frequently objectified through conventions associated with cultural tradition, propriety and exploitation. In the most dramatic sequence of her series *Orphée*, Rumando turns away from the mirror (which seems to burn and bleed simultaneously), posing as the Japanese writer and nationalist activist Yukio Mishima (the bodybuilding subject of Hosoe's *Ordeal by Roses*), who is famous in Japan for having ritually committed suicide at the end of a failed uprising. Rumando's

assumption of the identity of an icon of narcissistic machismo and misguided patriotism plays not only with the language of everyday self-image, how one might relate to such a figure, but draws this logic inevitably towards the value and power of iconicity in the mediated image: precisely the ground prepared by artists like Sherman and, perhaps even more so Hannah Wilke. Wilke's constant provocations around the use and abuse of the naked female body through performances in which she stripped in relation to iconic imagery challenged both normative and feminist conventions about desire and spectatorship. In her important film *Through the Large Glass* of 1974 she performs an arrested striptease, stopping to hold poses as though being photographed, behind Marcel Duchamp's sculpture *The Bride Stripped Bare by her Batchelors, Even* 1915–23, known as *The Large Glass*. This performance, directed at one of the icons of art history, is also closely related to a live performance event that Wilke used as the basis for a specifically photographic work *Super-t-Art* (p.167).[22] In both cases, for the live audience and for the camera, Wilke performed a similarly arrested strip, freezing at, and holding, specific set poses; but whereas in *Through the Large Glass* she appears to remove stylish contemporary clothes, in *Super-t-Art* she uses only a draped cloth that starts out resembling some kind of toga or classical garment, but ends up enabling Wilke to adopt the form of a crucified Christ complete with loin-cloth.

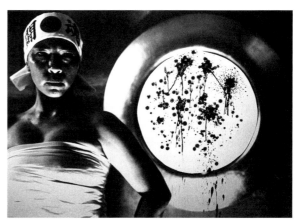

## IMPOSTURES

Performing for the camera, however, need not necessarily imply the kind of performed drama and melodrama found in the work of Sherman, Rumando, Wilke and many others. These artists, after all, deliberately take on extreme alternatives (film stars, porn stars, religious martyrs, even suicidal poets) to question the boundaries of constructed identities within their own practice. Yet there are other kinds of performance that draw their power not from the distance between reality and fantasy, but rather the proximity of the two. There are many examples of artistic practices that rely precisely on the everyday fact of photography and the ways in

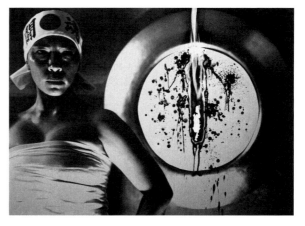

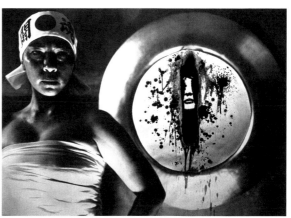

which we respond to photographic conventions in our daily lives: incidental snapshots, family portraits, holiday views, photographs of loved ones, even the now ubiquitous 'selfie', are all governed by unspoken rules and performative logics.

The impact of online platforms such as Facebook, Instagram and Snapchat, following on from the universality of camera-phones, has been to collapse the boundary between the production and reception of photographs to one of virtual instantaneity. Although in many, perhaps most cases this open sharing of everyday photographic material is simply that, it is hard to overstate the transformative effect that such a traffic in images has had on the role of photography in daily life, and therefore, by implication, the potential role for artists seeking to exploit its performative aspect. Amalia Ulman's work *Excellences and Perfections* 2014, for example, took the form of a four-month long series of Instagram posts apparently documenting the artist's relocation to Los Angeles and decision to have cosmetic surgery (pp.210–11). Ulman sought, however, not only to adopt, but also to subvert the quasi-intimate language of the selfie, as popularised by celebrities who have millions of 'followers' hungry for revealed fragmentary images of their daily lives. Each of Ulman's apparently diaristic daily posts was carefully staged and performed by the artist, before being edited to conform to the various conventions of similar Instagram accounts; yet in reality many of the sequential 'daily' images were produced at once and then gradually released over the duration of the work. It is also important to note that Ulman had used Instagram before, and continued to use it after this performative intervention in the world of social media, which, like its mainstream equivalents was calculated to draw responses and feedback ('likes' and so on…). Ulman's project clearly reflects critically on both the medium and the message; or perhaps on the incremental collapse of the two in a contemporary context where the 'instant' photographic image appears to have reclaimed a fragile authenticity long-since believed lost in the digital era.

However, such interventions at the boundaries of photographic plausibility are by no means new, and relate directly to a subtle aspect of the relationship between conceptual art and photography that has its roots in the late 1960s. Hans Eijkelboom, for example, working in the Netherlands in the 1970s, produced a series of remarkable works questioning notions of recognition and identity, in each case by inserting his own image into the everyday photographic conventions of his time. For *In the Newspaper* 1973 he contrived to appear somewhere in the cover photograph on the front page of his local newspaper ten times in May 1973; in another work from 1976 he replaced advertisements in his local railway station with almost identical duplicates in which he was the model in every case: selling beer, butter or other products.[23] In *With My Family* 1973 (pp.184–5), perhaps his most subtle work from this period, he contrived to present himself as the father of four different families in his home town. Having waited for his male neighbours to leave for work, Eijkelboom asked their wives if he could make a photograph with them and their children in their living rooms, making himself at home in place of the absent husbands and fathers. As with Ulman's Instagram project today, the success of Eijkelboom's work depends largely on the artist's subtle understanding of the normative rules and conventions of the kinds of photographic language into which he inserts himself: the generic awkward, posed group-photograph of a 'typical' family. But in common with Eijkelboom's other early series, the overall effect of the work is achieved by the uncanny repetition of the artist's face, equally comfortable and plausible, in four mutually exclusive settings signalled by the title (they could not, after all, all be *his* family).

Boris Mikhailov's work *Crimean Snobbism* is another photographic game played out on the borders of what is possible and plausible, this time in the Soviet Union in the 1980s (pp.200–3).[24] Taking the form of a series, or album, of holiday photographs, *Crimean Snobbism* is an elaborate photographic performance featuring Mikhailov, his wife Vita and various

24

supporting friends, all of whom are pretending to be on holiday at a seaside resort in Crimea. Of course, in a way, they actually were on holiday, as they had to go there to make the pictures of their 'fake' Crimean holiday. The fine line between fantasy and reality, between the real place and the fabricated performance of what was supposed to occur there (or at least what people in the Soviet Union assumed occurred there), relates both to the politics of everyday life (Mikhailov's social circumstances) and to the use and understanding of photography as a means of recording it. Mikhailov has noted that under communism (a totalitarian system with limited freedom of expression), people were forced into playing roles all the time in daily life. For this reason, he has argued, his 'documentary' street photographs of life in Soviet Ukraine are full of people performing for the camera – doing what they believed was expected of them. Whereas, by contrast, his photographs of himself and his friends performing for the camera, playing and pretending to live alternate lives in the same situation, were some of the few photographs in which the performances were 'real' in as much as they were genuine

performances, chosen and owned by the subjects.[25] This reversal of apparent common sense is typical of Mikhailov's practice in general, but also reflects the ever-more complex boundaries of documentary practice and performance where photography is concerned. Romain Mader's work *Ekaterina*, for example, also appears simply to document tourism in Ukraine, through the artist's construction of a narrative in which he seeks a bride in the imaginary city of Ekaterina (pp.196, 198–9). The real issue of this speculative trade in spouses underpins a photographic and filmic project which seems to 'document' its subject, but which also, through the presence of the artist as subject of the work, manages also to expose the performative aspect of investigative projects of this kind. Mader's embodiment of the role of western bachelor searching for a Ukranian bride engages with a whole series of obvious stereotypes about such potentially exploitative situations. Yet what is most significant about the work, beyond the finely balanced performance of its author, is that it is delivered in a photographic language that duplicates perfectly, almost uncannily, the conventions of contemporary documentary practice.

Although such artists as Eijkelboom, Mikhailov, Mader and Ulman insert themselves into almost possible versions of their own lives, walking the tightrope between reality and fantasy through the ways in which photography has become central to our experience of daily life, there are also artists for whom the performance of the everyday becomes the heart of both their lives and their practice as artists. The Japanese photographer Masahisa Fukase, for example, produced several compelling photographic series documenting his family, and in particular his relationship with his wife.[26] *Yoko*, published by Fukase in 1978, offers an apparent account of daily life from newly wedded bliss to the break-up of the relationship, comprising not only candid and intimate scenes, but also a strange accumulation of staged and performed actions with everyday objects and pet cats.[27] Most moving, however, are those parts of Fukase's work where daily actions come to resemble performances, or are revealed as

performative through their repetition; such as the series within a series where Yoko looks up at Fukase in the window of their apartment as she leaves for work every day, and he photographs the full range of her exaggerated facial expressions: anger, longing, frustration, joy, playfulness and so on (pp.206–7). Years after the end of that project, and indeed his marriage, Fukase continued to make performative work about his daily life, acting out his own interpretations of his situation and personal emotional landscape. *Bukubuku* 1991 is perhaps the funniest and also the bleakest of these late works, following on from the better-known and more obviously expressive *Solitude of Ravens*.[28] *Bukubuku*, the Japanese onomatopoeia for the sounds of bubbling, sees a much older, lonelier Fukase than the playful young husband so obsessed with Yoko, in a sequence of seventy-nine self-portraits made entirely in his bath (pp.26, 192–5). Playing games with clothing, props and the waterline, Fukase performs his own isolation and solipsistic curiosity for the camera, each image digitally tagged with the date, so that it is clear that *Bukubuku* was produced over around a month of experimental bathing. One of the strangest series of photographic self-portraits of all time, *Bukubuku* is intimate, explicit, playful, occasionally hilarious, but also deeply moving. It is as though, having devoted his life to photographing those around him, Fukase finally finds himself completely alone, restricts himself to the impossible confines of his bathroom, and then sets about rethinking the essential coordinates of photographic practice.

It seems clear, then, that the relationship between photography and performance encompasses a broad and expanding field, from the photographic documentation of performances, through sculptural posing, self-portraiture and the adoption of alternative identities, to the performative daily practice of photographers like Fukase. But what is more surprising, perhaps, than the pervasiveness of the relationship, is the extent of its history, from Bayard's *Self-Portrait as a Drowned Man* at the birth of the photographic medium in 1840, to Fukase's restless submersible creativity at the end of the analogue era, and forward into a digital age in which performing for the camera has become a daily fact of life.

## NOTES

1 Yves Klein, *Dimanche: Le Journal d'un Seul Jour*, 27 November 1960. See also Lucy Gallun, 'Performance for the Camera: Trace of the Body, Gesture of the Body', in Quentin Bajac et al., *Photography at MoMA 1960 – Now*, New York 2015.

2 Mia Fineman, *Faking It: Manipulated Photography before Photoshop*, New Haven and London 2012.

3 The use of the term 'performative' throughout this essay relates directly to the notion of performance art; practice that involves live performance. However, the associated use of the term from the linguistic theory of J.L. Austin, identified by Judith Butler in relation to the acts that constitute normative patterns of behaviour in her groundbreaking work *Gender Trouble*, also has relevance for some of the works discussed below. I am grateful to Catherine Wood for drawing attention to the ways in which the term is currently used.

4 Aaron Siskind, *Harlem Document: Photographs 1932–1940*, Rhode Island 1981.

5 *Aaron Siskind: Photographer*, exh. cat., George Eastman House, Rochester 1965.

6 Ray is primarily known for his sculptures, including many that have a performative element, but made several key early photographic works that also involved performances, including *Plank Pieces* and *All My Clothes* 1973.

7 Alice Maude-Roxby (ed.), *Live Art on Camera: Performance and Photography*, exh. cat., John Hansard Gallery, Southampton 2007.

8 *Anthropometries of the Blue Period* was performed at the Galerie internationale d'art contemporain, 253 rue Saint Honoré, Paris, 9 March 1960. Paintings made at the performance were subsequently exhibited as works.

9 *Nocturnes* was first performed in 1956 with music by Eric Satie, and *Aeon* in 1961 with music by John Cage: Shunk-Kender photographed

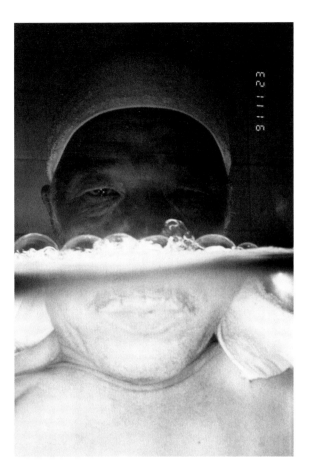

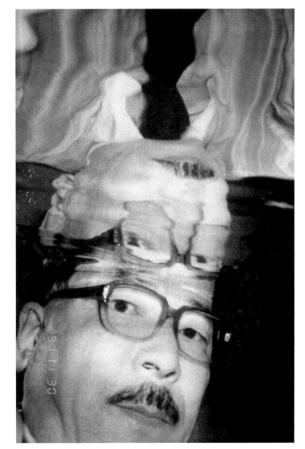

MASAHISA FUKASE, *BUKUBUKU (BUBBLING)* 1991

the performance at Théâtre de l'est Parisien, Paris on 12 June 1964, with decor and costumes by Robert Rauschenberg.

10 Trisha Brown's performance *Woman Walking Down a Ladder* was performed on 25 February 1973 at 130 Greene Street, New York; the event was photographed by Babette Mangolte.

11 Eikoh Hosoe, *Dance Experience 1 & 2* (July 1960 and September 1961), facsimiles published by Akio Nagasawa, Tokyo 2012; Eikoh Hosoe, *BaraKei (Ordeal by Roses)*, Tokyo 1971; Eikoh Hosoe and Tatsumi Hijikata, *Kamaitatchi,* Tokyo 1969; Eikoh Hosoe, *Simmon: A Private Landscape*, Tokyo 2012.

12 Maria Morris Hambourg et al., *Nadar*, exh. cat., Metropolitan Museum of Art, New York 2013; *Nadar/Warhol: Paris/New York. Photography and Fame*, exh. cat., Getty Center, Los Angeles 1999.

13 M. Knowles, 'Lost Ground: The Performance of Pierrot in Nadar and Adrien Tournachon's Photographs of Charles Deburau, *Oxford Art Journal*, vol.38, no.3, 2015.

14 See Geoffrey Batchen, *Burning with Desire: The Conception of Photography*, Cambridge, MA 1999.

15 Edward Steichen is known to have written in defence of Holland Day's work, arguing that had they been paintings they would not have been problematic. See http://www.metmuseum.org/collection/the-collection-online/search/269295, accessed 29 October 2015.

16 David Hopkins, *Dada's Boys: Masculinity after Duchamp*, New Haven and London 2008.

17 Cahun was born Lucy Schwob but worked under a series of masculine alternate names, often collaborating with her partner Suzanne Malherbe, who likewise adopted the more androgynous name Marcel Moore.

18 For a critique of the sexual politics of the surrealist movement, see Natalya Lusty, *Surrealism, Feminism, Psychoanalysis*, Aldershot 2007.

19 Arthur Rimbaud, 'Letter to Georges Izambard', 13 May 1871.

20 Jacques Lacan, 'Le Problème du style et la conception psychiatrique des forms paranoïques de l'experience', *Minotaure*, no.1, 1933; 'Motifs du crime paranoïque', *Minotaure*, nos.3–4, 1933.

21 These ideas can be traced back to Joan Riviere's landmark essay 'Womanliness as Masquerade', first published in the *International Journal of Psychoanalysis* in 1929. For more on these issues in relation to photography see: Jennifer Blessing et al., *Rrose Is a Rrose Is a Rrose: Gender Performance in Photography*, exh. cat., Solomon R. Guggenheim Museum, New York 1997; Shelley Rice (ed.), *Inverted Odysseys: Claude Cahun, Maya Deren, Cindy Sherman*, Cambridge, MA 1999; Danielle Knafo, *In her own Image: Women's Self-Representation in Twentieth-Century Art*, Teaneck, NJ 2009. See also Judith Butler, *Gender Trouble: Feminism and the Subversion of Identity*, London 2006; Helena Rickett and Peggy Phelan, *Art and Feminism*, London 2006.

22 The performance was first staged at The Kitchen in New York in 1974. See Nancy Princenthal, *Hannah Wilke*, Munich, Berlin, London, New York 2010.

23 See *Hans Eijkelboom: Photoworks*, exh. cat., Museum of Modern Art, Arnhem 1999.

24 Boris Mikhailov, *Crimean Snobbism*, exh. cat., Rat Hole: Tokyo 2006; Boris Mikhailov, *Krymskaja FotoManija (Photomania in Crimea)*, Cologne 2013.

25 See 'I am not I (and you are not you)', in Boris Mikhailov, *I Am Not I*, London 2016 (forthcoming).

26 Fukase's series *Family* was produced over many years from the 1970s onwards, but not published as a book until 1991.

27 Masahisa Fukase, *Yoko*, Tokyo 1978.

28 Masahisa Fukase, *Solitude of Ravens*, Tokyo 1986; Masahisa Fukase, *Buku Buku*, Tokyo 2004.

# DOCUMENTING
# PERFORMANCE

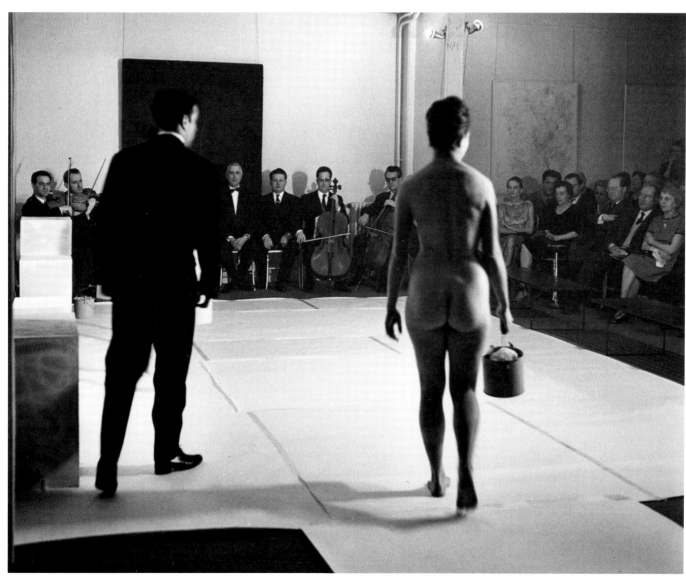

**YVES KLEIN** / *ANTHROPOMETRIES OF THE BLUE PERIOD* / 1960. PHOTO: SHUNK-KENDER

**The use of photography to document** performance has been one of the predominant ways in which the history of performance has been relayed and understood. Artists whose primary concern may not have been the documentation of their work, often found themselves confronted with images representing their actions in ways they could not have anticipated. For the photographer, performance has posed the challenge of how to represent an event that may be unpredictable and chaotic, in locations that can vary from a gallery to the street. Often the results reveal the reliance of many performances on photography, an inter-dependence that enables a small and sometimes fleeting moment to be transformed into a grand gesture.

The importance of photography to performance was recognised by the Japanese Gutai group who from 1954 extensively documented their actions, which involved breaking away from traditions of painting and sculpture towards an expressive use of the body. In 1956 they staged the *2nd Gutai Art Exhibition*, which was documented by Kiyoji Otsuji, a co-founder of the radical Experimental Workshop, in a series of images that captured some of the dynamism and experimentation of the performances. In a similar manner, photo-journalist Minoru Hirata was asked to document actions by other Japanese art groups, the resulting photographs often serving as the only record of the performance. Documentation of Hi-Red group's *Dropping Event* 1964 display Hirata's awareness of constructivist photography in the use of extreme perspective and high contrast; his photographs of a street happening by Kyushu Faction (Artists Alliance Against the World's Fair) in 1970 that attempted to stop traffic on the streets of Tenjin in Hakata, Fukuoka, however, employ a looser style to reflect the chaotic nature of the event.

In the west, the photographs taken by Harry Shunk and János Kender (known together as 'Shunk-Kender') of events from the 1960s and 1970s provide a broad context within which to understand the history of documenting performance. For Yves Klein's *Anthropometries of the Blue Period* 1960, a work that involved him directing models to become his 'living paintbrushes' by pressing their naked bodies against canvas, Shunk-Kender used high contrast, successive cropping and deliberate blurring to capture the theatrical nature of the work. They went on to assist Klein in the realisation of his iconic conceptual works *Leap into the Void* and *The Dream of Fire*. By contrast, their photographs of Marta Minujín's first solo happening *The Destruction* 1963 and of the political protest performances of Yayoi Kusama reflect the unpredictable nature of the works they record by being shot from different angles and over the shoulders of spectators. Shunk-Kender's readiness to experiment is shown in their photographs of a Merce Cunningham production, where the balletic movement and poses of the dancers are transformed into near-abstract ghostly entities.

Babette Mangolte began to photograph performances in New York in the 1970s as a way to record the event and to understand different ways of seeing. In her documentation of Yvonne Rainer's rehearsals and performances, Mangolte complements the choreographer's interest in everyday gestures, and her association with minimalism, through an informal and restrained style. In two of her best-known images, Mangolte translates Trisha Brown's *Roof Piece* and *Woman Walking Down a Ladder* – events which would have been seen by few people – into evocative photographs that capture a specific time and space for posterity.

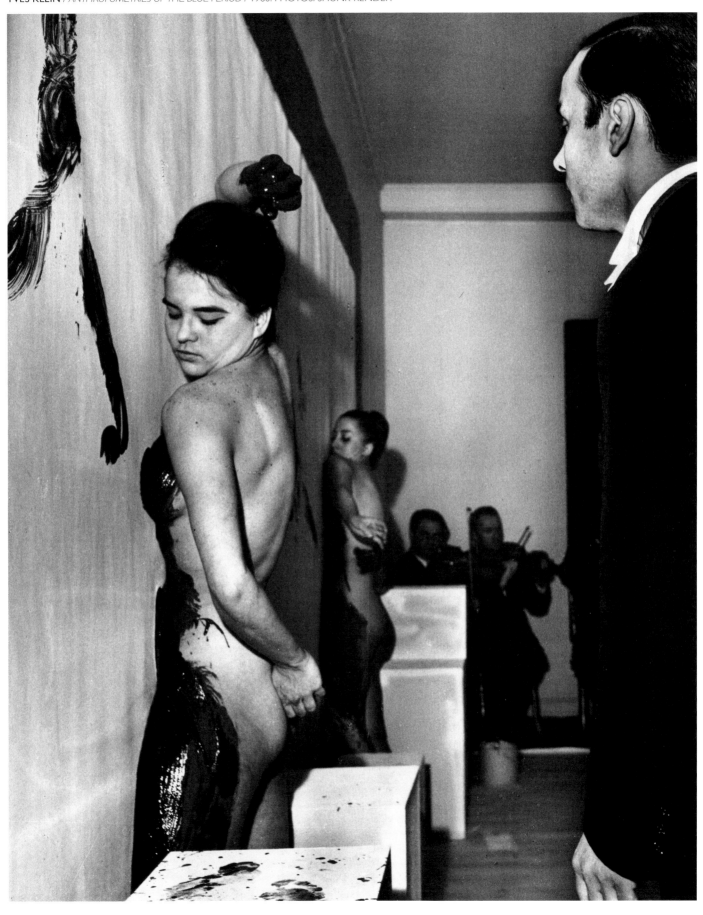

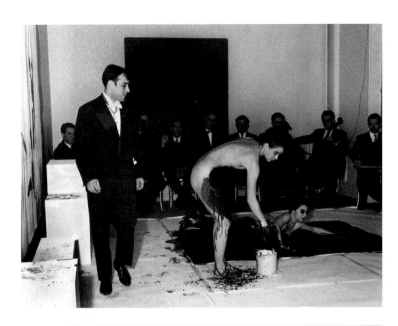

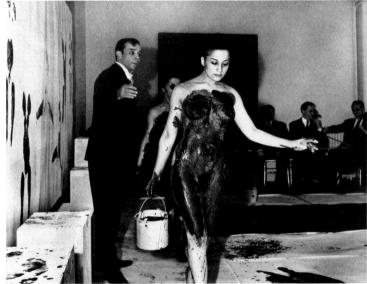

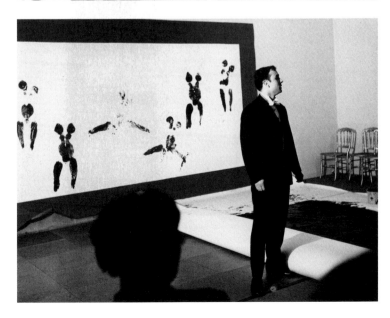

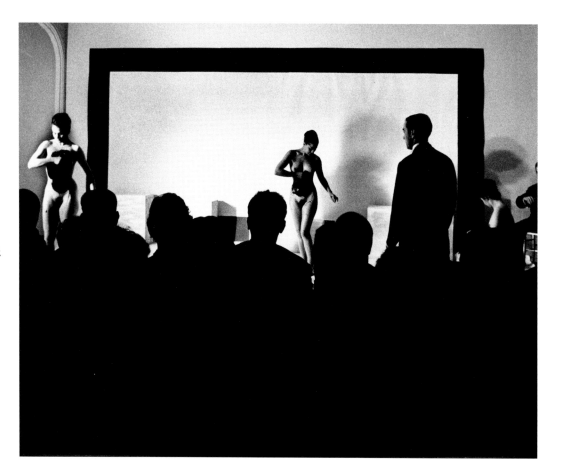

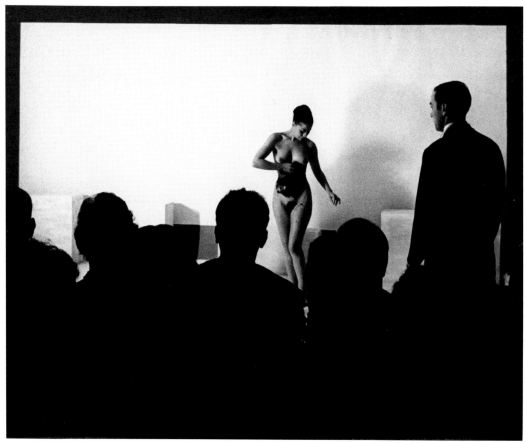

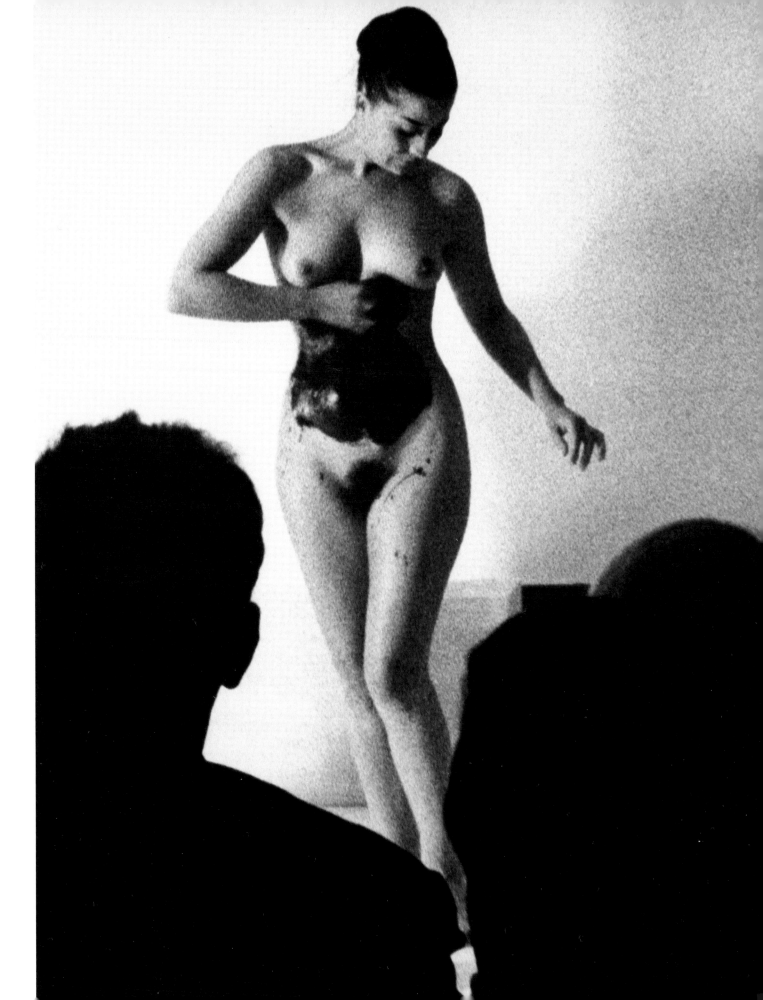

YVES KLEIN / *JUDO DEMONSTRATION, TOKYO, JAPAN* / 1953 | bottom *JUDO DEMONSTRATION, LA COUPOLE, PARIS* / 1954. UNKNOWN PHOTOGRAPHER

34

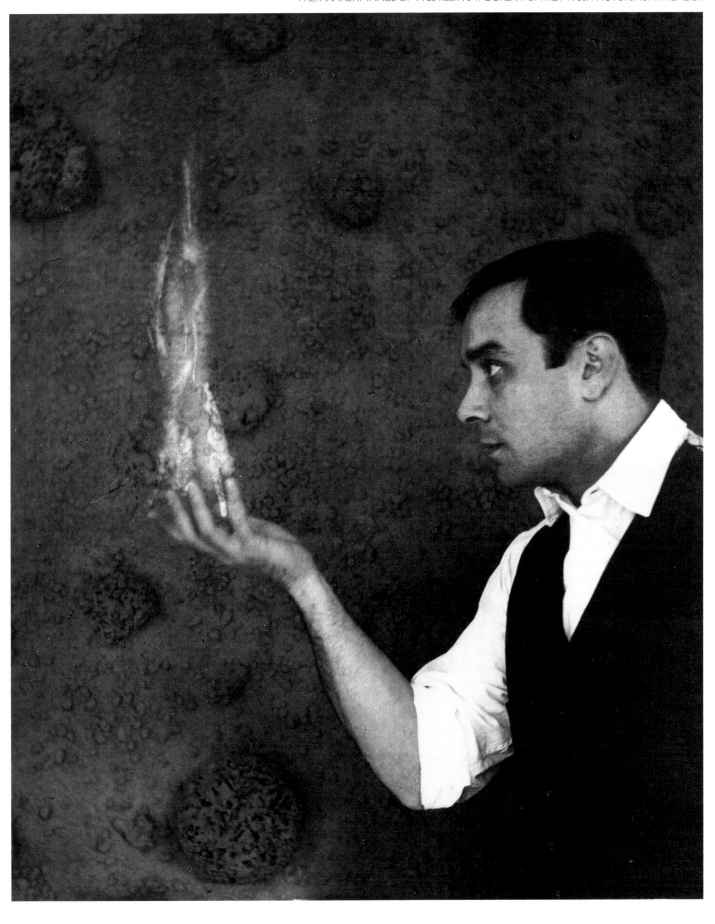

36

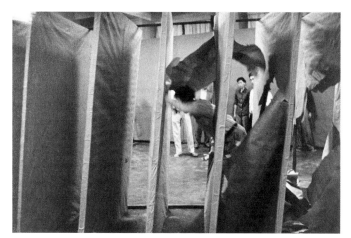 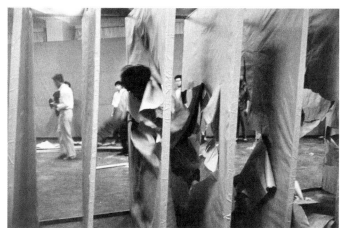

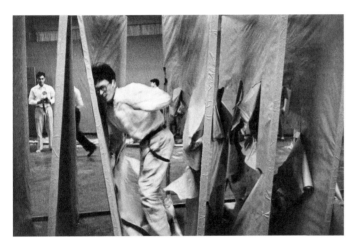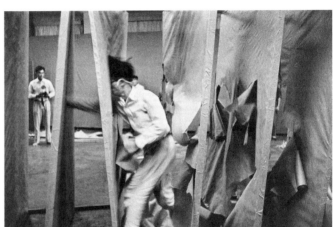

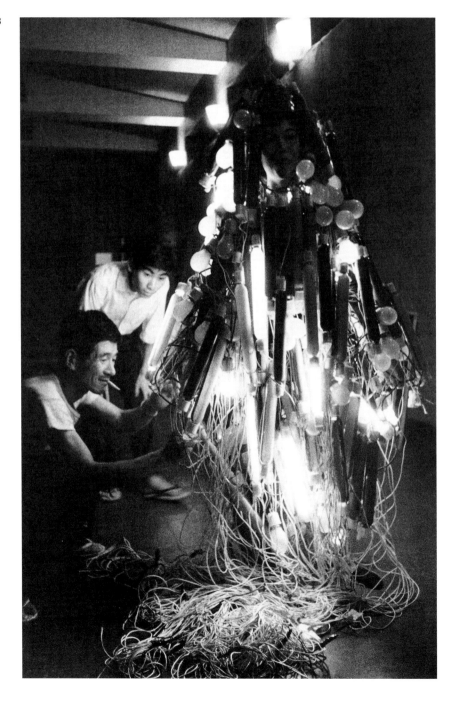

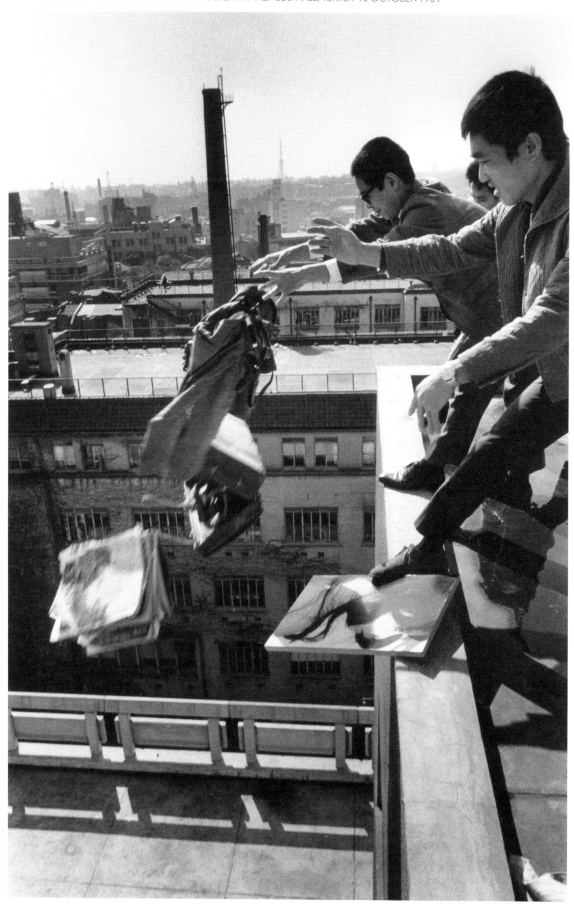

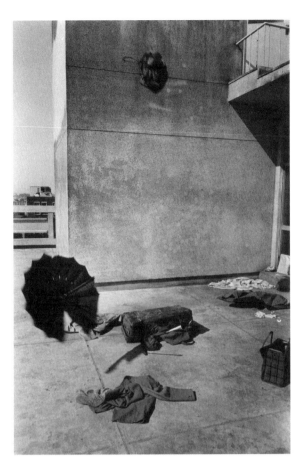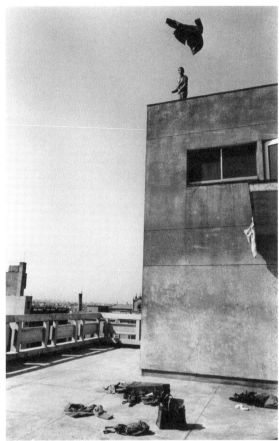

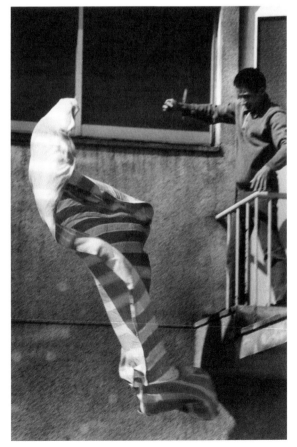

42

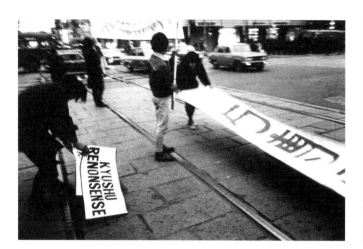

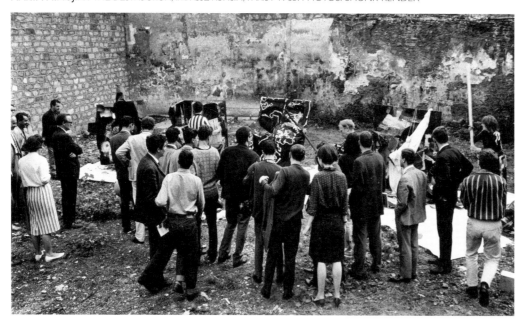

44

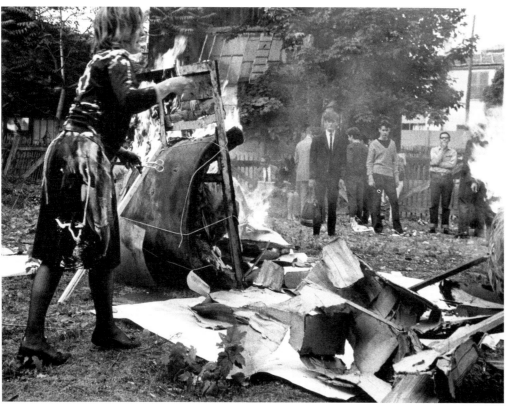

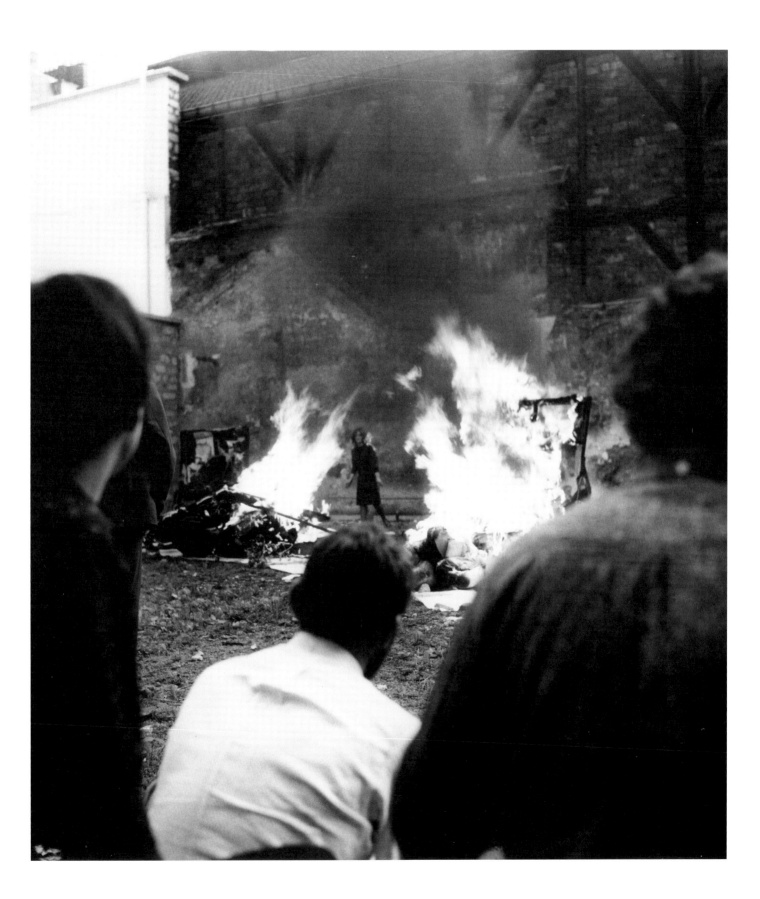

46

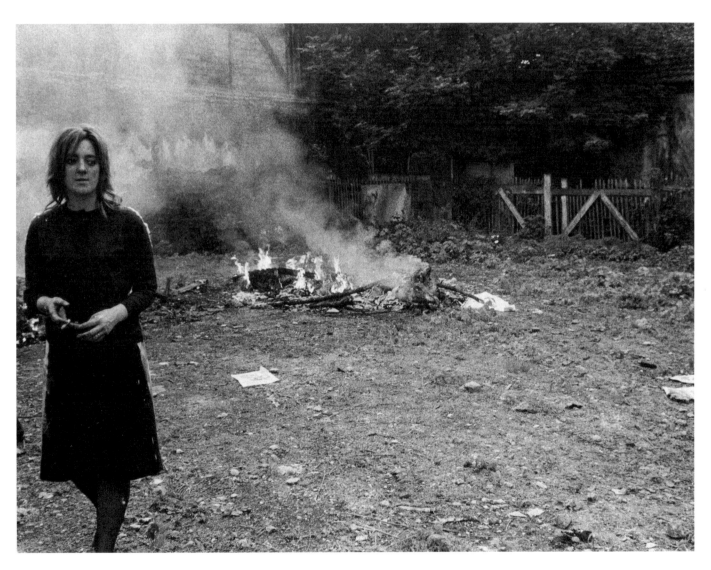

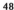

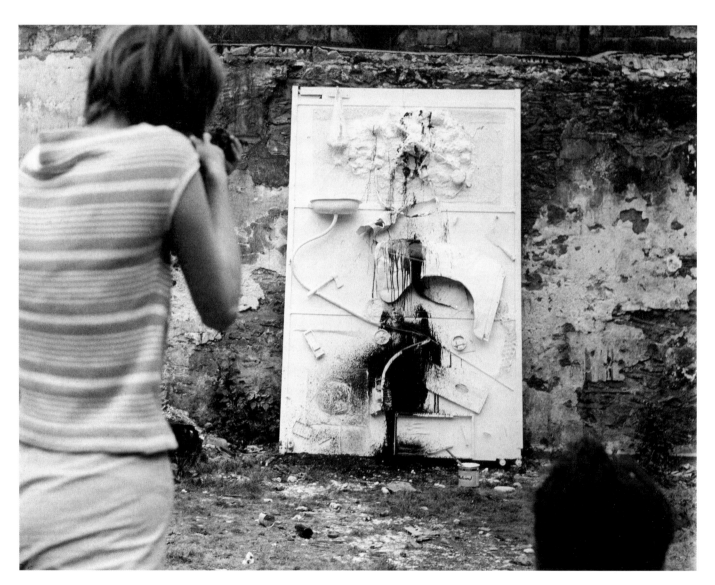

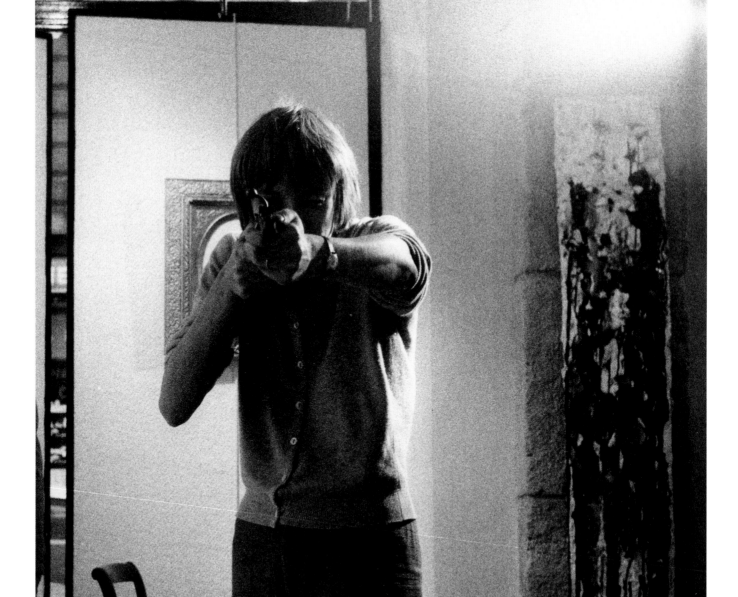

50

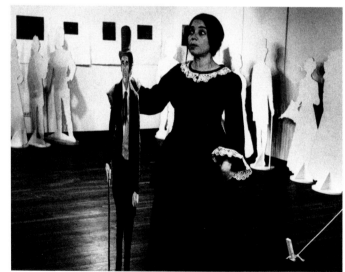

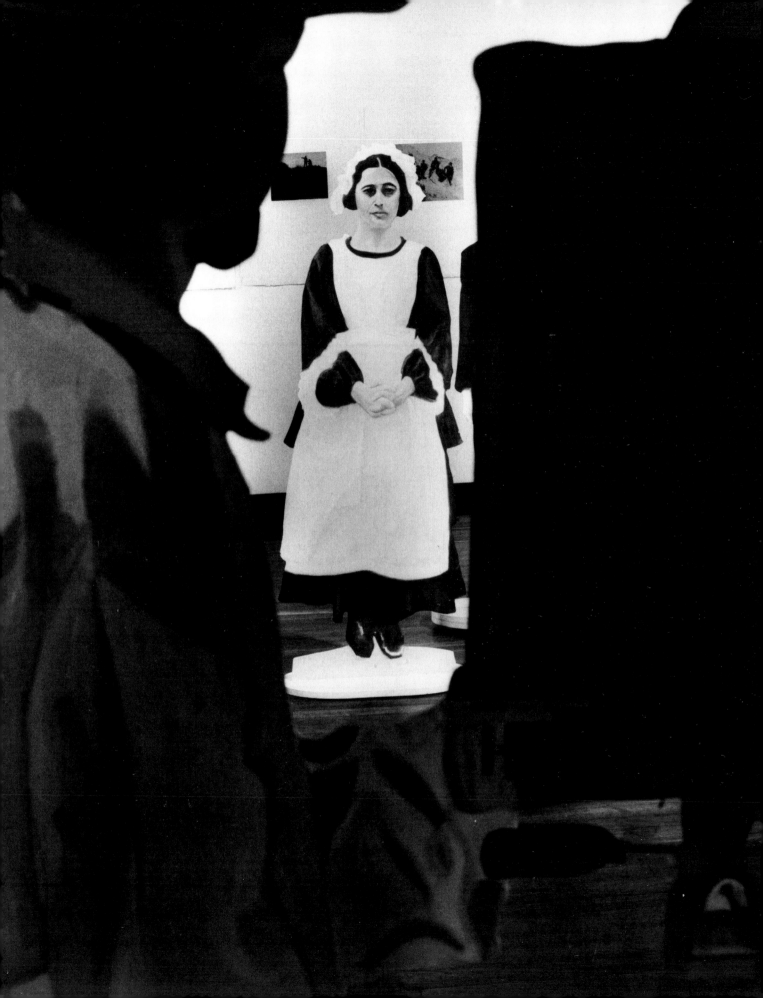

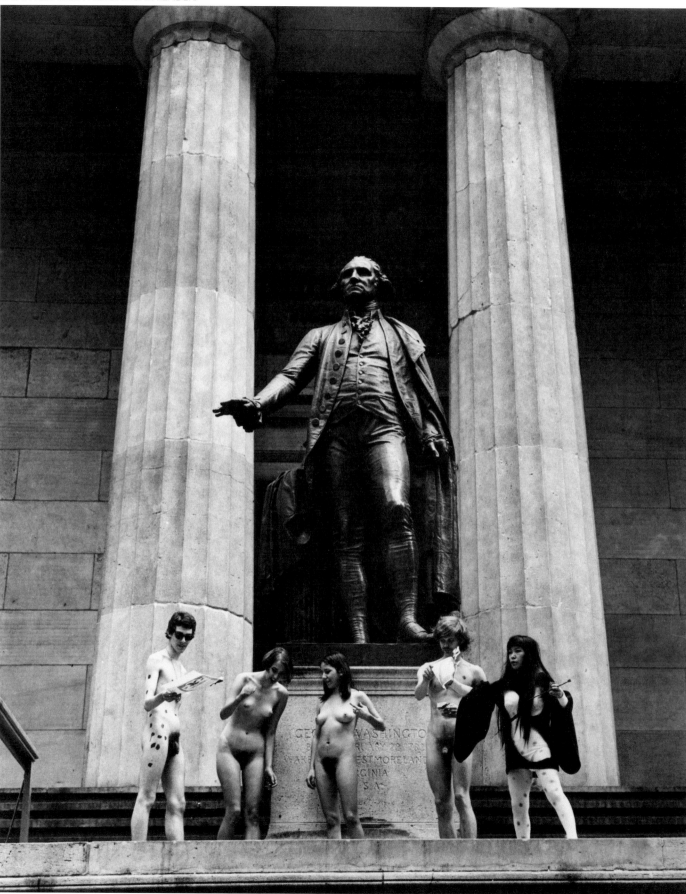

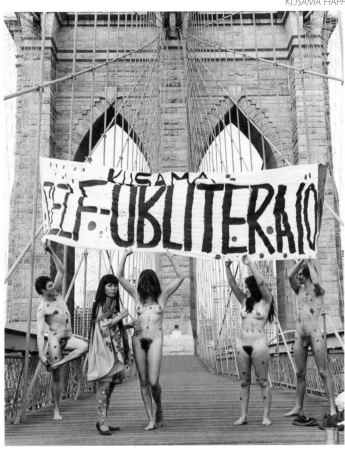

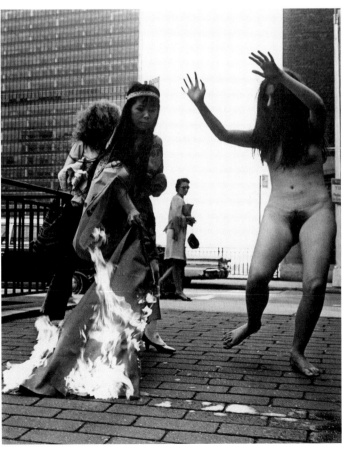

54

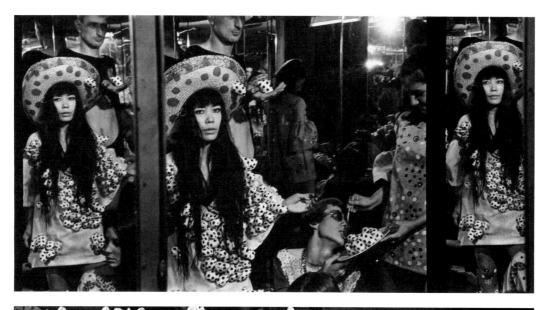

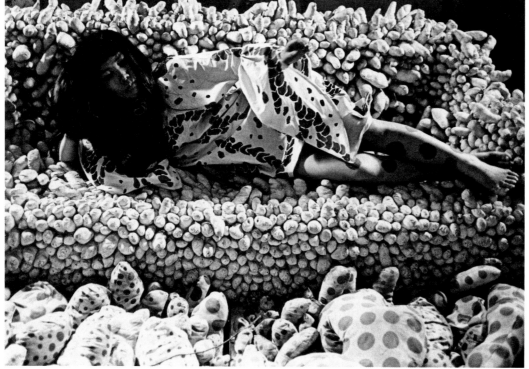

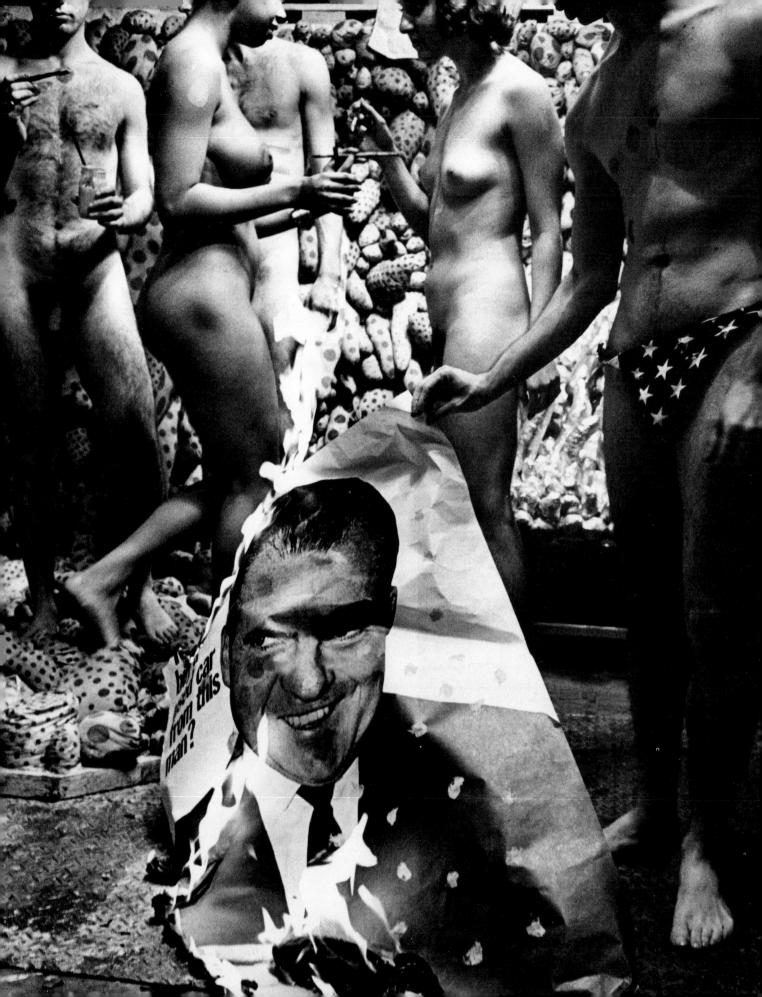

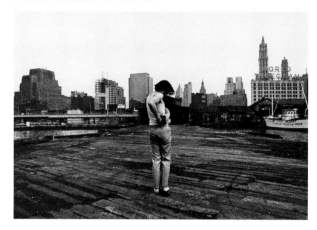

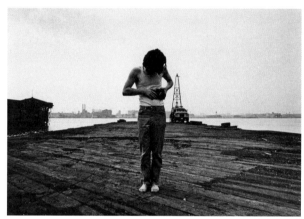

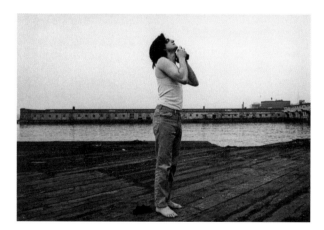

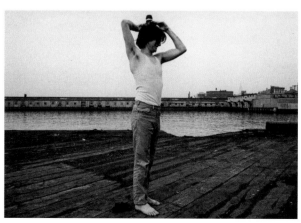

58

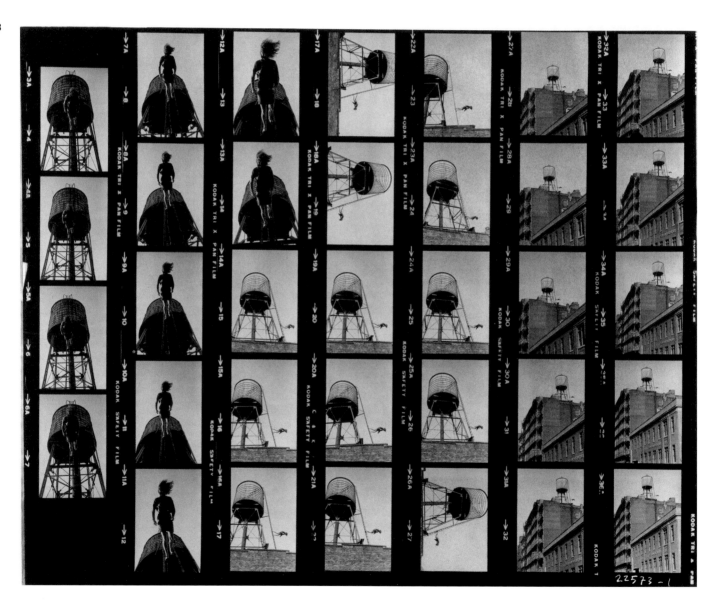

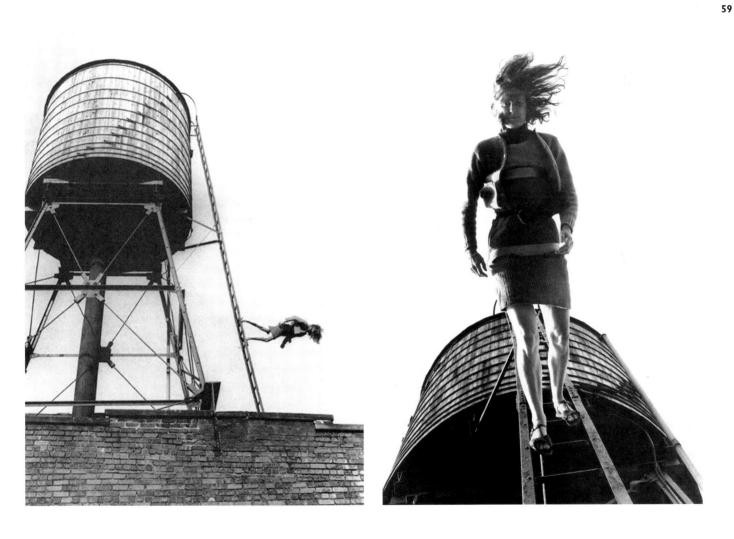

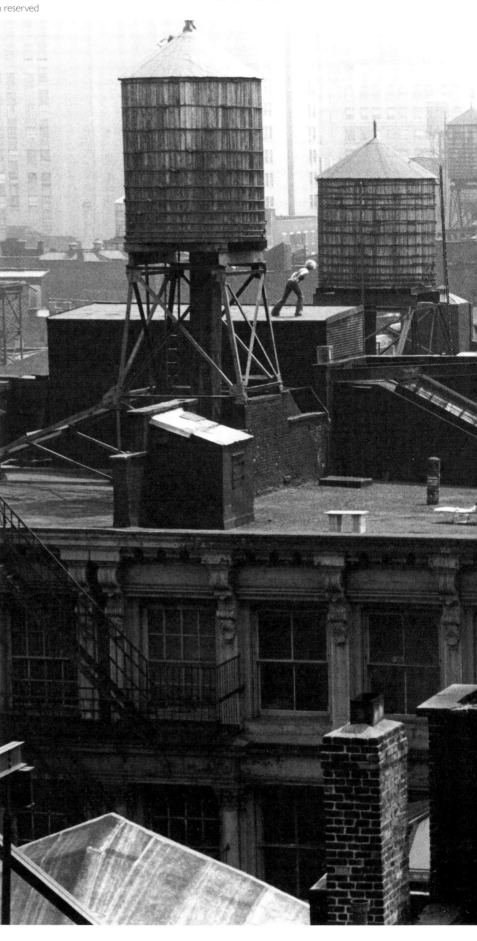

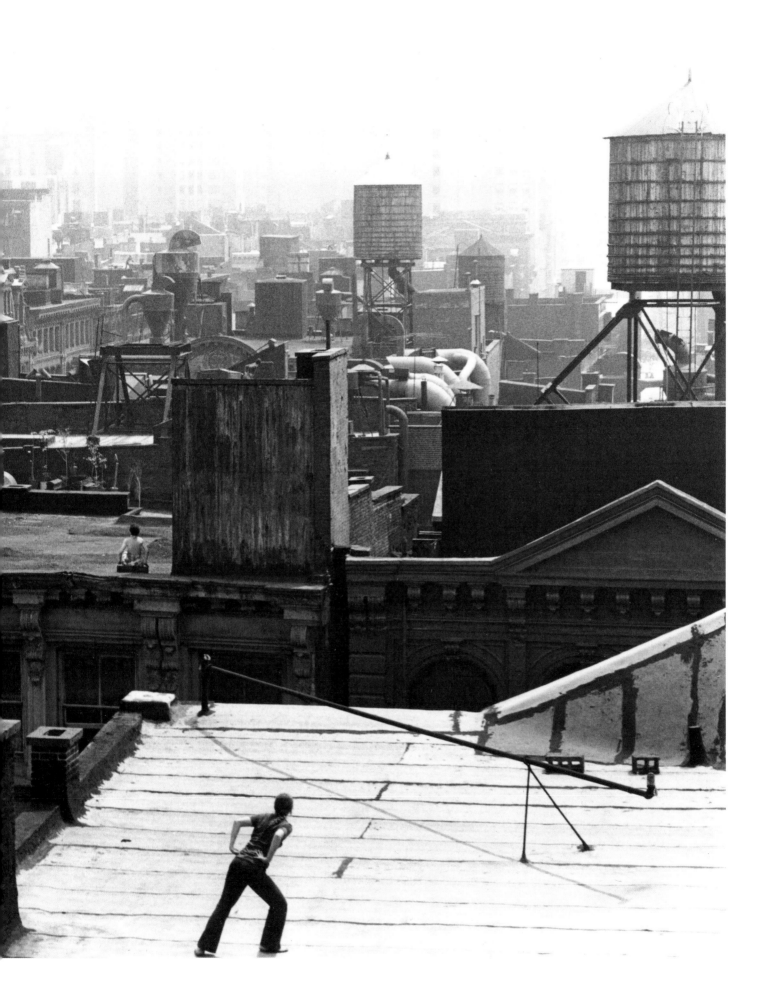

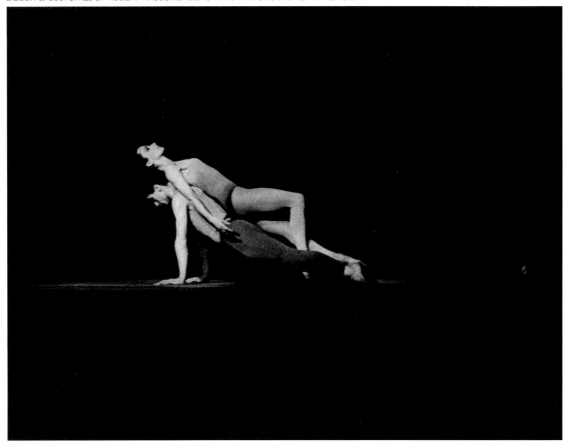

62

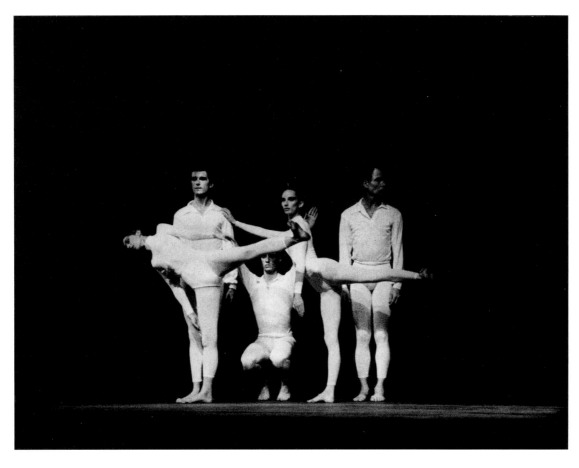

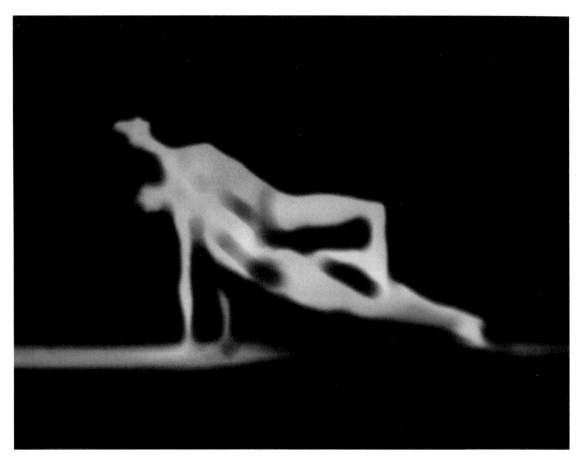

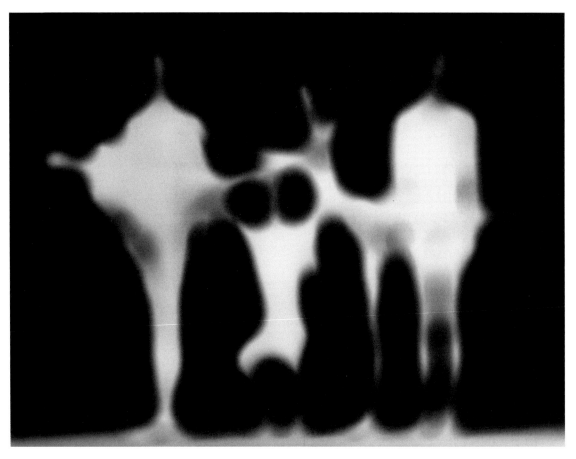

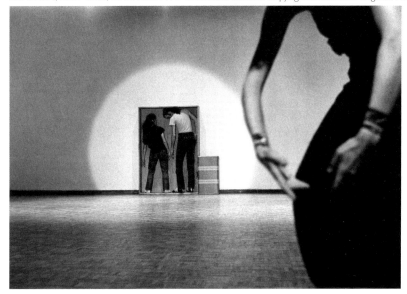

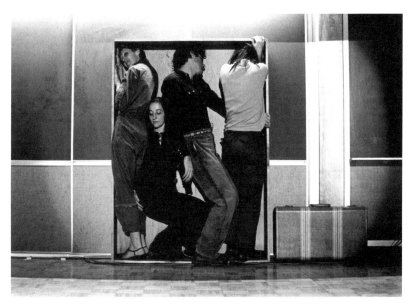

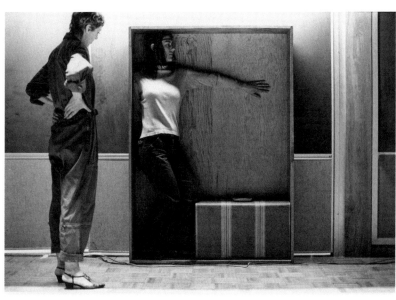

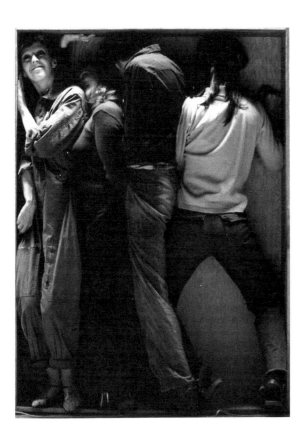 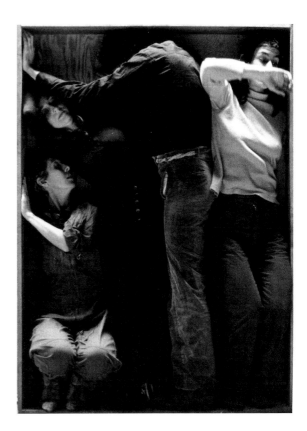

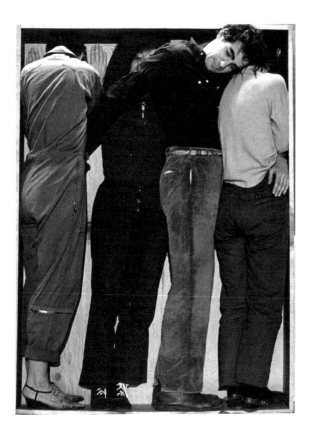 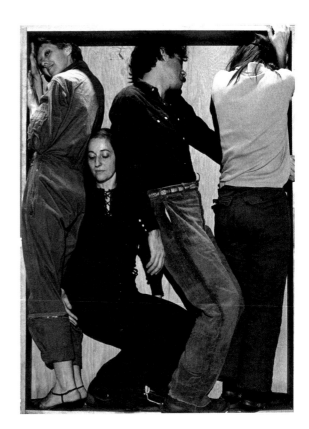

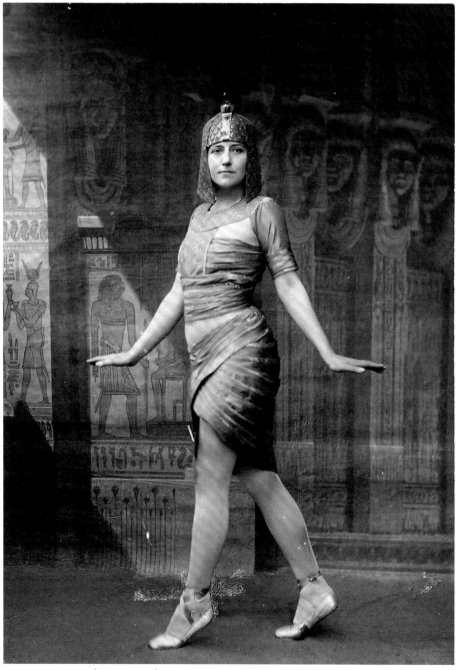

**NADAR STUDIO** / *LÉA PIRON – OPÉRA* / 1917

**Staging and collaboration are terms that** relate to the ways in which photographers have worked directly with performers to produce works that were only ever destined to exist as photographs. While many images documenting the actions of artists were related to events that would have taken place regardless of the presence of the photographer, these staged, collaborative events were performed only for the camera.

This relationship between photography and performance dates back to the birth of the photographic medium in the nineteenth century, and in particular the ability of the camera to capture the postures and expressions of actors and dancers already known for their work on the theatrical stage. The Nadar studio in Paris was famous for celebrity portraiture in the mid-nineteenth century, and would go on to become renowned for its publicity stills of popular plays in which scenes would be restaged for the camera in the confines of the photographer's studio. Stars like Sarah Bernhardt and Réjane would be invited to act out scenes within specially installed versions of the actual theatrical sets, resulting in collectable cabinet cards that avid fans could buy. Nadar also made portraits of these early stars in full costume for large-scale photographic prints; forerunners of celebrity pin-ups. One of the earliest and most intriguing examples of this practice is a collaboration between the mime Charles Deburau, Nadar (Gaspard-Félix Tournachon) and his brother Adrien Tournachon. Deburau was invited to the studio to perform his famous character Pierrot, a role he inherited from his father, acting out various signature expressions and poses that Nadar photographed and then presented for sale as a collectable portfolio of photographic prints. The series constitutes a genuine collaboration between the mime and the photographers, even stretching to a cleverly staged image in which Pierrot pretends to be a photographer himself, enhancing the sense of his participation as an author in the work (p.19).

Such collaborative projects, while unusual, would become more common in the twentieth century, as performers and photographers increasingly produced work together. Perhaps the most significant of these collaborations are those made by the Japanese photographer Eikoh Hosoe, who worked with choreographers, actors, poets and musicians from the 1960s onwards in his photographic practice. The first publication Hosoe made was called *Dance Experience* and consists of a series of images made in collaboration with Tatsumi Hijikata, the founder of the Butoh movement, set alongside poems and texts. Most celebrated, however, in Hosoe's output is the photobook *Kamaitachi*, which is almost unique in crediting both the photographer and the performer as equal authors. *Kamaitachi* is a series of photographs, once again showing Hijikata acting scenes, dancing and moving through a series of performances that were destined only ever to exist in the sequence of photographs that Hosoe published. Such collaborative practice was vital to Hosoe who sought to bring the performing arts and photography together into a unified body of work. Hosoe made comparable projects with other avant-garde dancers, with the poet Yukio Mishima, and the actor Simmon Yotsuya. The series made with Yotsuya follows a performance in the streets of Tokyo from the moment the actor applies his make-up and androgynous costume, through a series of games, poses and expressive scenes, culminating in his disappearance on the outskirts of the city.

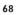

68

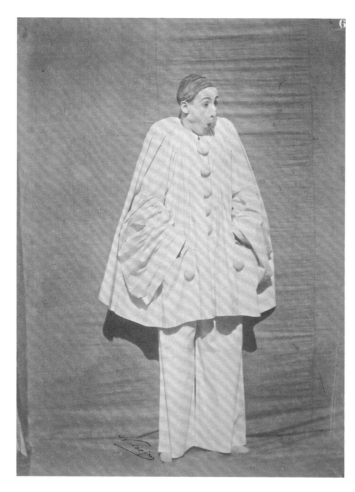

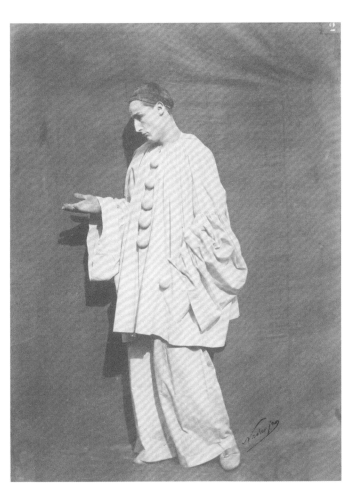

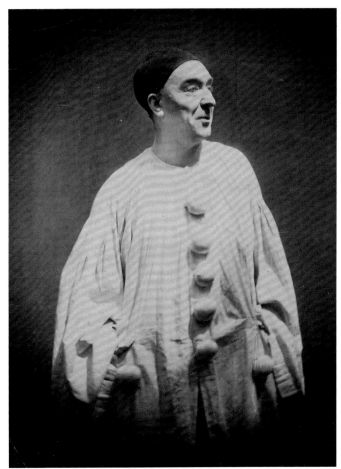

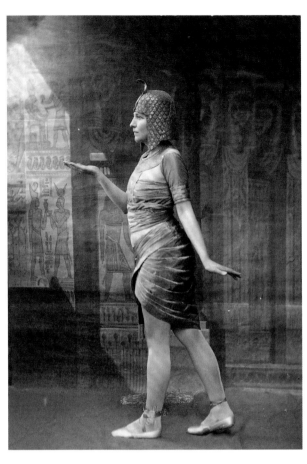

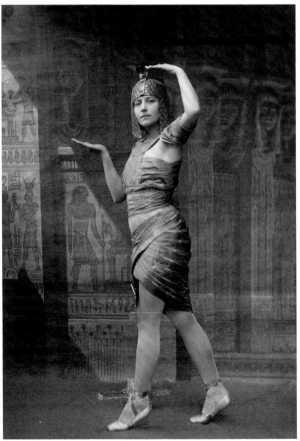

**NADAR STUDIO**
Top left and right: *HÉLÈNE PETIT IN 'L'ASSOMMOIR'* BY ÉMILE ZOLA / 1879
Bottom left: *'MADAME SANS-GÊNE'* BY VICTORIEN SARDOU AND ÉMILE MOREAU / 1895
Bottom right and opposite, left: *SARAH BERNHARDT IN 'LA TOSCA'* BY VICTORIEN SARDOU / 1887
Opposite, right: *REGNARD AND SÉRIER* / c.1880–90

72

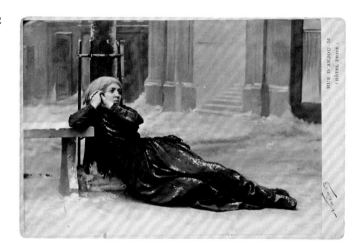
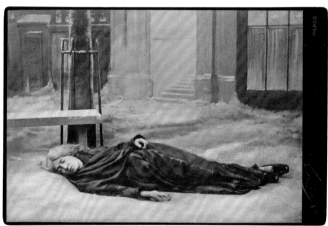
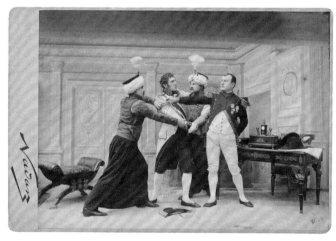
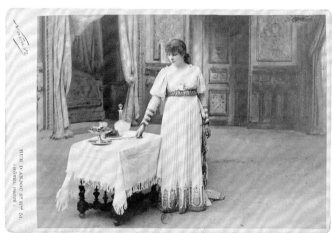

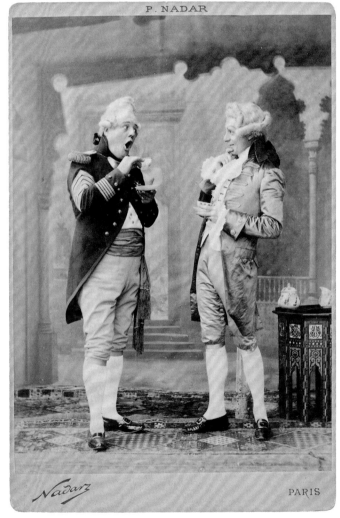

P. NADAR

*Nadar*

RUE D'ANJOU St. Hrē 51.
(HÔTEL PRIVÉ)

*Nadar*

PARIS

74

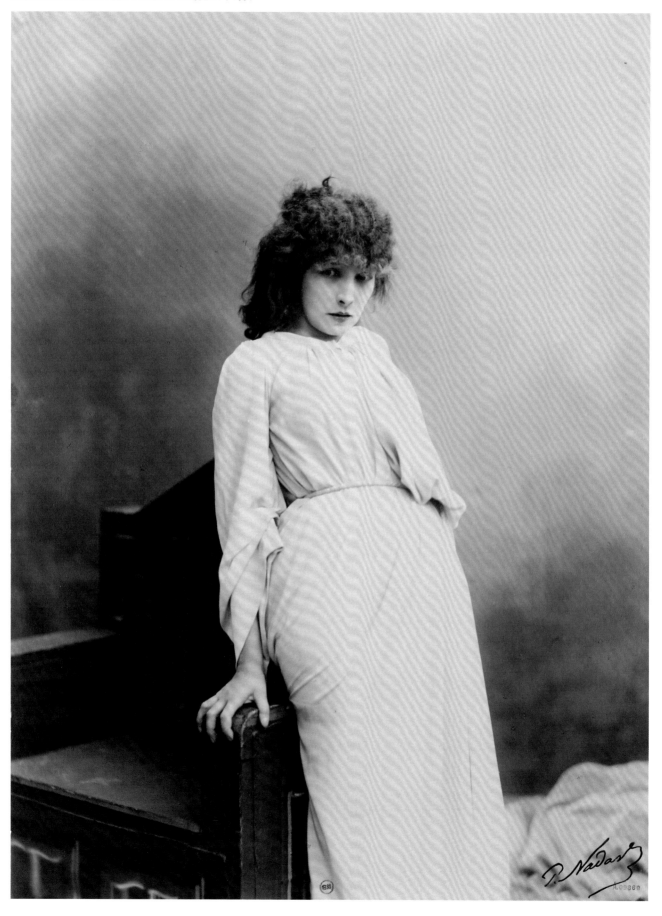

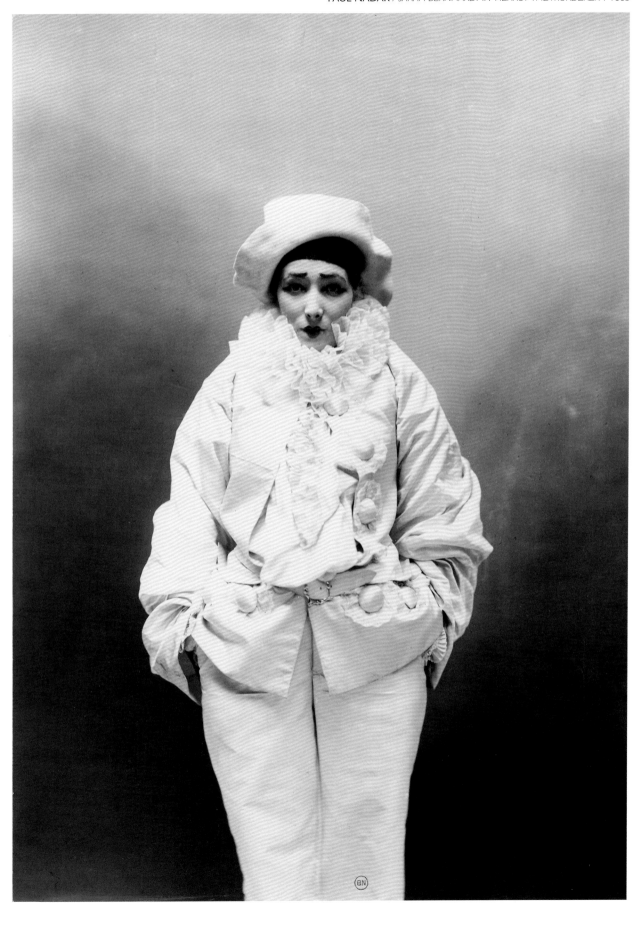

76

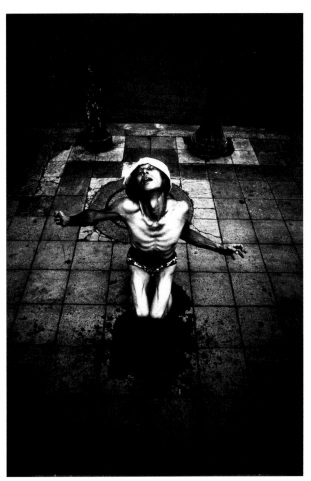
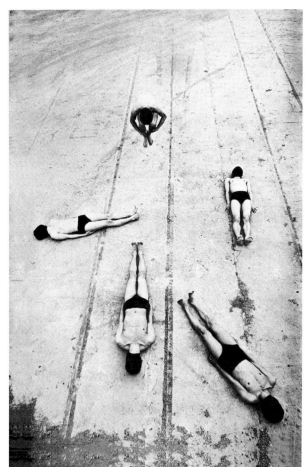

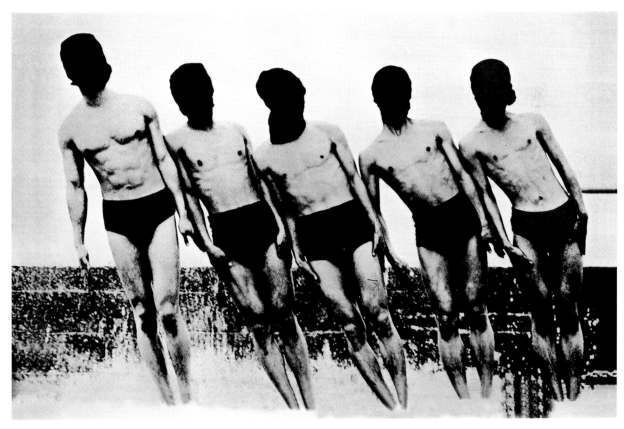

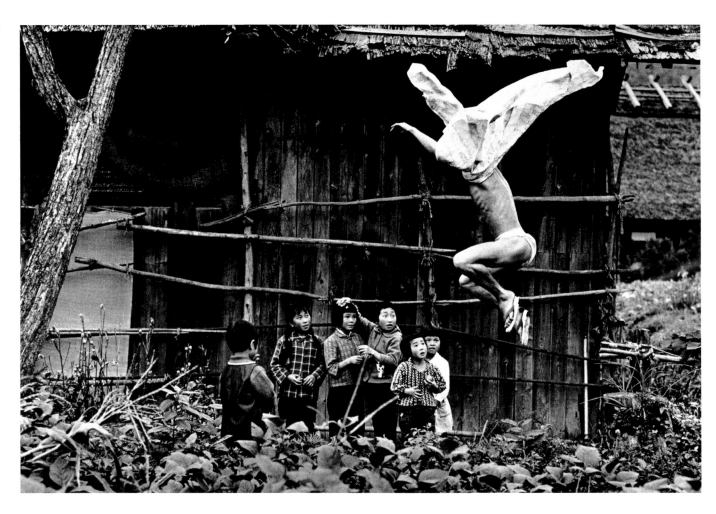

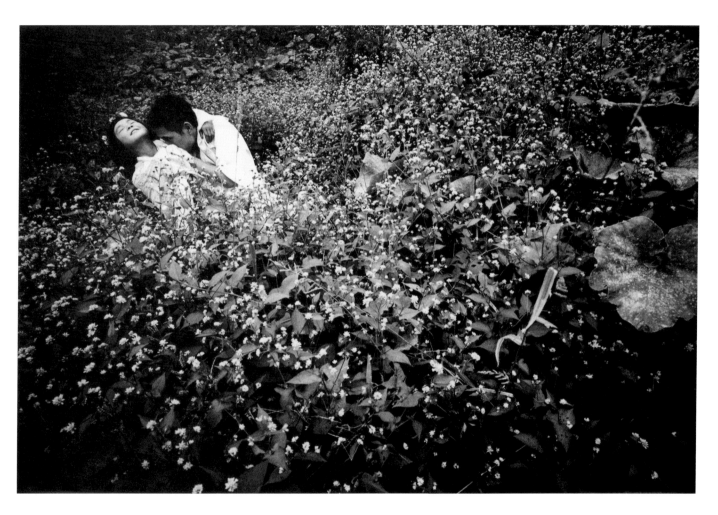

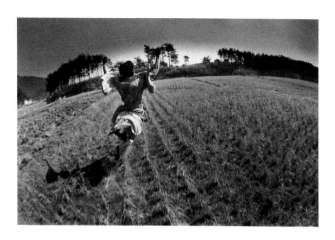

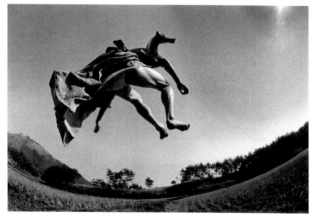

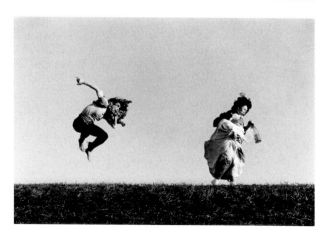

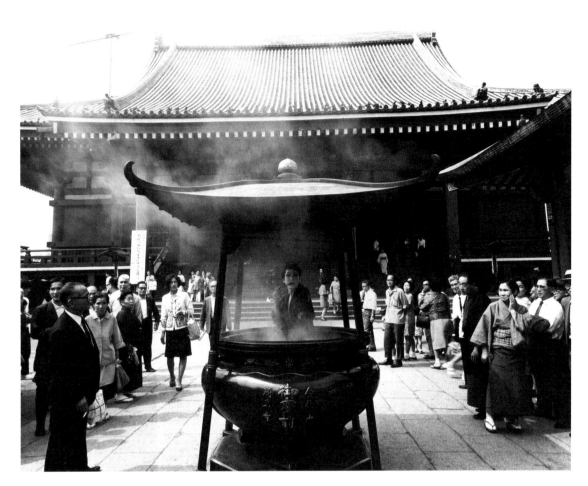

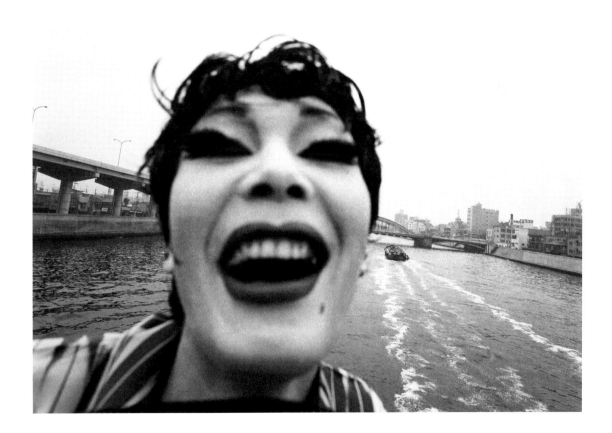

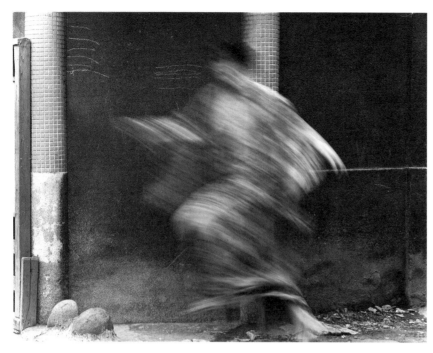

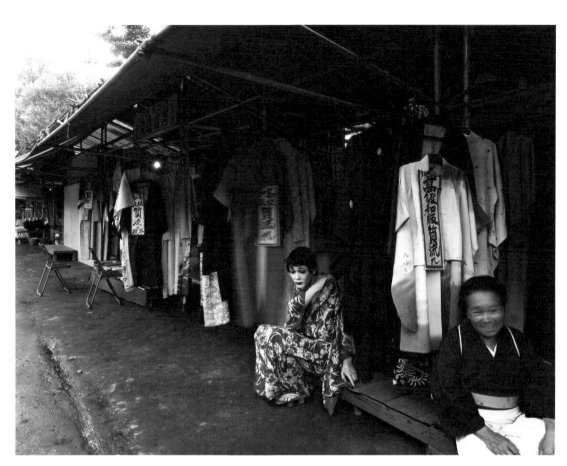

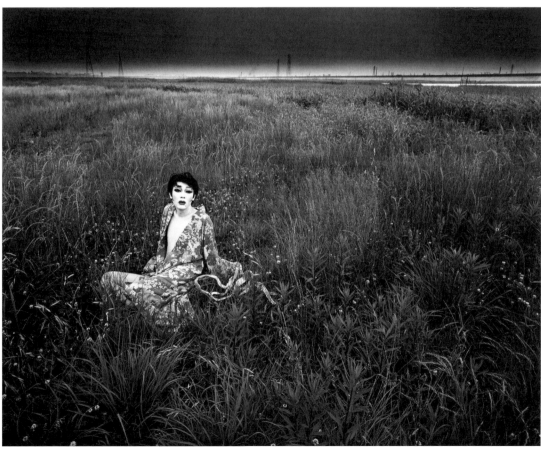

# PHOTOGRAPHIC
# ACTIONS

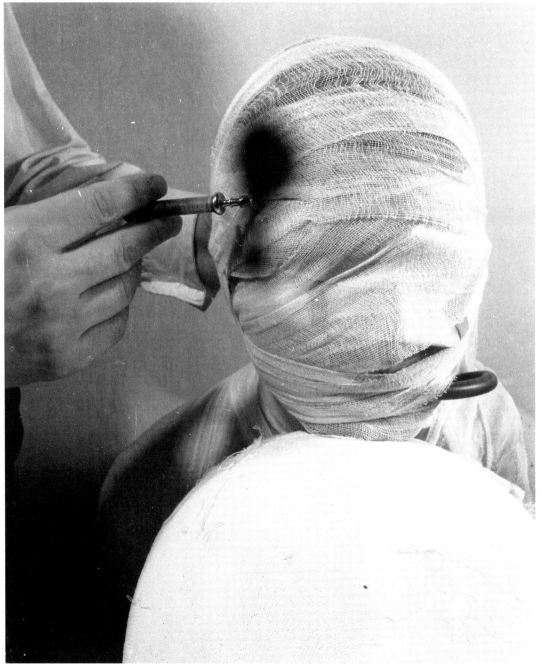

RUDOLF SCHWARZKOGLER / *3RD ACTION* / 1965

**Photographic actions encompass works by** artists whose practice relies heavily on the ability of photography either to capture different stages in a process or to frame and fix a performed action. Some of the artists included under the idea of photographic actions would consider themselves primarily photographers who work with an understanding of the performative qualities of the medium; while others would view the camera merely as the most effective means by which to produce and reproduce a performative event. There are other relationships between the works included in this category, notably the idea of the studio as an arena for action, and the use of everyday objects as the basis for strange and unusual performances.

The photographic actions begin, in a sense, in 1933 with Man Ray's work *Erotique voilée*, a carefully staged and posed *mise-en-scène* with the artist Meret Oppenheim as model, in which she acts out a scene with ink and a printing press. Man Ray's relationship with surrealism suggests an evocation of dreams and the unconscious, although Oppenheim could be interpreted as performing either her own dream, or the fantasy of the male surrealist artist. Carolee Schneeman's *Eye Body (36 Transformative Actions)* is likewise the result of a collaborative relationship, this time with the photographer Erró, who captured Schneeman performing in relation to the paintings in her studio. However, although Erró was essential to the production of the work, Schneeman is very much the author of the series which specifically addresses issues in her own practice. She described 'becoming entranced with the materials of the studio' so that [her] 'body became a collage source in motion'. Viennese actionist Rudolf Schwarzkogler was also interested in expanding the limits of painting. Preferring to stage performances solely for the camera, he worked with photographer Ludwig Hoffenreich to create a series of carefully composed photographic tableaux that used the human body, everyday materials and abstract forms.

Both Paul McCarthy and Stuart Brisley use their own bodies as physical components of their painterly practices, albeit with differently balanced relationships between process and end result. In *Moments of Decision/Indecision* Brisley worked with the photographer Leslie Haslam who directed him as he gradually covered his entire body in paint. McCarthy's *Face Painting* suggests the kind of absurdist attitude to the trials and tribulations of studio experimentation that can also be found in the more obviously sculptural practices of artists like Charles Ray. Hicham Benohoud, meanwhile, extends this notion beyond the artist's studio and into the classroom, with his photographic sequence of school pupils performing as involuntarily sculptures, reflecting both the constraints of the educational system and the wider societal limitations in his native Morocco.

Many of the photographic actions that include everyday items and materials seek to redefine the boundaries of art and life through experimental and at times playful attitudes to the object. These works range from what appear to be studio or gallery-based performances in the cases of Komar and Melamid, Boris Mikhailov and Erwin Wurm, to elaborately posed and staged domestic interventions by Les Krims and Jimmy DeSana. This phenomenon also underpins Ai Weiwei's *Dropping a Han Dynasty Urn* and the work of Keiji Uematsu, both of whom employ the frozen photographic frame to transform ephemeral performative acts into controlled static images. For artists like Ai Weiwei, Mikhailov and Komar and Melamid, it is significant that their performative gestures have specific registers of political significance, often highlighting repression or suggesting resistance to it.

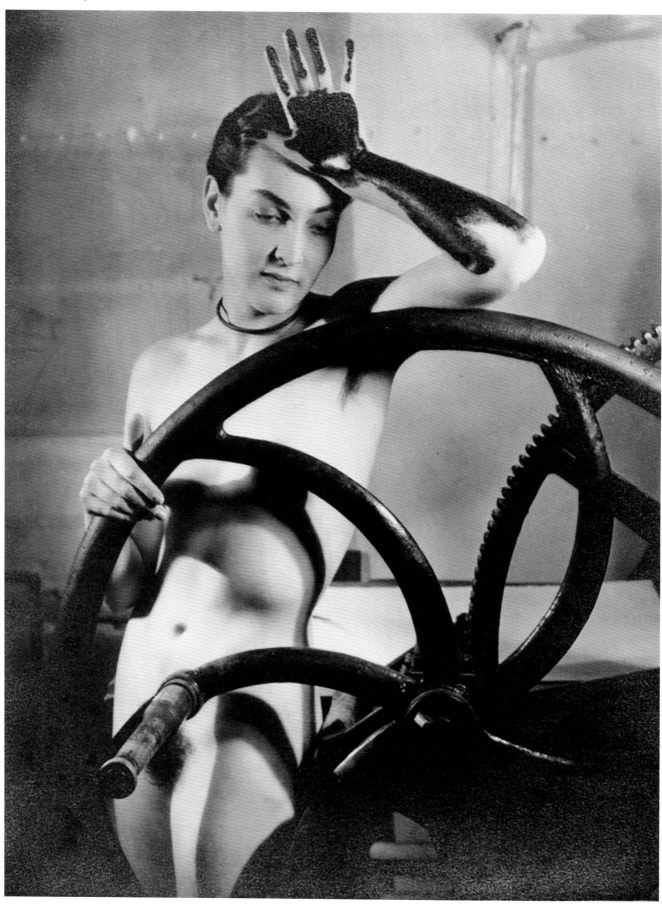

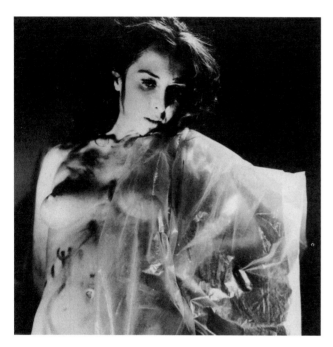
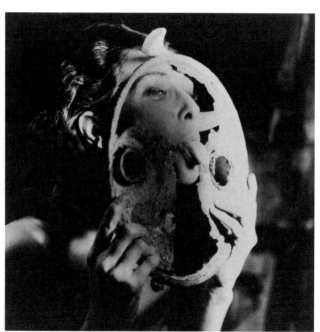
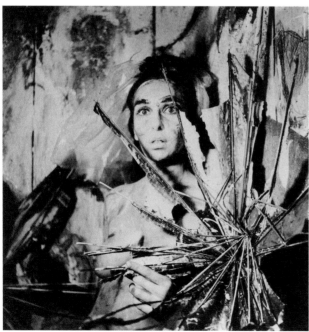
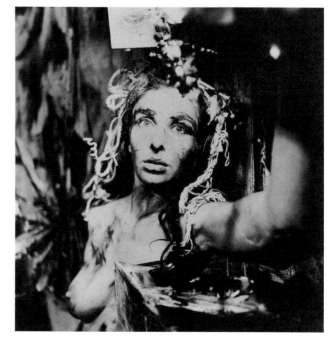

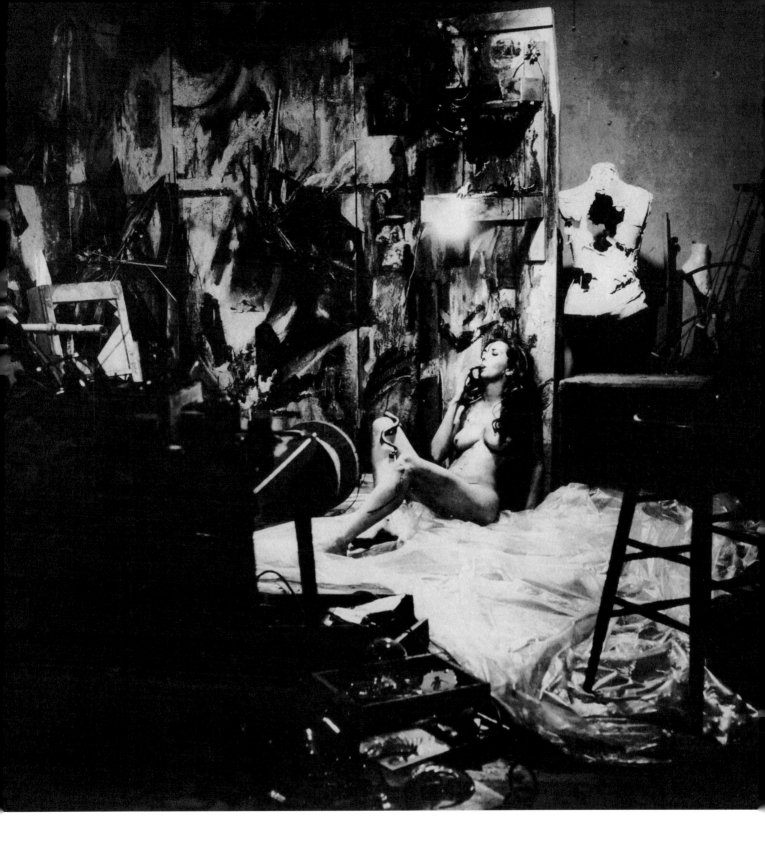

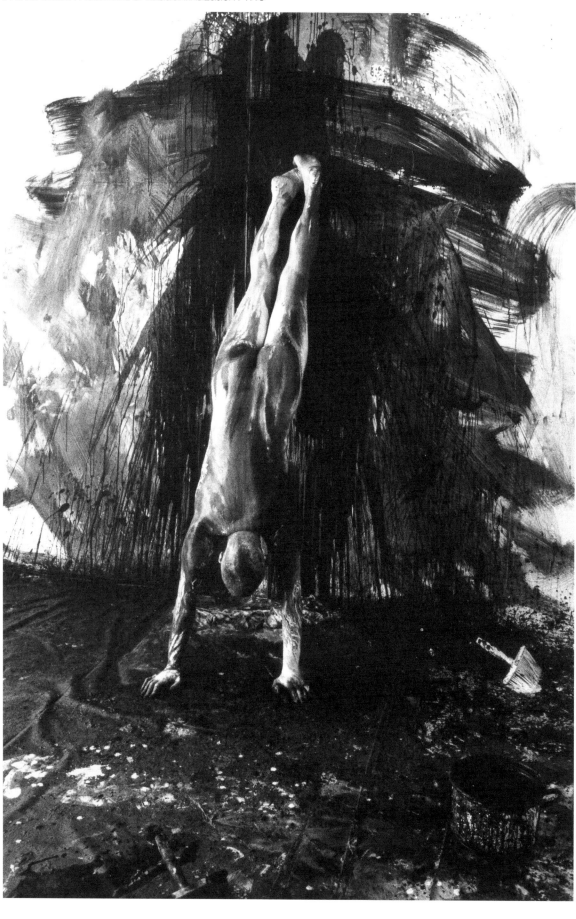

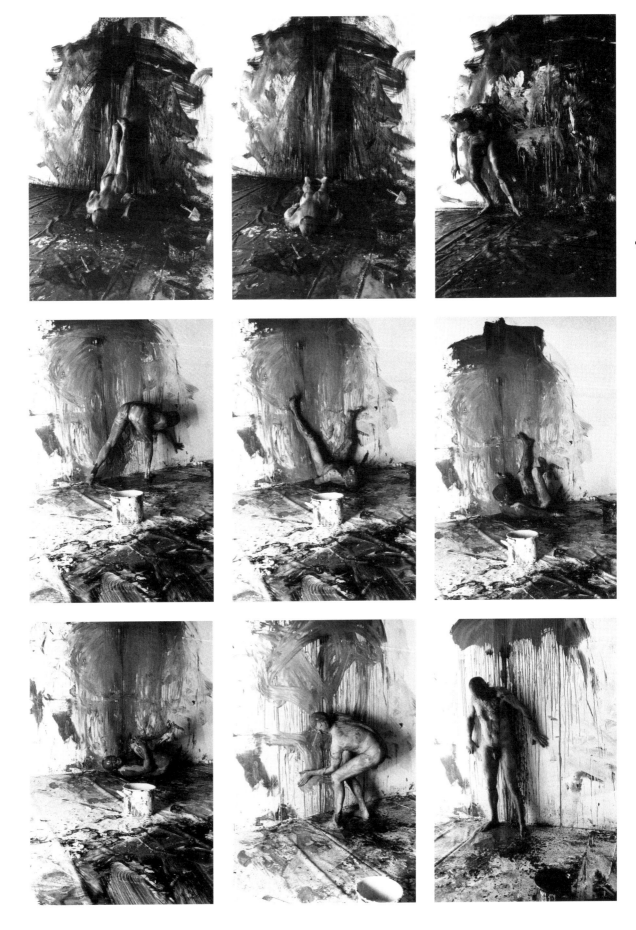

94

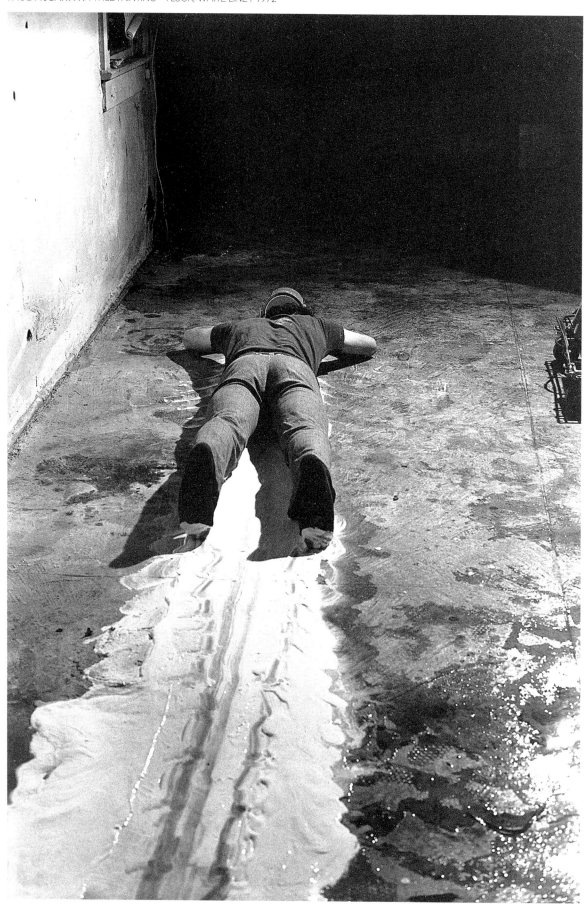

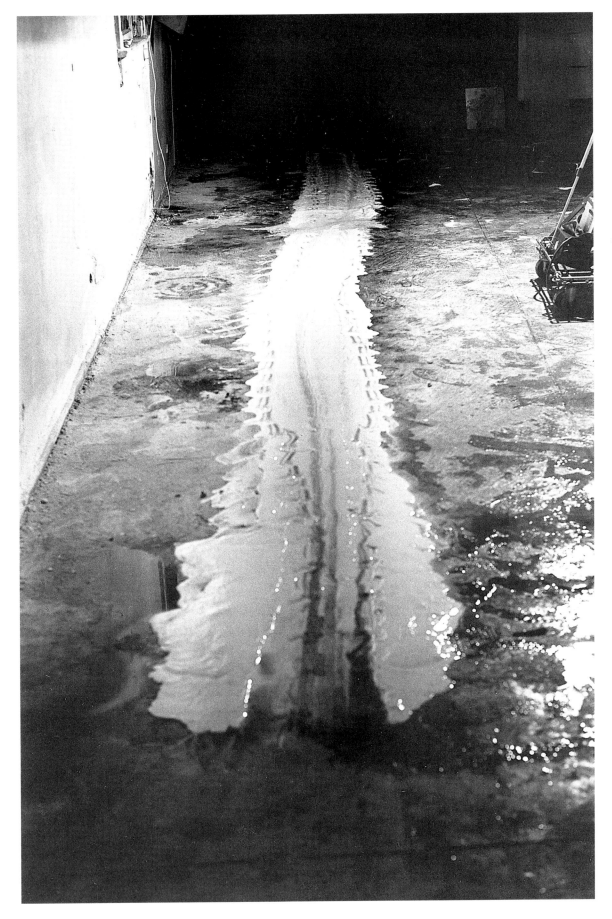

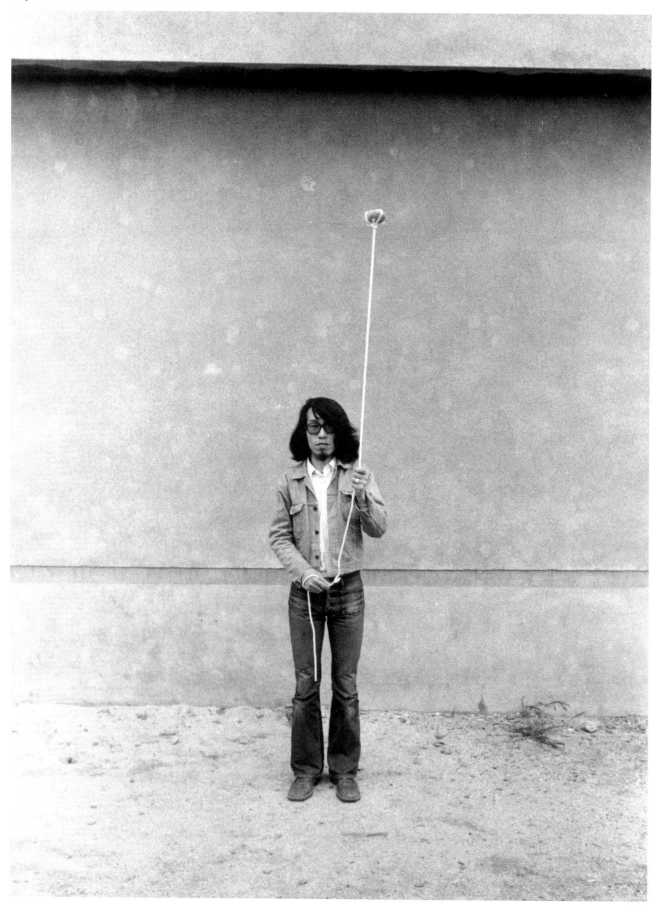

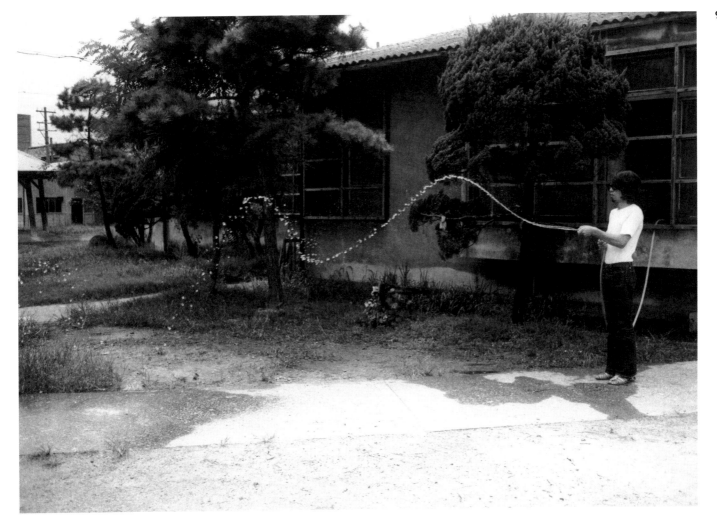

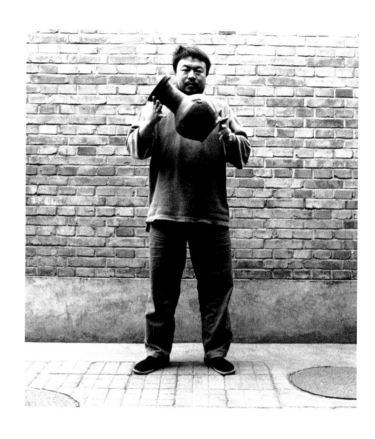

98

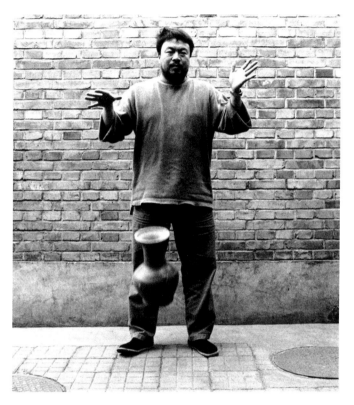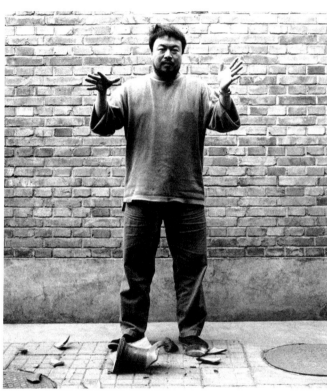

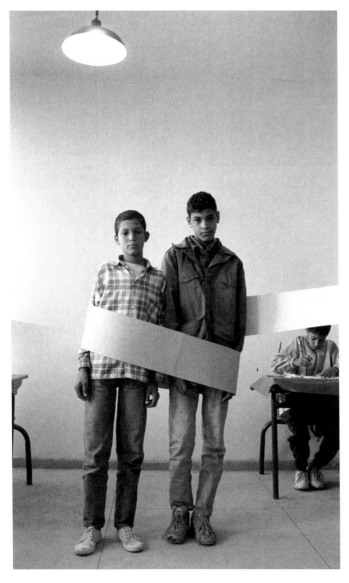

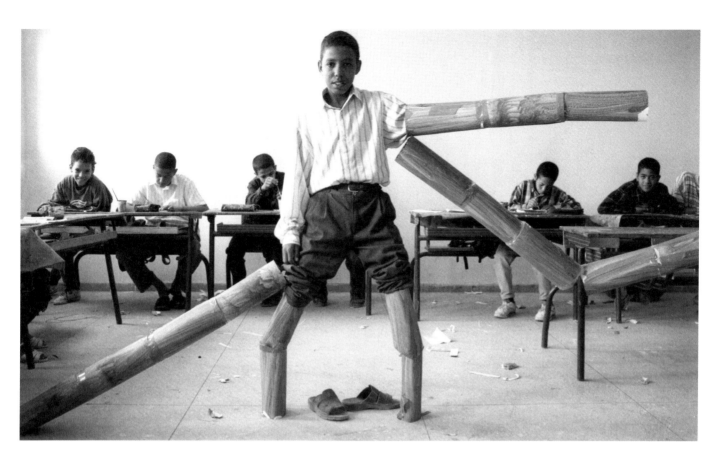

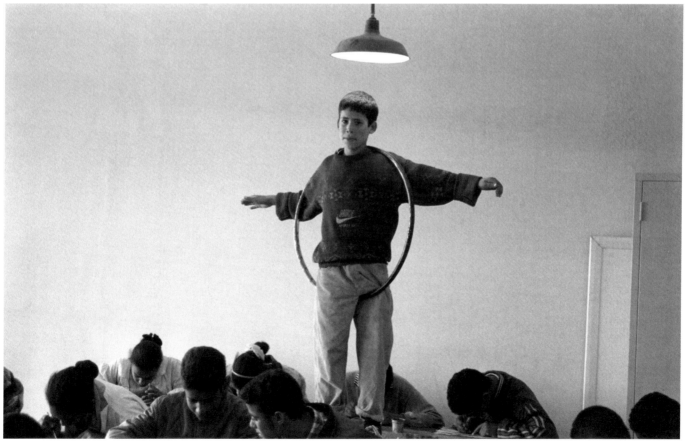

102

16. <u>CHAROG - 15</u>

Protect the purity of your thoughts!

Incantations and curses hold no fear for
the CHAROG owner.

CHAROG:  Real security against mass hypnosis and
demagoguery.

Thin, gold-plated strings lock the vices of the
surrounding world behind a grill and protect
your individuality from coarse assaults.

The top of CHAROG is carved from black wood and
can be used as a head piece completing this
original veil.

Through CHAROG you can look to the future with Assurance!

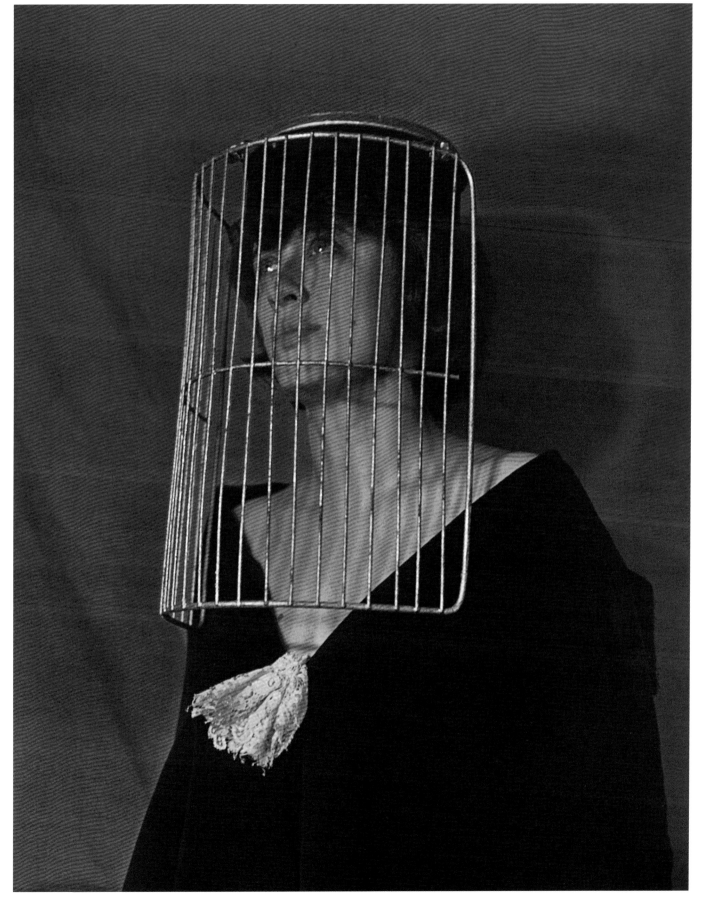

19. <u>TYAIRP</u>

Wake up your Dozing Inner Eye!

TYAIRP: A device for contemplating the
Inner World.

Easy to Use

Essential for any person striving towards
Self-Knowledge.

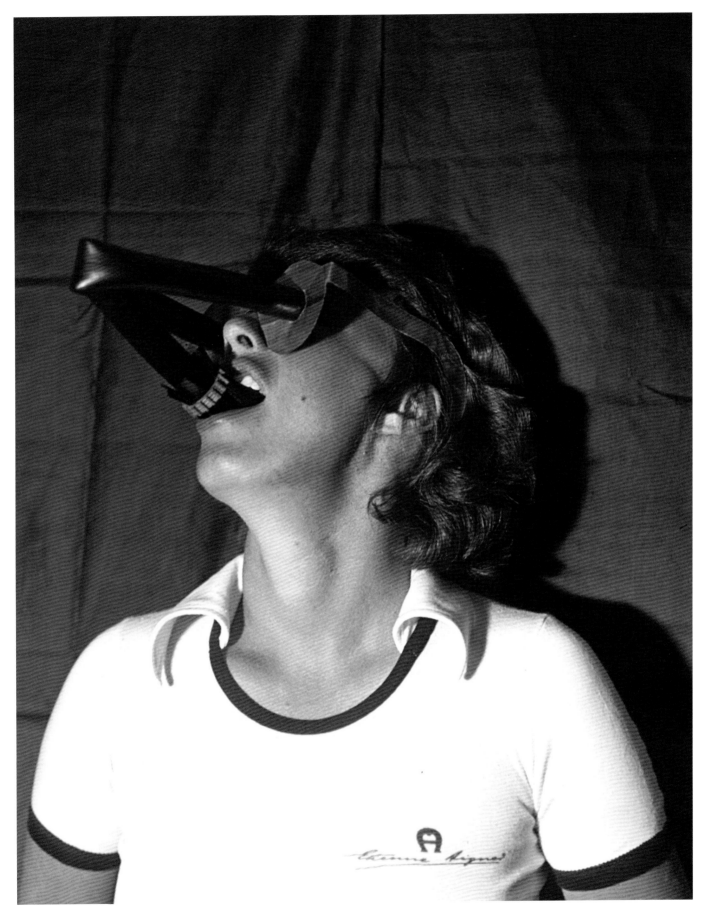

108

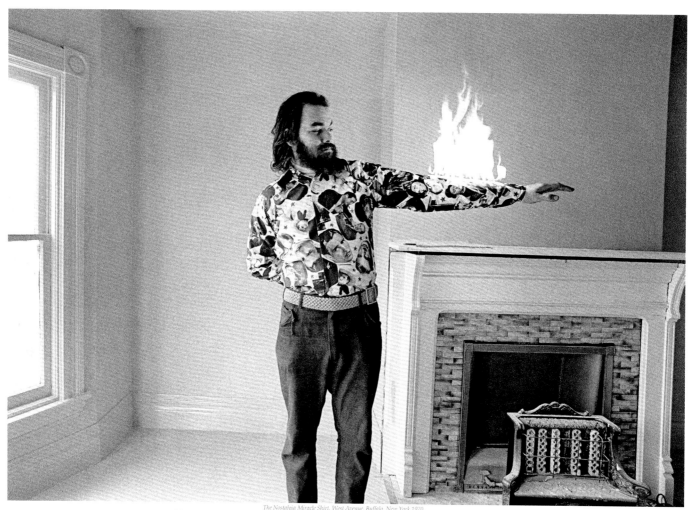

*The Nostalgia Miracle Shirt, West Avenue, Buffalo, New York 1970,*
by Les Krims, in a Basement in Buffalo, New York—a Failed Border Town Where the Stank of Government Cheese Meets the E.coli Scented Lake Erie Breeze.

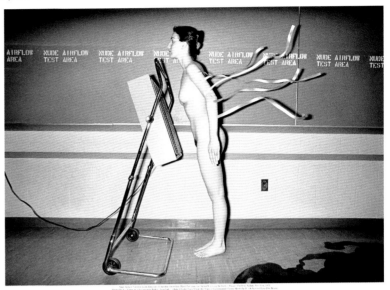

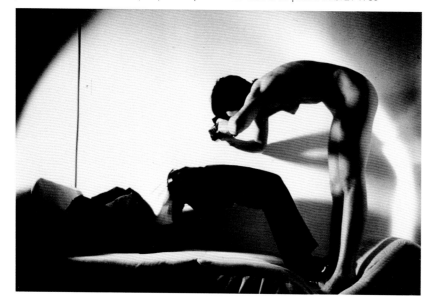

110

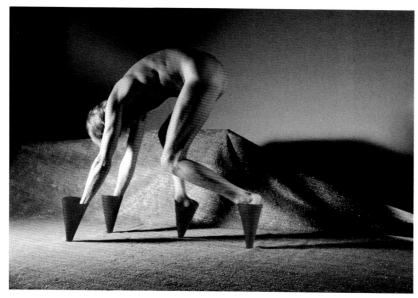

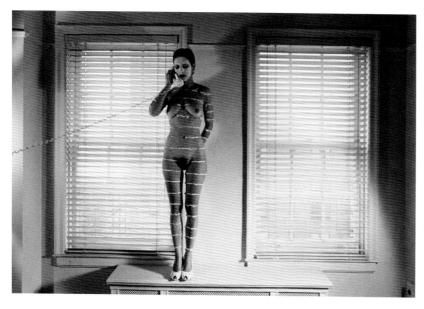

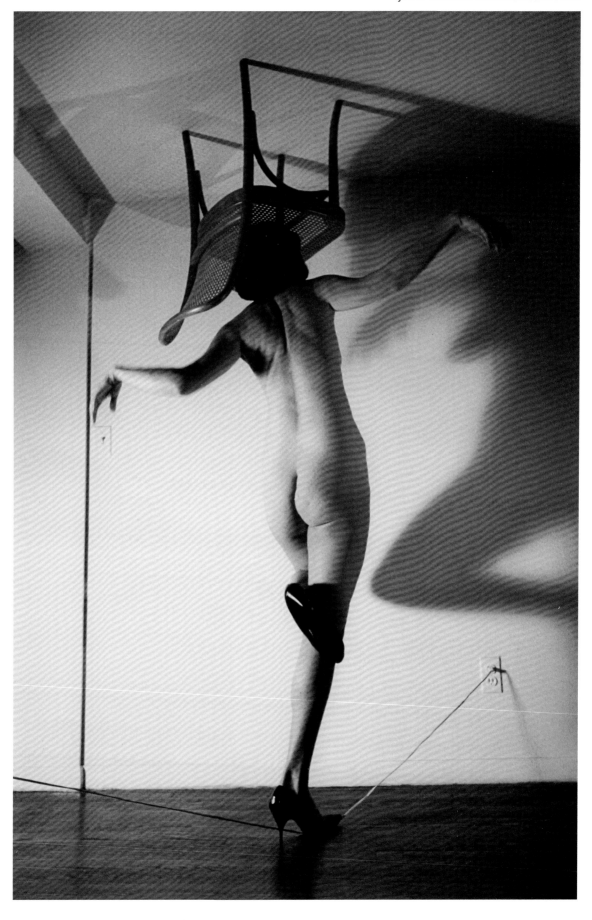

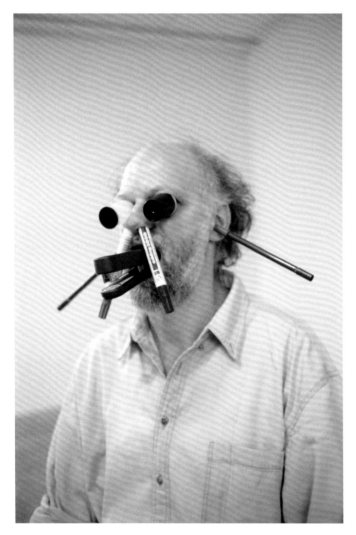

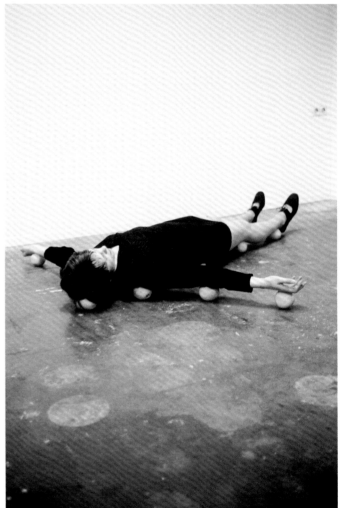

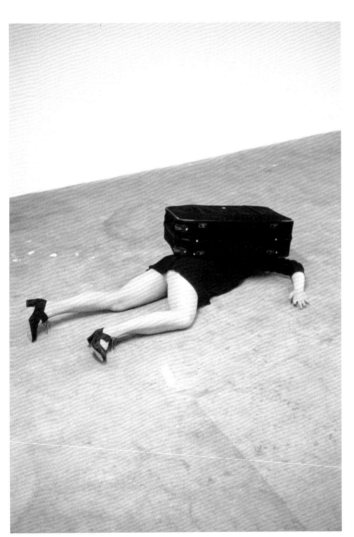 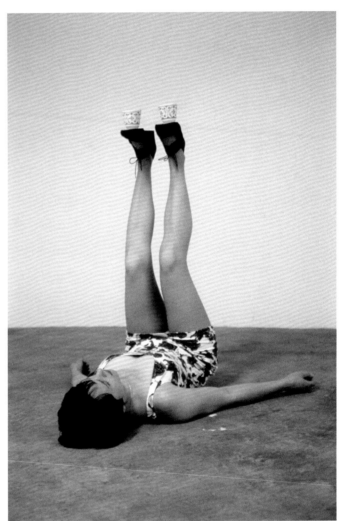

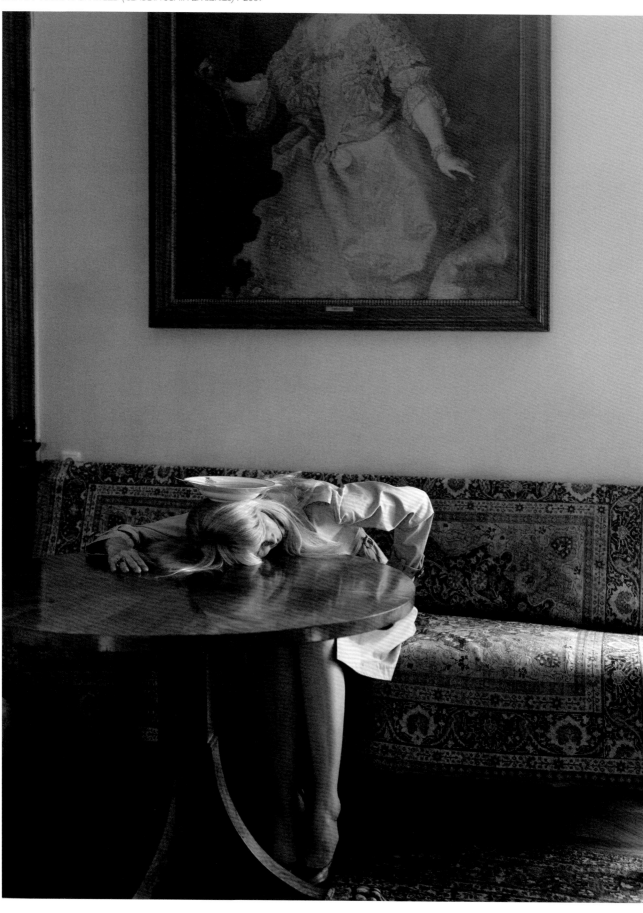

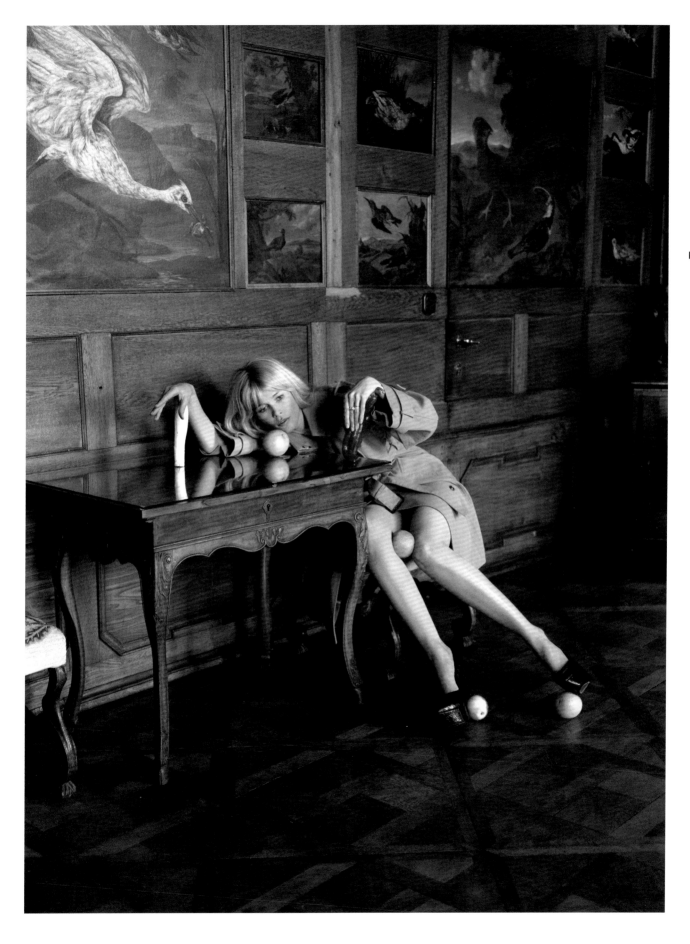

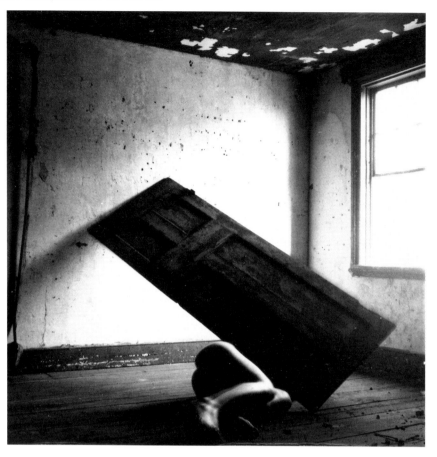

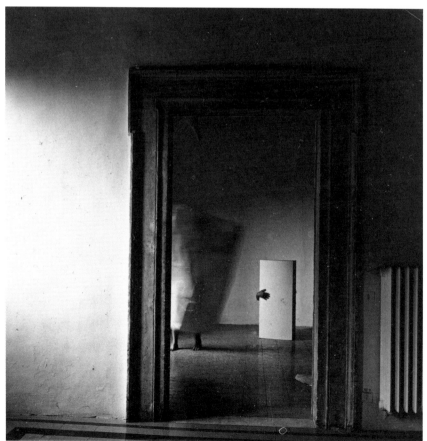

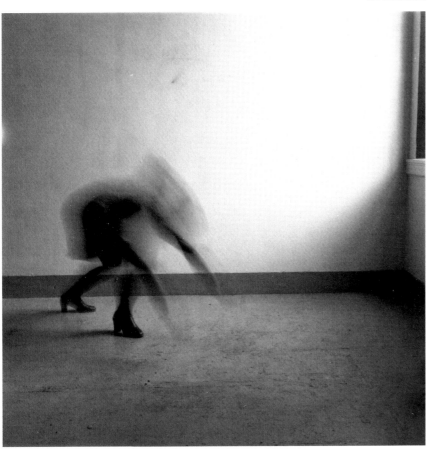

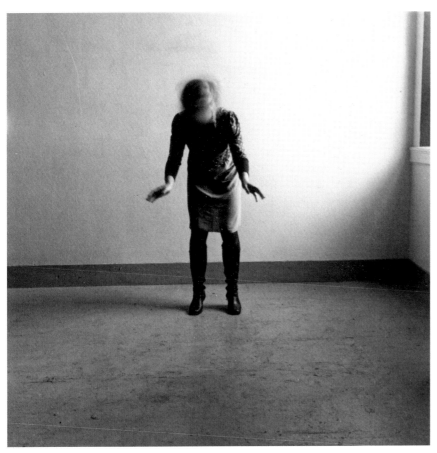

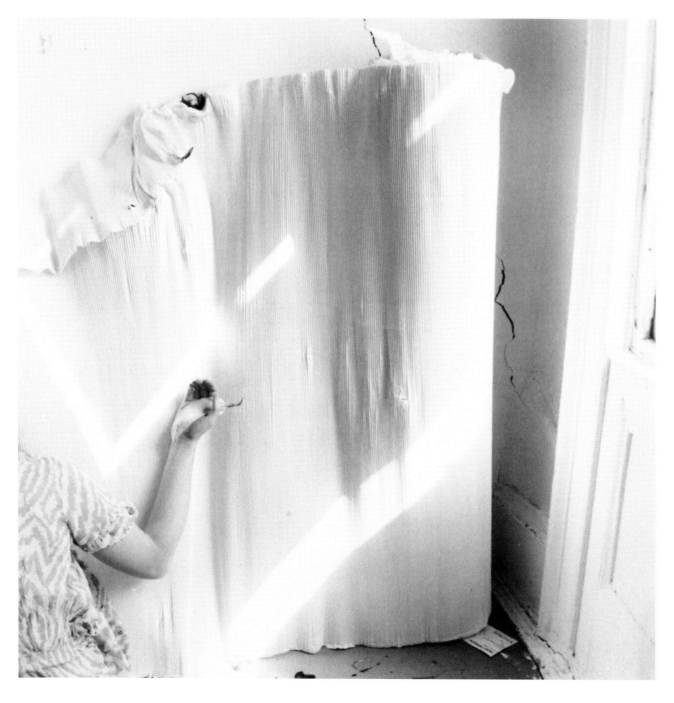

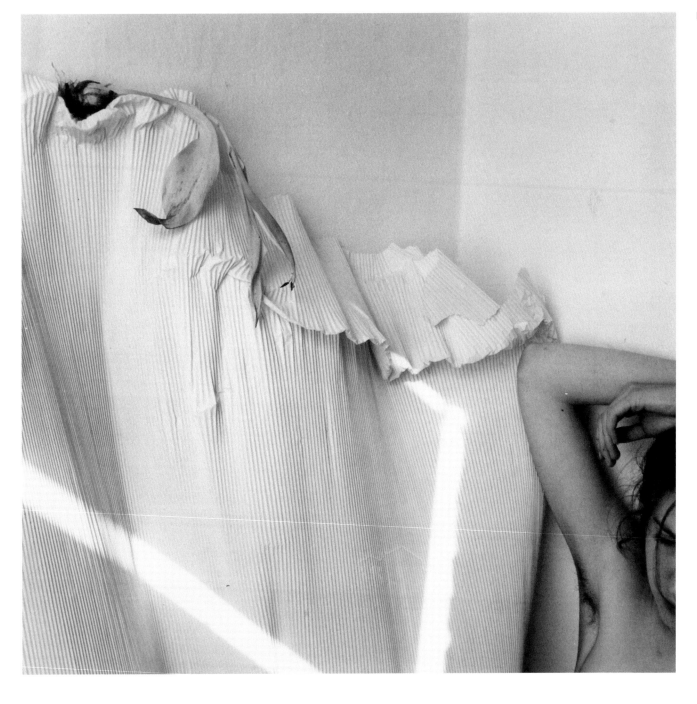

# PERFORMING
# ICONS

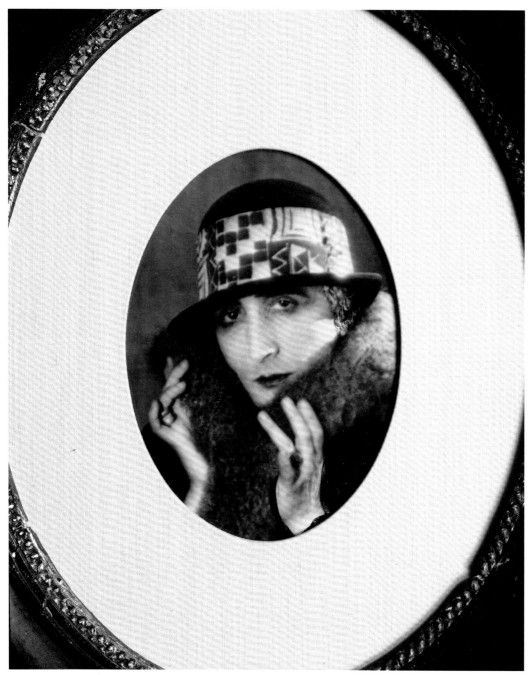

**MAN RAY** / *RROSE SÉLAVY* / 1921

**Since the invention of photography, its** apparent ability to record appearances accurately has been questioned by artists, who have used it as a means by which to privately perform alternative identities separate from those enacted in the space of the live stage. This has often involved playing on familiar or iconic tropes within the history of art, popular culture and photo-journalism, in order to explore how images can shape ideas about gender, politics and culture.

An early example of the camera being used in this way can be found in F. Holland Day's *The Seven Words* 1898. Evocative of a devotional object, these seven small close-up portraits depict the artist, with newly grown beard, carefully re-enacting the final moments of the crucifixion of Jesus. By using the modern medium of photography to recreate a scene that has been depicted for centuries, Day created a contemporary religious icon that was considered by some to be blasphemous. Some twenty years later, Marcel Duchamp was photographed by Man Ray as his female alter-ego Rrose Sélavy, to create a photograph that has since acquired a mythic-like status in the history of art. Described by Duchamp as a 'game between I and me', he used this drag persona to author artworks and explore notions of identity, sexuality and the unconscious.

By the mid-twentieth century, the prevalence of mass media and popular culture was such that many artists turned to pre-existing images for their source material. Throughout his career Yasumasa Morimura has mined the archive of art history and popular culture to take on and perform the role of famous artworks, celebrities and artists, even recreating Yves Klein's *Leap into the Void*. In 1974 David Lamelas used the popularity of rock music to imagine himself as a charismatic performer through a series of images that imitate the conventions of rock photography with out-of-focus shots and back-lighting. For *African Spirits* 2008 Samuel Fosso took on the role of iconic leaders in America and Africa by copying their pose, dress and expression. By recreating the identities of well-known figures, Fosso was also performing the photographs that captured each person (such as Eve Arnold's famous image of Malcolm X), and in the process lent his own work a kind of iconicity.

The identity of the writer Arthur Rimbaud is conflated with that of the artist, writer and activist David Wojnarowicz in a series of images that document a character, wearing a mask made from a Xeroxed photograph of Rimbaud, as he moves through the same cruising spots in New York City that the artist would frequent. Using a historical figure with whom he closely identified, Wojnarowicz attempted to fuse historical time and contemporary activity in order to trace a queer reality in which private desires are acted out in public spaces.

Cindy Sherman's *Untitled Film Stills* are a seminal example of how photography has been used to explore the performance of identity in the mass media. Created between 1977 and 1980, Sherman used the visual vocabulary of low-budget b-movie scenarios to perform different female characters in an array of settings that point to the constructed nature of femininity. In later works such as the 'Pink Robe' series, Sherman appeared without costume or makeup and instead used a confined setting and studio lighting to convey a psychological state of mind. In Tokyo Rumando's *Orphée*, the artist uses a mirror as a portal to other identities and worlds, and as a metaphor for the transformative potential offered by the camera lens.

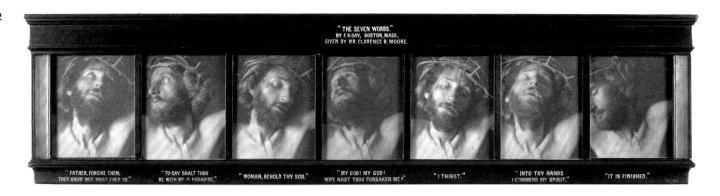

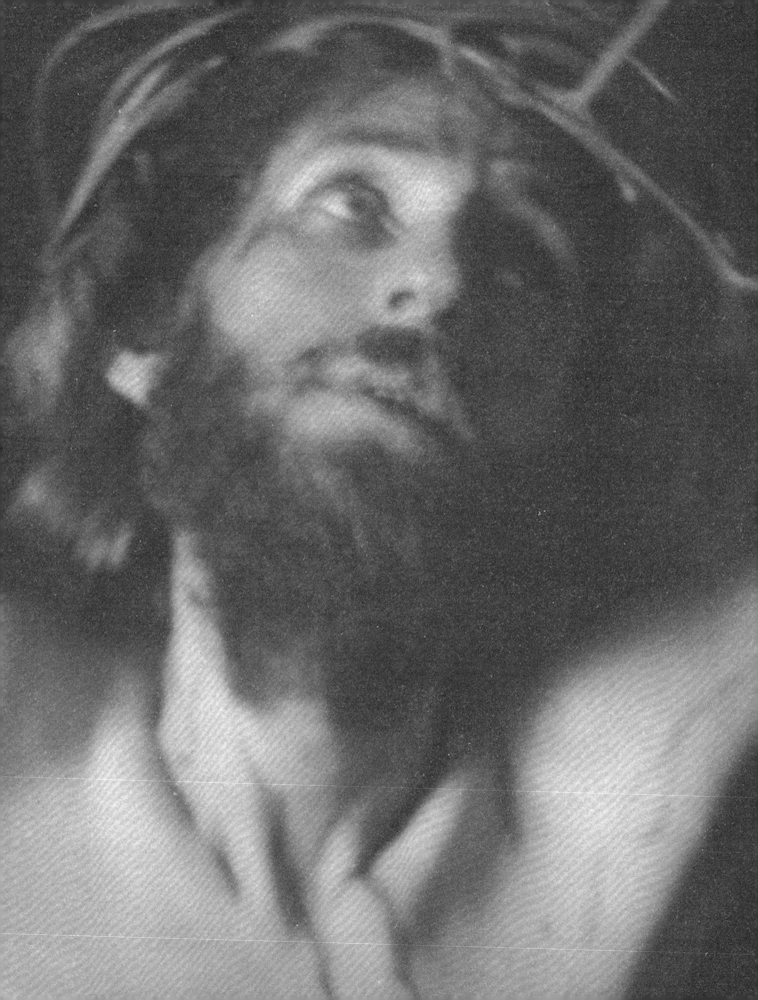

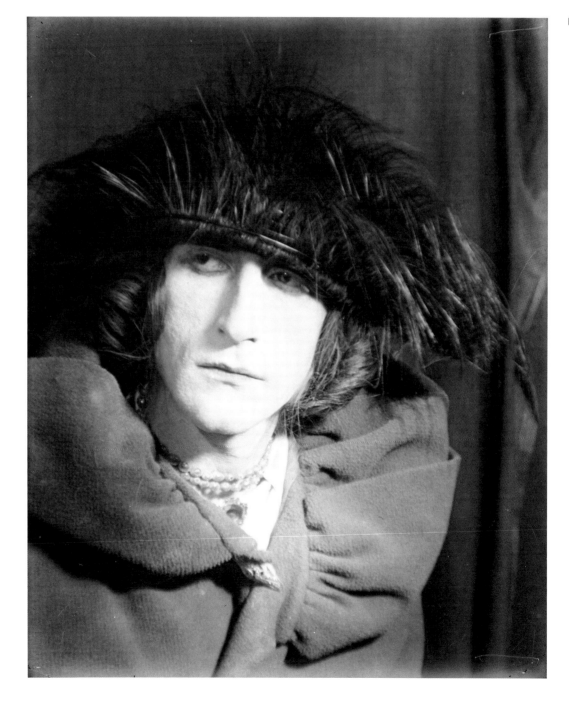

126

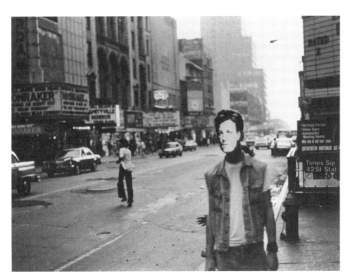 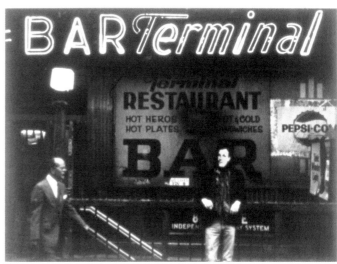

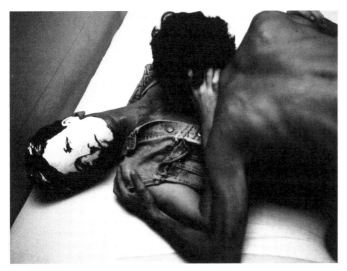 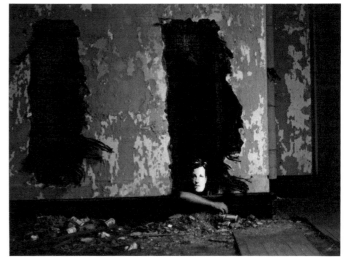

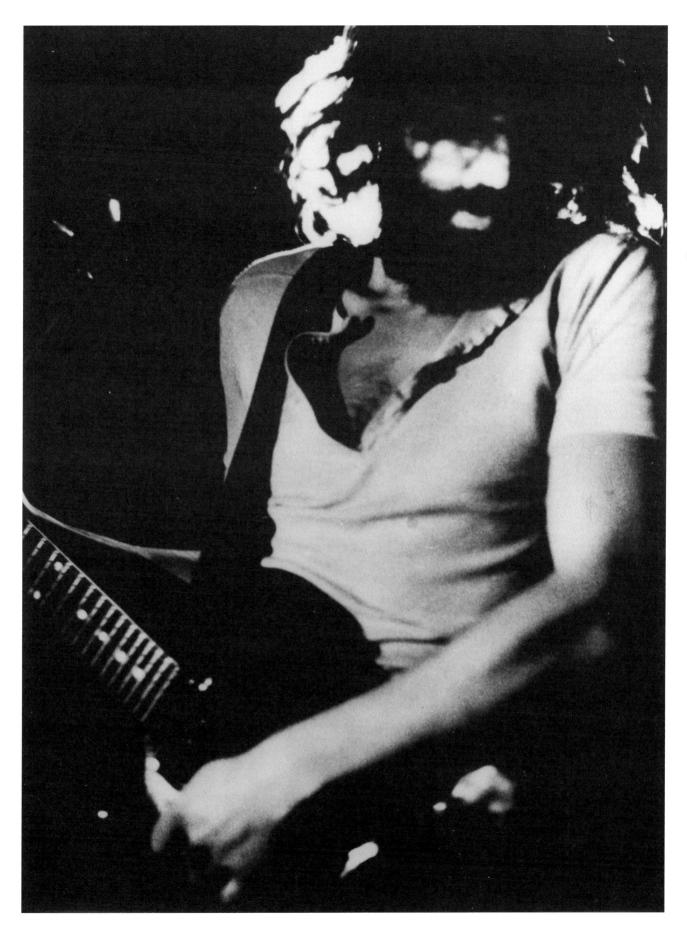

130

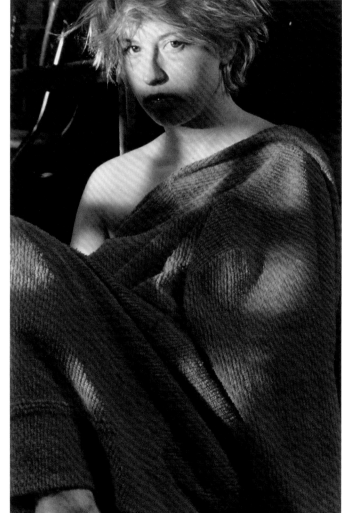

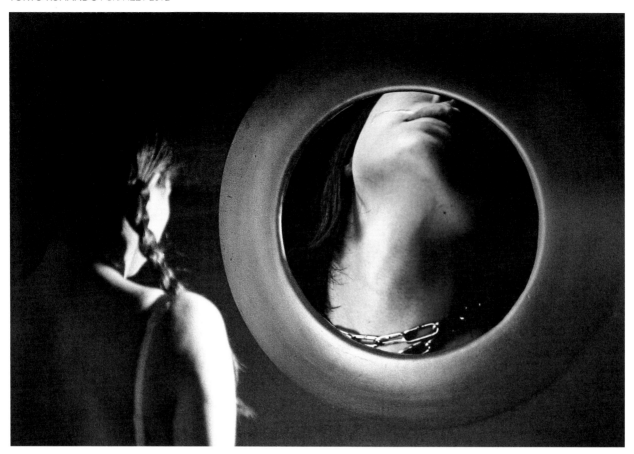

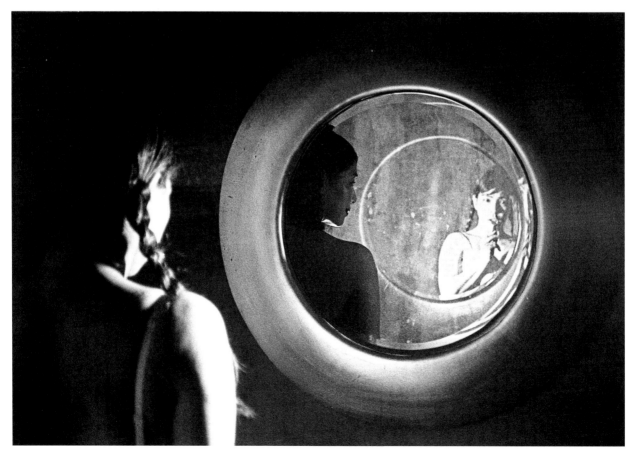

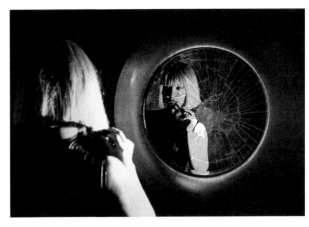

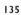

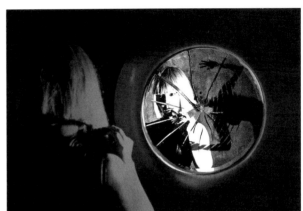

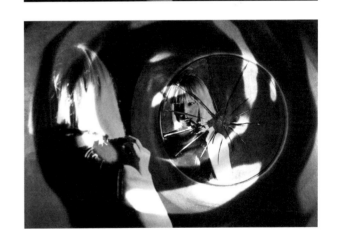

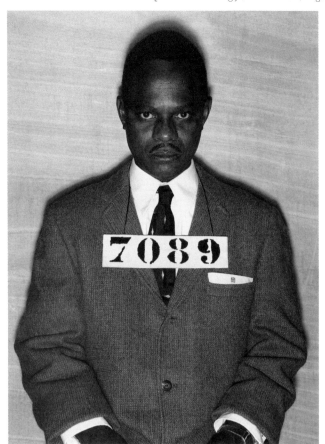

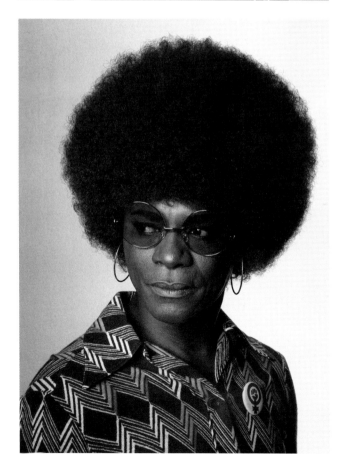
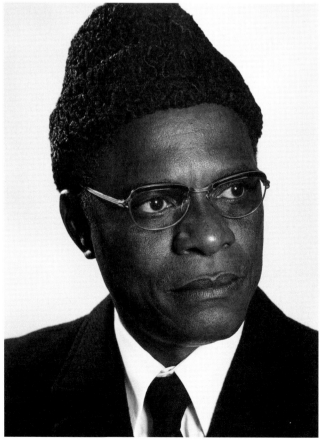

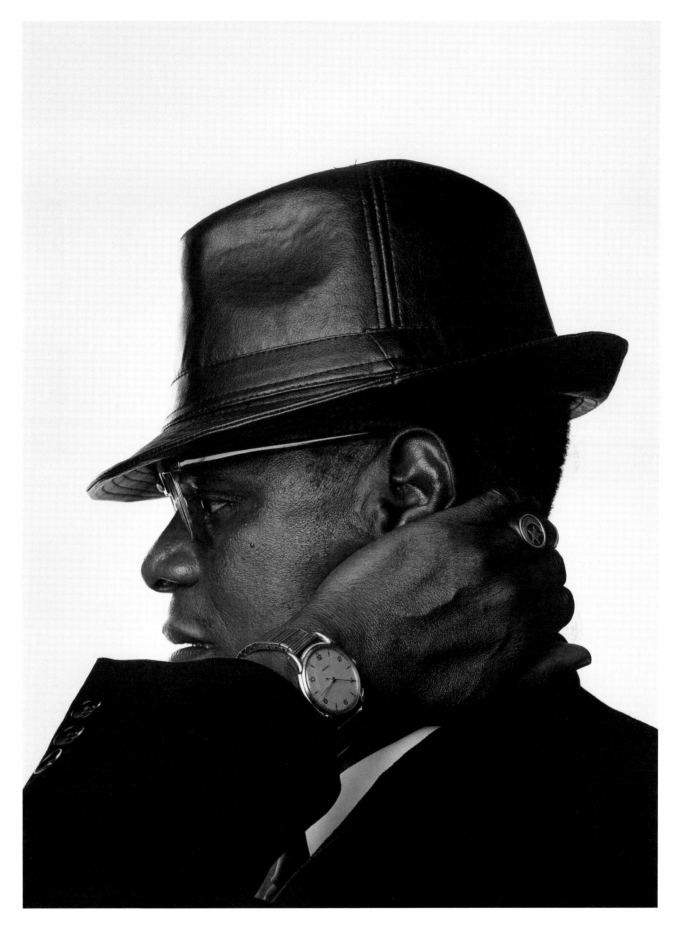

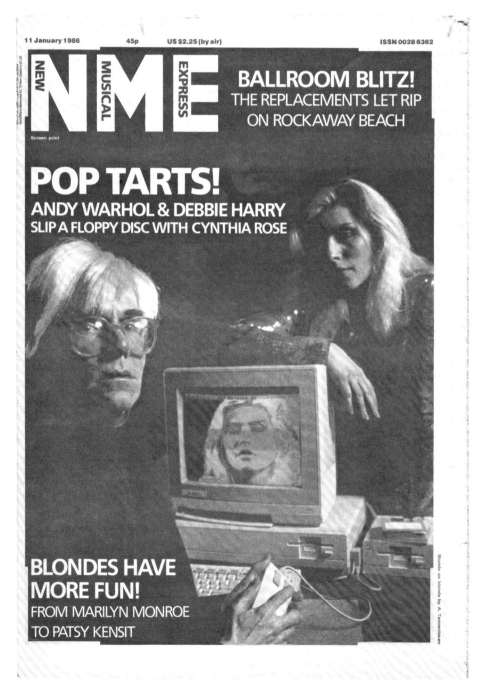

Text on magazine cover:

11 January 1986    45p    US $2.25 (by air)    ISSN 0028 6362

NEW MUSICAL EXPRESS

**NME**

Screen print

**BALLROOM BLITZ!**
THE REPLACEMENTS LET RIP
ON ROCKAWAY BEACH

**POP TARTS!**
ANDY WARHOL & DEBBIE HARRY
SLIP A FLOPPY DISC WITH CYNTHIA ROSE

**BLONDES HAVE
MORE FUN!**
FROM MARILYN MONROE
TO PATSY KENSIT

Blonde on blonde by A. Tannenbaum

ANDY WARHOL / *NME, 11 JANUARY 1986*

**Throughout art history the performative** nature of portraiture has been used by artists to construct their own self-image. With the invention of photography and the emergence of the mass media and advertising, the representation of a 'self' (albeit a constructed one) came to be used by artists to promote and question their own positions within the art market.

As a life-long fan of the Hollywood star system and celebrity, Andy Warhol perfectly understood the performative nature of being an artist in a modern age, carefully constructing his own 'look' with great success. Consisting of an ill-fitting white wig, pale skin and an attitude of nonchalance and passivity, it was an identity that by the end of his life was instantly recognisable. Across a series of posters for film, television and events, the articulation of his 'aura' was so consistent that it could be used to promote department stores, computers and films. While the clothing, and work, of Joseph Beuys – in felt hat, fishing jacket and walking stick – may appear to be the polar opposite of Warhol's fashion-conscious look, it too was a persona that he retained throughout his life and contributed to his status as a shaman-like artist. Beuys was an important figure in the history of performance, and the posters that promoted his exhibitions and projects often focused on the cult of his personality.

From the 1960s, the rise in mass media led female artists to co-opt advertising strategies as a form of subversion. In 1967 Waltraud Höllinger used the Export cigarette brand to construct her own artistic identity as VALIE EXPORT. A year later she walked into a cinema in crotchless jeans in a performance that addressed the use of women's bodies in the media. EXPORT commemorated the event in 1969 by posing for photographer Peter Hassmann in the same outfit, but now with a gun, and created a poster of the image that she pasted in public spaces. In 1974 Lynda

Benglis upset art critics and feminists when she placed a nude photograph of herself holding a giant double-edged dildo as an exhibition advertisement in *Artforum* magazine. This carefully constructed self-portrait came out of a series of performative photographs that played on gender bias and the phenomenon of the (male) artist as star. Hannah Wilke responded to her own experience of being criticised for using her nude body, with the creation of a poster that declared 'Beware of Fascist Feminism' and used the photographic documentation of her performances to summarise ideas to do with spectatorship and identity. In Judy Dater's well-known *Imogen and Tinka at Yosemite* 1974 she depicts the ninety-year-old photographer Imogen Cunningham 'discovering' a female nude. Drawing upon Thomas Hart Benton's painting of the mythic figure Persephone, the photograph uses Cunningham's legendary status to explore the relationship between the artist, the gaze of the photographer, and the nude female body.

In 1974 Mike Mandel travelled across America photographing 134 photographers and curators as baseball players; the images were printed as cards and sold in packs of ten with chewing gum. This imitation of sport-themed trading cards toyed with an artist's (market) value and exploited photography to create a commodified object. The image of the artist as professional was also cultivated by Jeff Koons from the beginning of his career. In 1988 he announced his *Banality* exhibition with a series of art advertisements, by celebrity photographer Greg Gorman, that presented the artist as a perfectly poised and coiffed star. For many, such blatant self-advertisement was repulsive, but proved to be a prescient precursor to the corporate presentation of many artists' personas in the decades to follow.

142

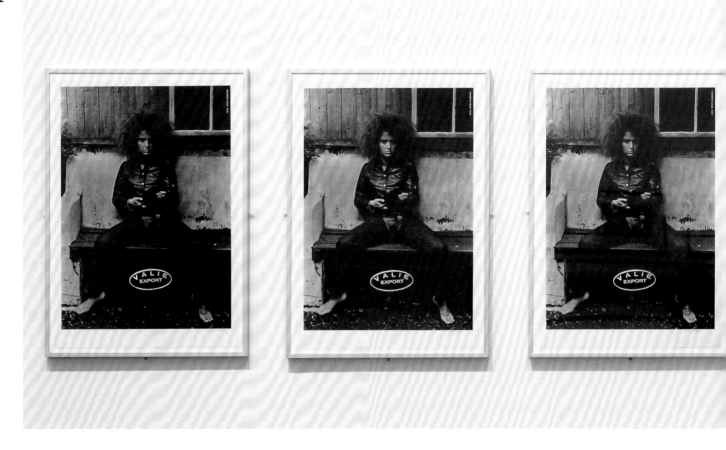

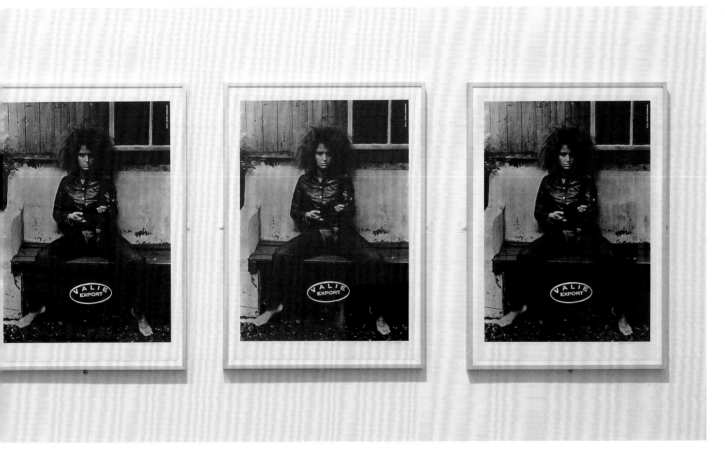

144

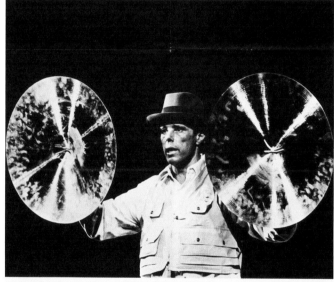

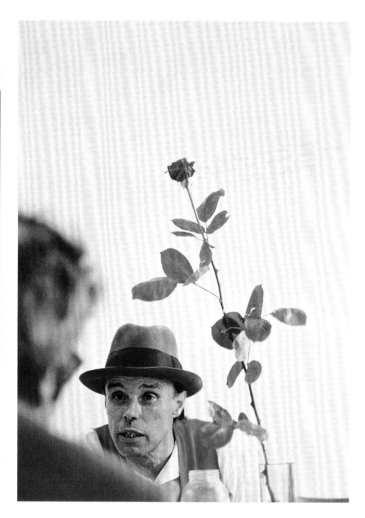

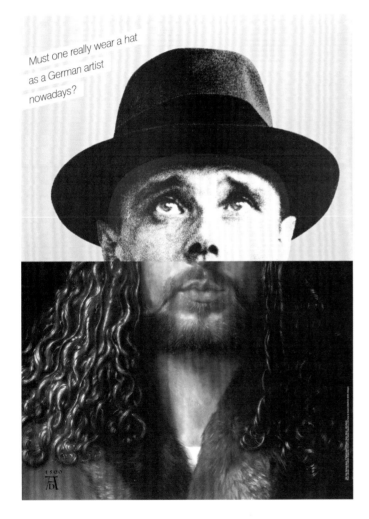

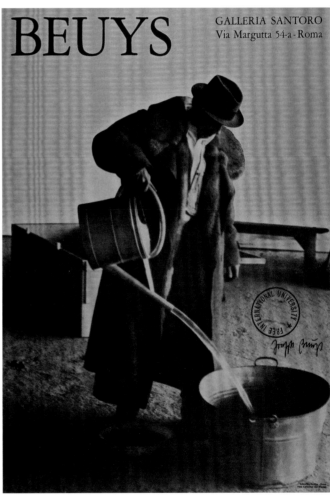

146

# Having a talent isn't worth much unless you know what to do with it.

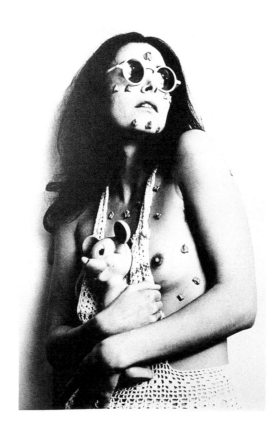

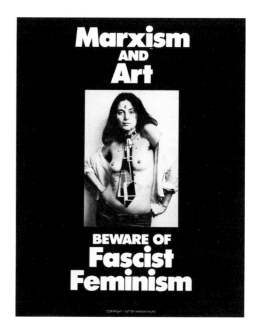

Degree and Non-Degree Programs. Day and Evening. Film. Photography. Media Arts
(Advertising, Fashion, Illustration, Design). Crafts (Ceramics, Jewelry) Fine Arts
(Painting, Sculpture, Printmaking). Video Tape, Dance, Humanities

## The School of Visual Arts
209 East 23rd Street, New York, New York 10010 (212) 679-7350

# HANNAH WILKE: PHILLY

An auto-documentary of her performance at the Philadelphia Museum of Art for the films
"Through the Large Glass" and "C'est la vie rrose"

produced by Hans-Christof Stenzel for German television
Video camera by Andy Mann. Editing by John Sanborn and Hannah Wilke.

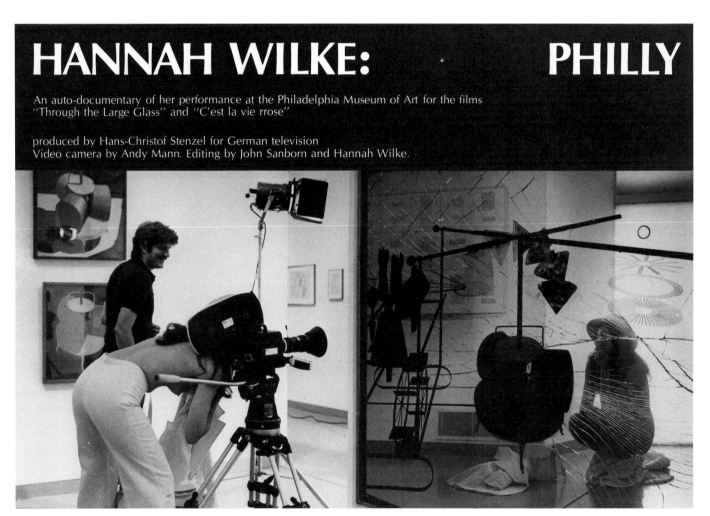

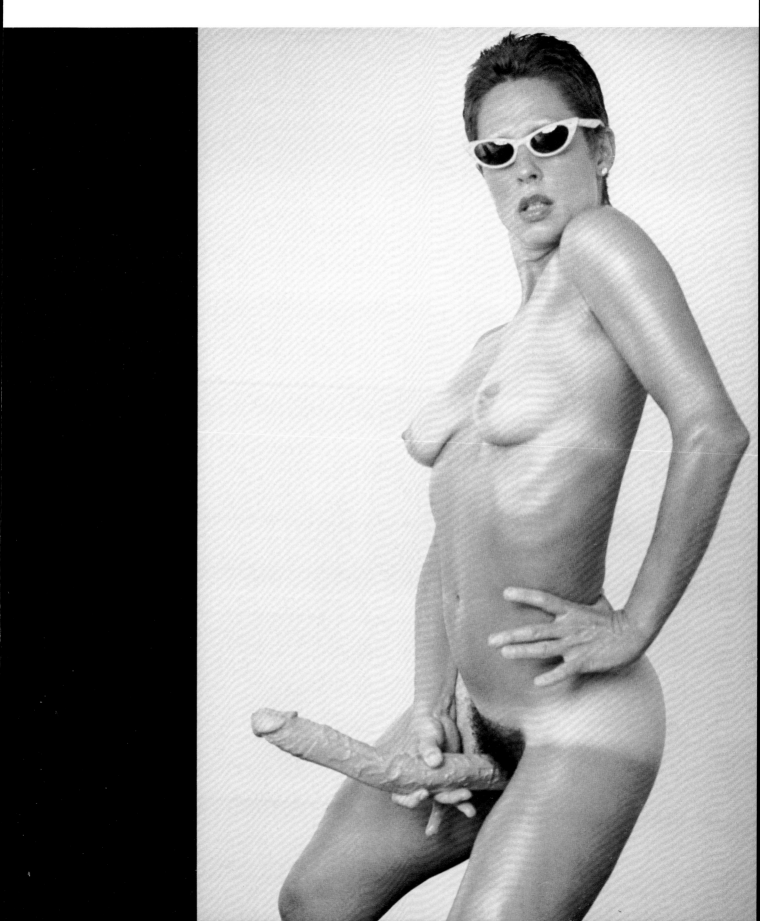

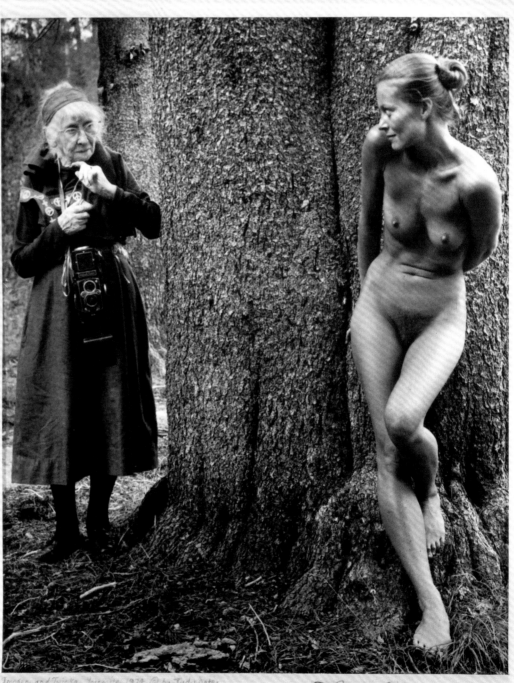

# IMOGEN CUNNINGHAM:
## A PORTRAIT

## BY JUDY DATER
in association with
The Imogen Cunningham Trust

### THE NEW YORK GRAPHIC SOCIETY
Boston 1979

152

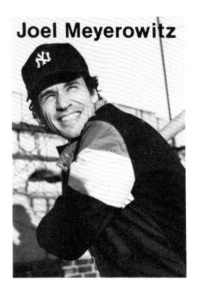

Joel Meyerowitz

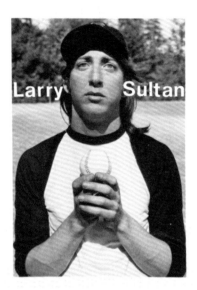

Larry Sultan

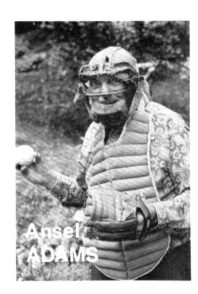

Ansel ADAMS

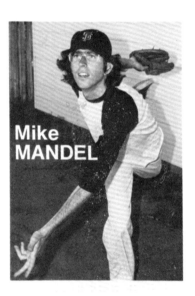

Mike MANDEL

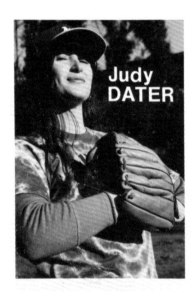

Judy DATER

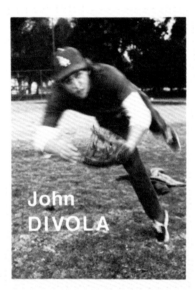

John DIVOLA

Duke BALTZ

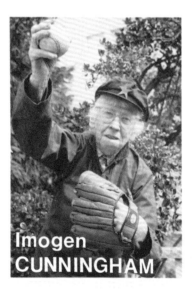

Imogen CUNNINGHAM

Bunny YEAGER

Height: 6'
Weight: 155
Born: The Bronx
Home: New York City
Throws: Right
Bats: Right          FP:
FC: Leica            FF: Kodachrome
FD:                  FPh: Robert Frank

**2**

## Joel Meyerowitz

My father was a terrific baseball
player. On summer Saturdays he left
early and played as many as 3 games
on the glass and ash filled lots of
the Bronx. Those were money games,
hard played and sometimes hard fought.
For the tight spots my pop brought a
special bat cut into 3 pieces and
hinged. To the pitcher it appeared
solid even as pop took a warm-up
swing. But at the crucial moment in
mid-windup, my pop would twist his
wrist and down would come his faith-
ful Hillerich and Bradsby and the
composure of any pitcher.

---

Height: 6'
Weight: 150
Born: Brooklyn
Home: S.F.
Throws: Right
Bats: Switch         FP: Portriga Rapid
FC: Leica M-2        FF: Tri-X
FD: Rodinal          FPh: J.H. Lartigue

**13**

## Larry Sultan

"Fear of a bat

Fear of getting spiked

Fear of the crowd

I don't care who they are

All ballplayers are afraid."

        Birdy Tebbitts
        Cincinnati Redlegs
        and Lew Welch

---

Height: 6'1"
Weight: 200 +
Born: San Francisco
Home: Carmel, Ca.
Throws: Right
Bats: Right          FP: Those that work
FC: None             FF:
FD:                  FPh: Daguerre

**21**

## Ansel Adams

Without a deep understanding of the
world in its natural aspects - an
awareness of elemental shapes, tex-
tures, substances, and light - the
photographer may discover himself in
a precarious relationship with real-
ity when he enters the more abstract
fields of artificial lighting and
its involved ramifications.

Natural Light Photography
Basic Photo 4
p. vi

---

Height: 5'10"
Weight: 125
Born: San Fernando Valley
Home: Santa Cruz
Throws: Left
Bats: Left           FP: Brovira 111
FC: Minnie           FF: Tri-X
FD: D-76             FPh: Ron Rafaeli

**24**

## Mike Mandel

Rapidly becoming one of the major's
finest first sackers, Mike came off
the last road trip fielding some
tough chances, and ended the season
tops on the club in thefts. Mike's
occasional power has paid off in key
homers.

Photo by Al Woolpert

Thank you Paramount Cap Corp., Santa Cruz Recreation
Dept., Ed Sievers, Bob Heinecken, Alison Woolpert and
The Roach for your help and support.

---

Height: 5'6"
Weight: 122
Born: Hollywood, Ca.
Home: San Anselmo, Ca.
Throws: Right
Bats: Right          FP: Agfa Brovira
FC: Deardorff        FF: Ilford FP4
FD: Rodinal          FPh: August Sander

**38**

## Judy Dater

They say behind every great man
there's a woman. Well, the reverse
is true too. 'Course I'm not brag-
gin' or nothin', but I owe it all to
my husband, Jack Welpott, who taught
me everything I know. Almost every-
thing that is.

---

Height: 6'1"
Weight: 175
Born: Santa Monica, Ca.
Home: Venice, Ca.
Throws: Right
Bats: Right          FP: Agfa
FC: 2¼               FF: Plus-X
FD: D-76             FPh: Evans

**59**

## John Divola

Statements are hard to make.

---

Height: 6'1½"
Weight: 190
Born: Casper, Wyo.
Home: Sausalito, Ca.
Throws: Left
Bats: Left           FP: Marfil Arroz
FC: Olympus Pen      FF: 2475
FD: 1:1 Dektol       FPh: Dead: Mortensen
                          Living: Too many

**78**

## Duke Baltz

There are some things that cannot be
generally told - things you ought to
know. Great truths are dangerous to
some - but factors for personal power
and accomplishment in the hands of
those who understand them. Behind the
tales of the miracles and mysteries
of the ancients, lie centuries of
their secret probing into nature's
laws - their amazing discoveries of
the hidden processes of man's mind.
These facts remain a useful heritage
for the thousands of men and women
who privately use them in their homes
today.

---

Height: 5'4"
Weight: 105 - 110
Born: Portland, Ore.
Home: San Francisco, Ca.
Throws: Right
Bats: Right          FP: Agfa Portriga
FC: Rollei           FF: XXX
FD: FG-7             FPh: Changes ?

**88**

## Imogen Cunningham

Apparently do not know enough

to quit. 1901-

---

Height: 5'10"
Weight: 140
Born: Pittsburgh, Pa.
Home: Miami Shores, Fla.
Throws: Right
Bats: Right          FP: Luminos
FC: Konica Auto T    FF: Tri-X
FD: D-76             FPh: Peter Gowland

**118**

## Bunny Yeager

The last time I remember playing ball
was in high school. I really wanted
to enjoy the game more, but they would
not let me pitch because I couldn't
throw the ball right. I always seemed
to end up in the backfield and I usual-
ly missed catching the ball because I
was afraid of getting hit and hurt by
it. I liked being up at bat best of
all, but that was so seldom. I just
never was the sports or "Tomboy" type.
I guess I like being soft and feminine.
Men are so much better at sports and
it's more fun to observe their bodies
when they're playing.

154

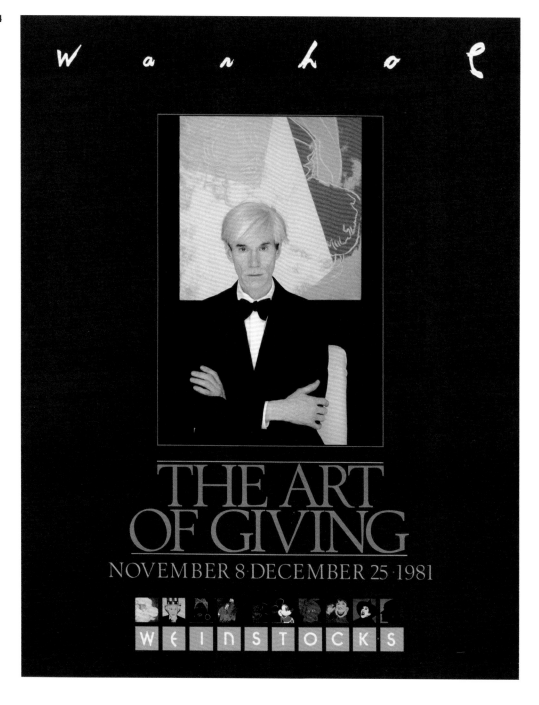

VOL. II, NO. 3

# JM *magazine*

## POW!

Modern impact: fashion

JM interviews Andy Warhol, modern icon

Arcosanti, Arizona—modern vision made real

# jordan marsh

*This is the place!*

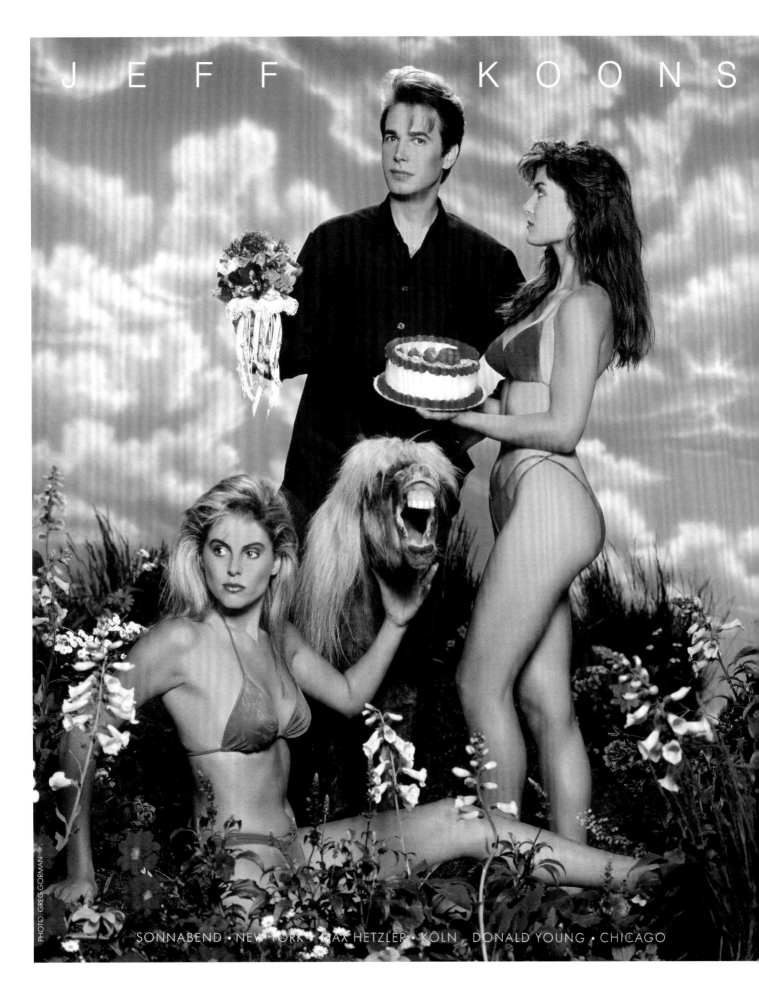

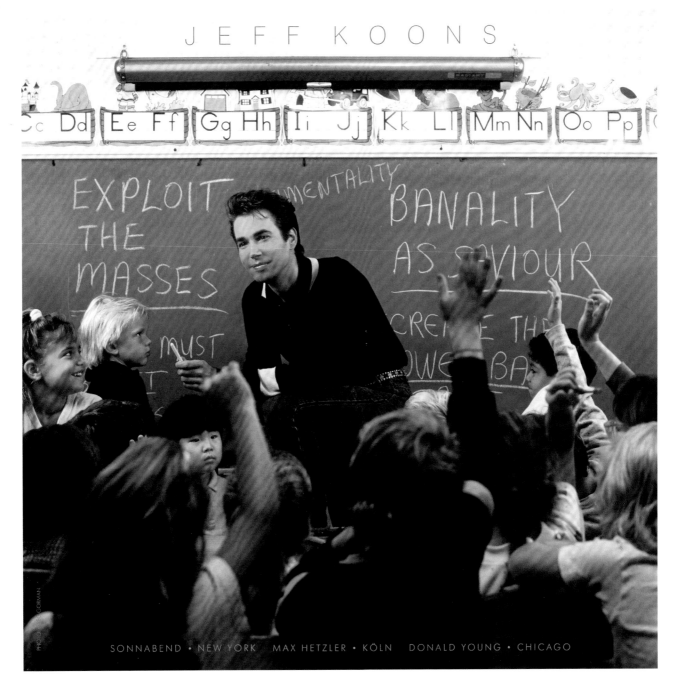

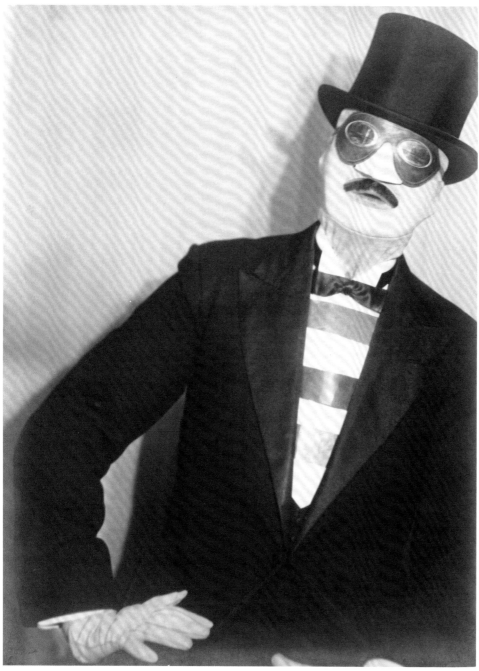

**PAUL OUTERBRIDGE** / *SELF-PORTRAIT* / 1927

**This section traces the use of the self-** portrait as a critical practice by artists who explore notions of identity through different aspects of performance. The popular uptake of ideas from psychology in the early twentieth century raised serious questions about the problematic relationship between appearance and identity. More recently, since the rise of feminism and gender politics, artists have been increasingly provocative in questioning the ways that societal roles are based on conventions that have been revealed and undermined through a broad range of performance and photographic practices.

Perhaps the earliest example of a performative self-portrait is Hippolyte Bayard's *Self-Portrait as a Drowned Man* of 1840 (p.20). Bayard's performance is just the first in a long and lively history of self-authored images by artists in which they play out parts or aspects of themselves. The brilliantly subversive practice of Claude Cahun dramatised the idea of self-regard by playing a game of mirrors with conventions of femininity from the perspective of a lesbian artist; Robert Mapplethorpe likewise made many self-portraits exploring different aspects of his character and sexual personae. Masahisa Fukase spent a month making various kinds of fantastic self-portraits in the confines of his bath, expressing his loneliness and isolation at the same time as his ingenuity and resourcefulness. Lee Friedlander made self-portraits throughout his career, from accidental reflections and cast shadows to elaborately posed compositions, and the series (covering fifty years of the artist's life) constitutes both an account of his artistic development and a study of its ageing subject. In an alternative long-term strategy, Martin Parr has had 'auto-portraits' of himself made for many years, giving over the responsibility for his self-image to commercial photographic studios and automatic photo-booths wherever he has travelled as a photographer. Parr's work, then, is less an account of his own practice than a global catalogue of commercial photography centred around his self-representation.

Adrian Piper and Jemima Stehli both incorporate the act of photography into their carefully staged self-portraits, revealing the presence and action of the camera (in Piper's case) and the shutter-release (in Stehli's) to dramatise the process by which the image is made. Both artists engage with the problem of self-representation as it relates to the naked female body before the camera. Stehli's *Strip* takes place before male subjects who are also making their own self-portraits, turning spectatorship itself into a spectacle in which the artist participates, both as author of the image and subject of the doubled gaze of sitter and viewer. Hannah Wilke's work also raises questions about spectacle, spectatorship and desire, through a series of images of herself stripping that shift sequentially from classical allusion to mock-blasphemy.

Artists like Tomoko Sawada and Hans Eijkelboom make portraits of themselves in which they act out different identities, or indeed perform against the notion of any one single identity. Sawada uses automatic photobooths to have passport-style portraits made of herself but made up in a staggering array of alternate guises, playing with notions of recognition, especially across cultural lines. In *With My Family* Eijkelboom assumes four equally plausible but mutually exclusive positions as the father of different families from the same neighbourhood in the Netherlands. In *Gone Fishing* Thomas Mailaender uses his real-life relationship with his pregnant wife as the basis for a whole series of simulated self-portraits accompanied by letters that try to rationalise his unacceptable macho behaviour.

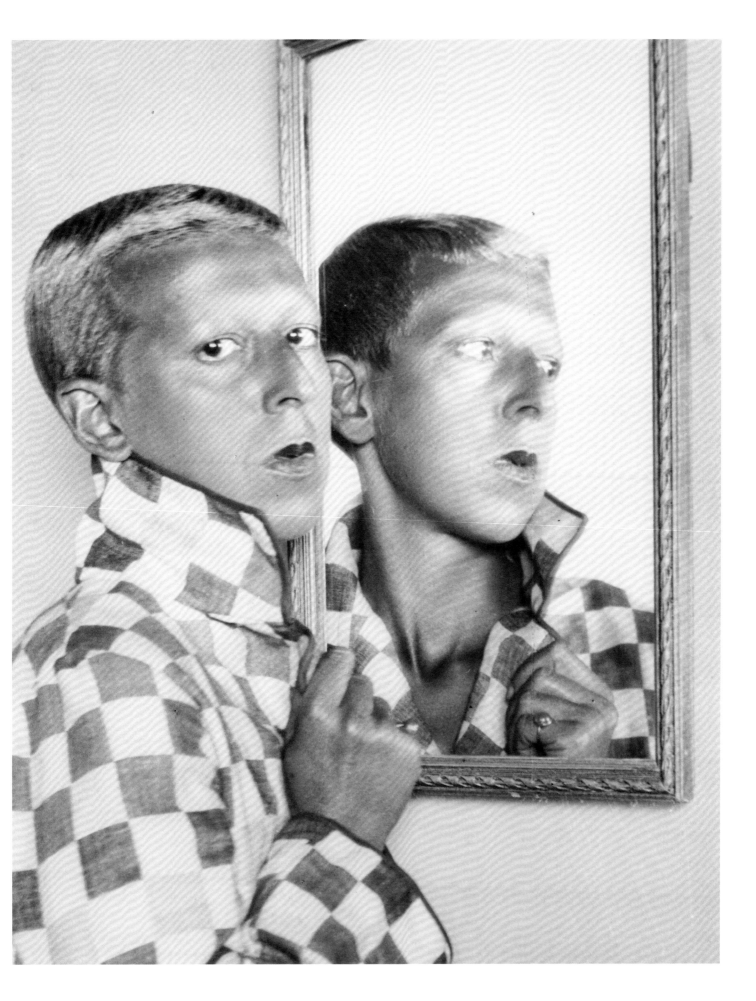

**162**

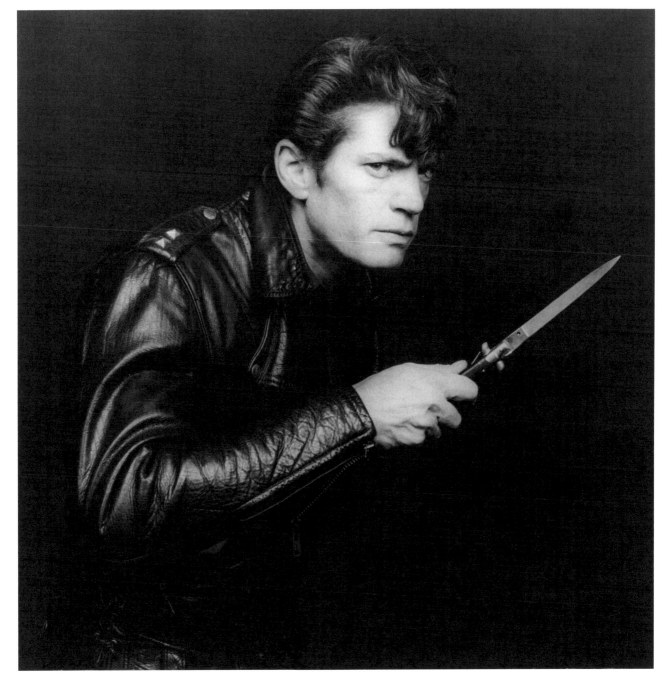

**164**

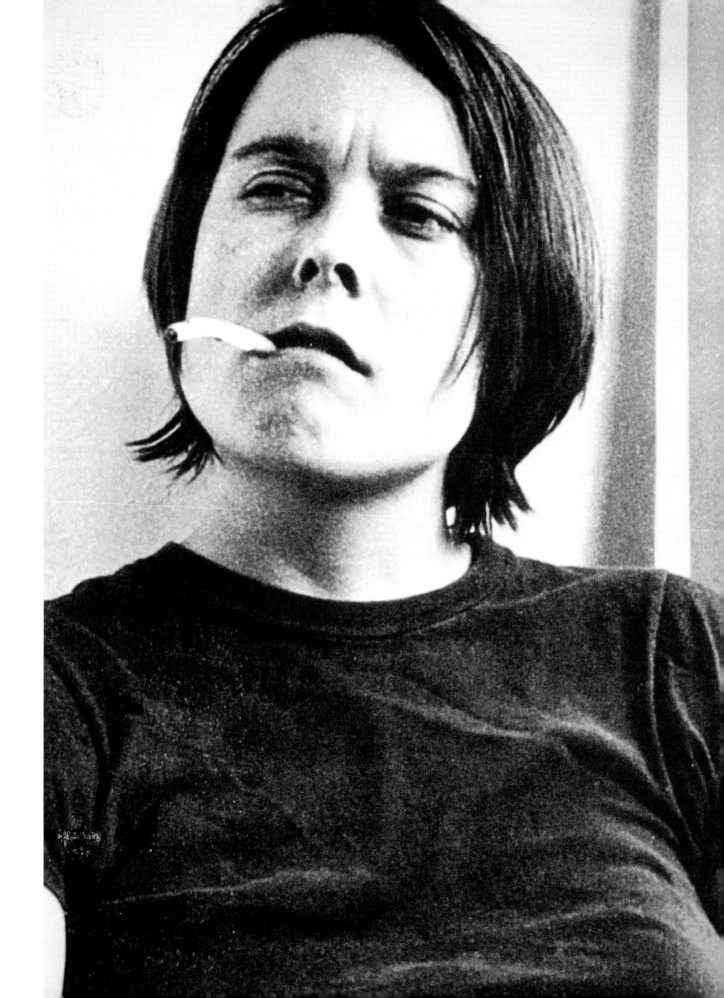

166

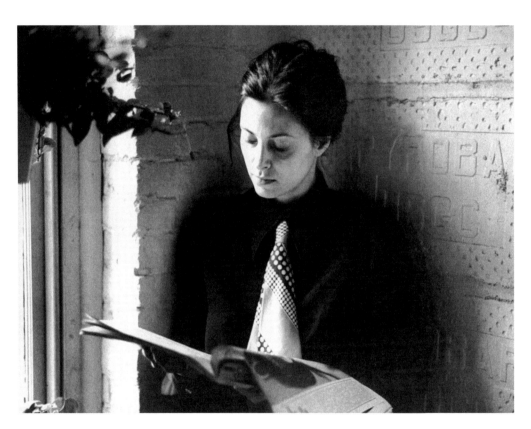

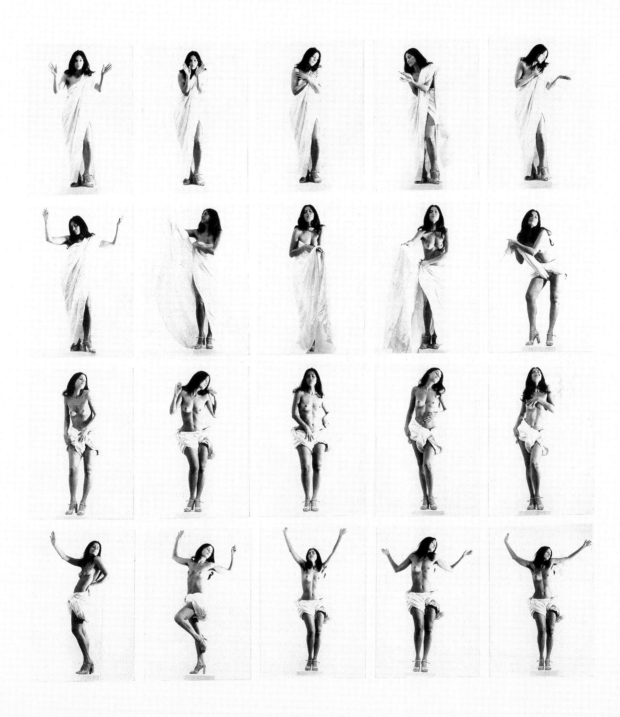

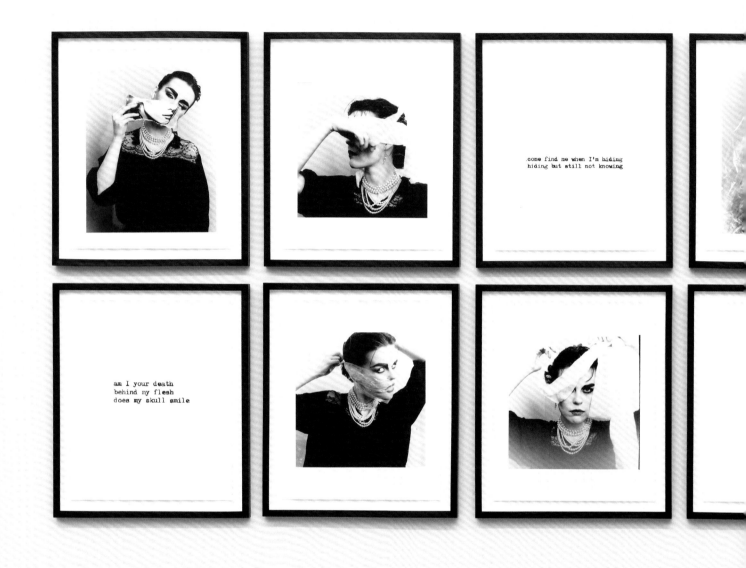

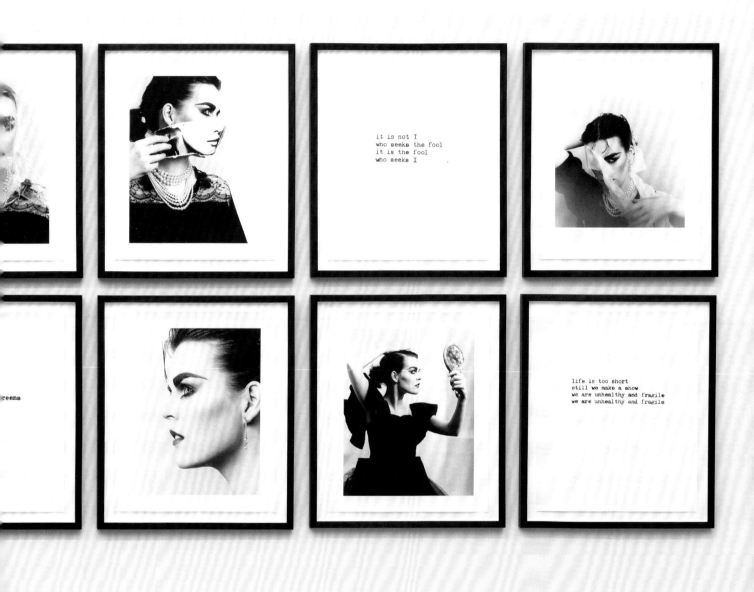

 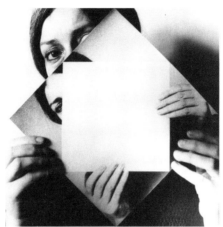 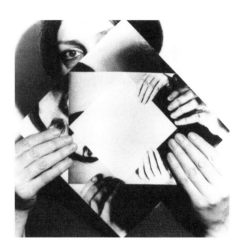

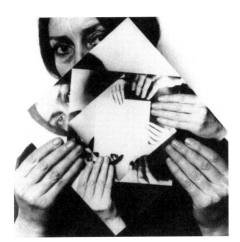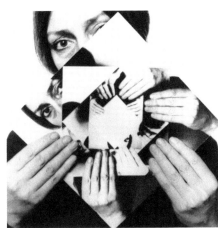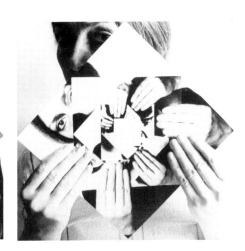

172

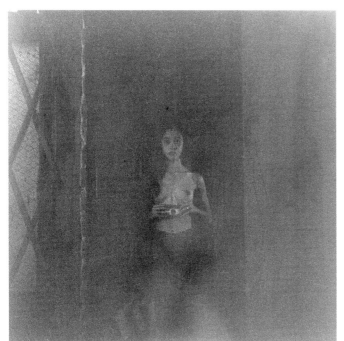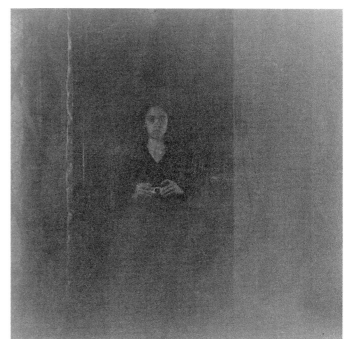

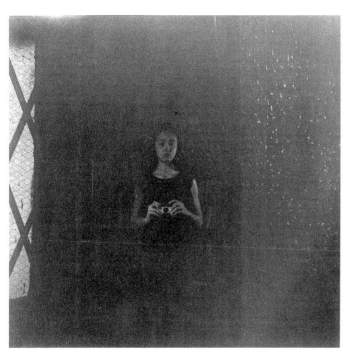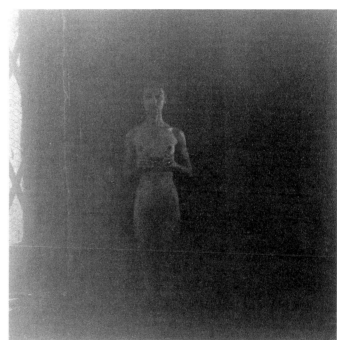

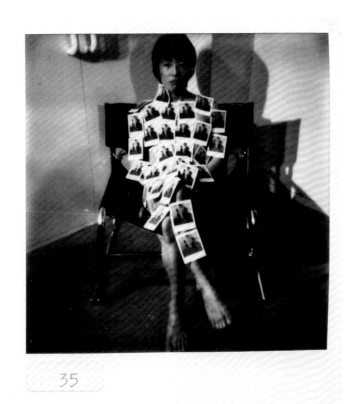

35

176

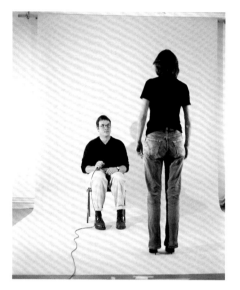 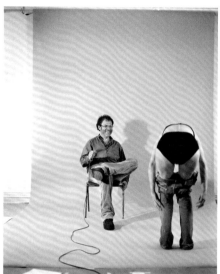 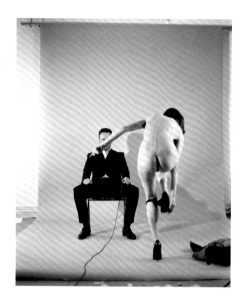

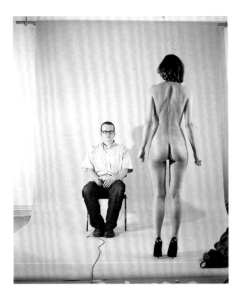 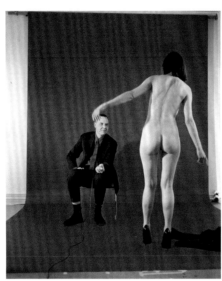 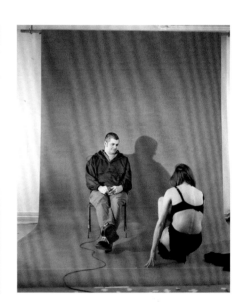

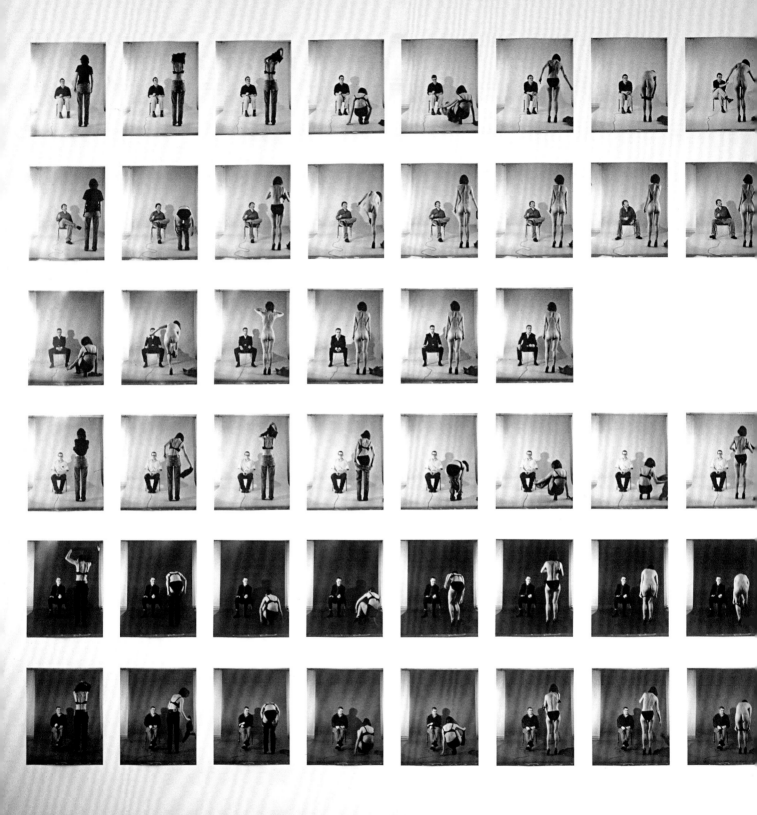

179

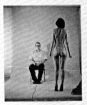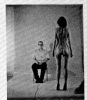

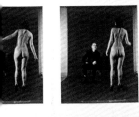

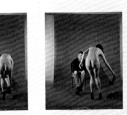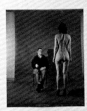

180

182

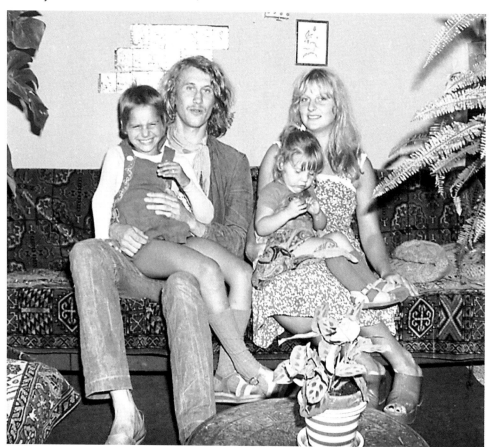

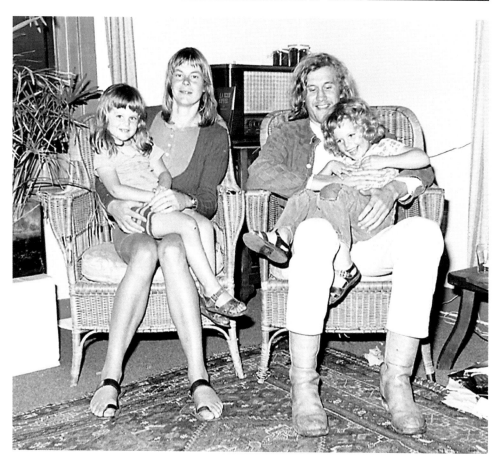

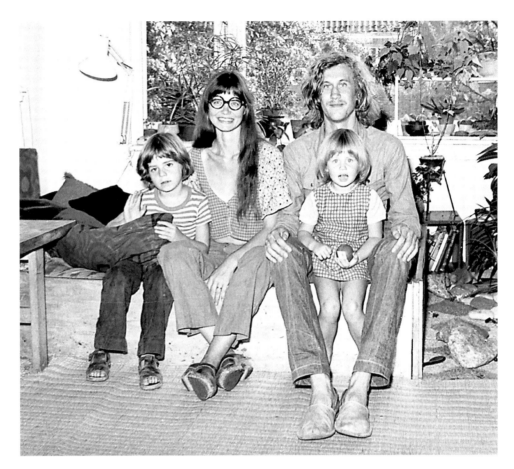

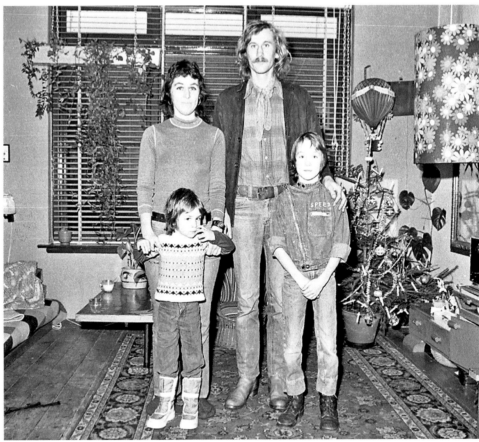

Marion,

I didn't know how to tell you this, so I'm writing you a letter. I am, like you always remind me, too much of a coward to say it to your face…
I'm not in Marseille like I told you. I'm in New Guinea fishing with Greg and Jerome. Sorry, but I needed to think about all this far from you and the baby. Soon I'll be a father… It keeps turning around in my head and this little escapade is doing me a lot of good (I even caught a shark) and I think that now I feel ready for us to have a little girl together. I'll be as promised in Paris Thursday evening. I hope you'll find the strength to pardon me… If this might console you, I have a horrible sunburn on my neck and I'm suffering like a martyr.

I love you.

Thomas

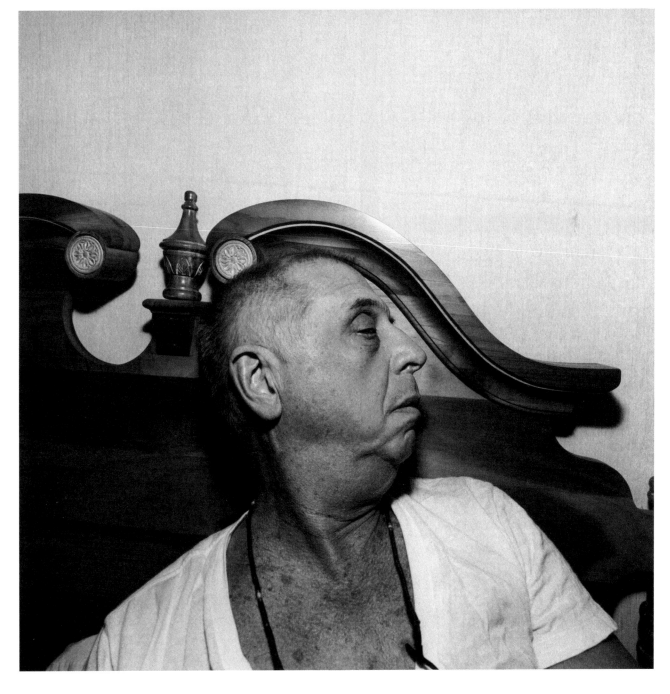

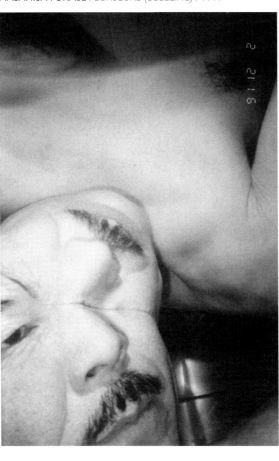

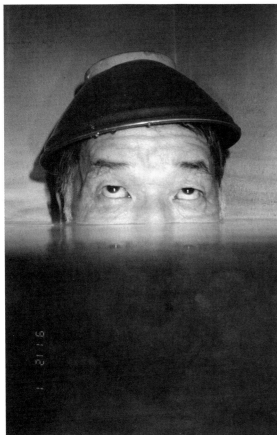
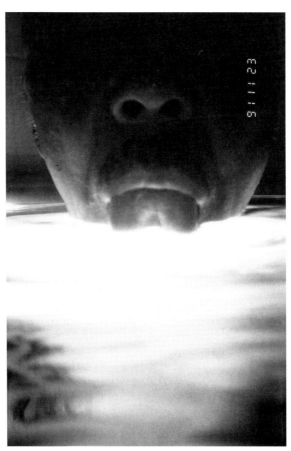

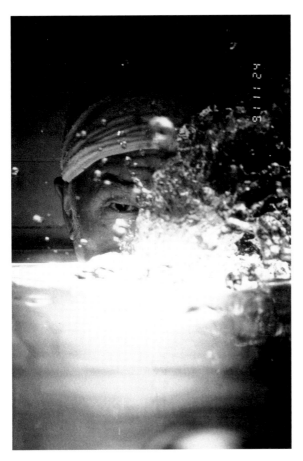
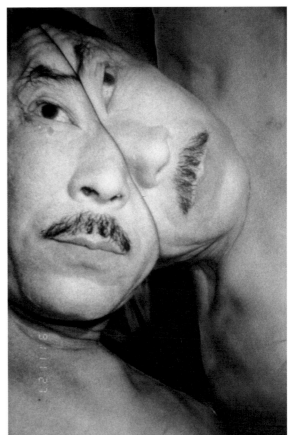

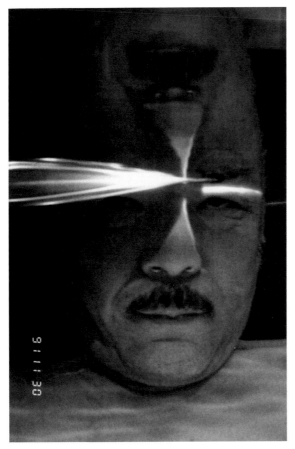
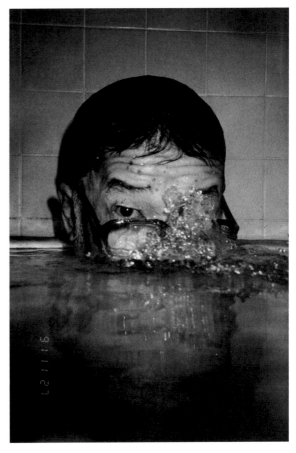

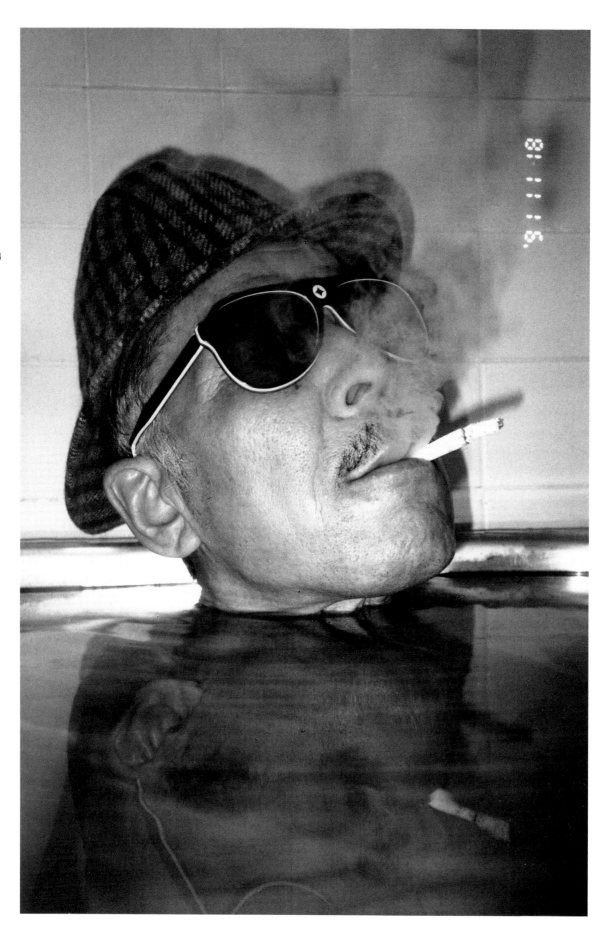

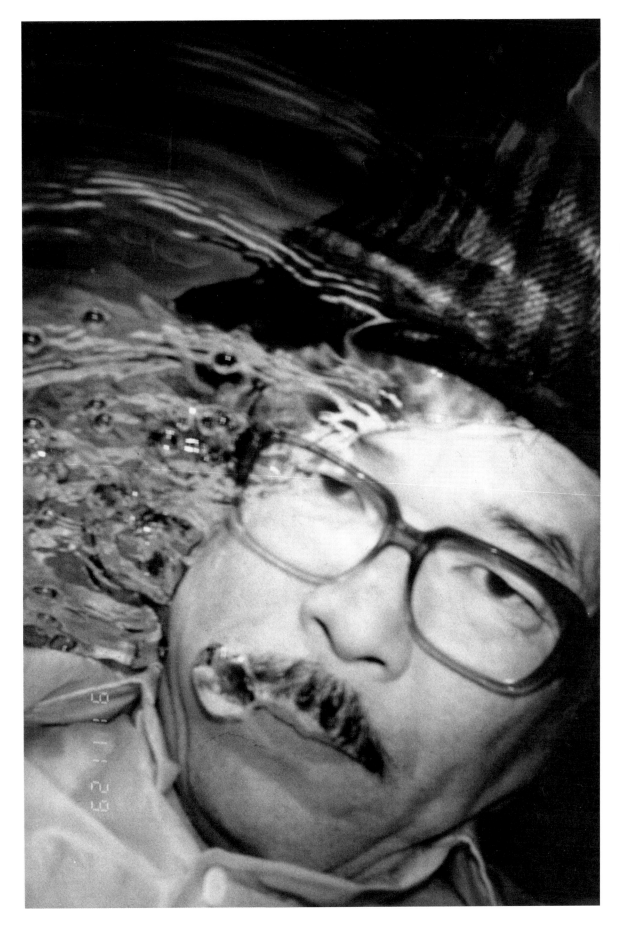

# PERFORMING
# REAL
# LIFE

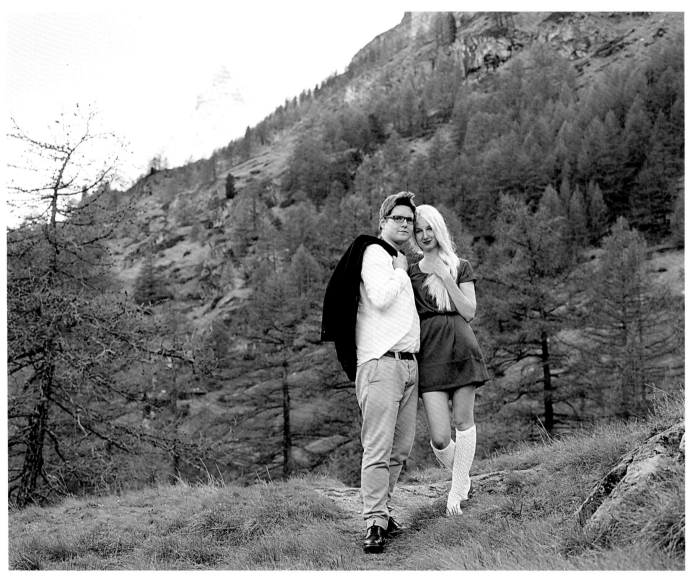

ROMAIN MADER / *EKATERINA: MARRIAGE PROPOSAL* / 2012

**The notion of performing real life reflects** upon the ubiquitous use of the camera to document people's lives. Artists have co-opted familiar photographic conventions such as the holiday snapshot, the family portrait and, more recently, the 'selfie' to deconstruct an idea of reality and the unconscious performances that people carry out in everyday life. This democratic approach to subject matter has resulted in images that embrace the banal and the accidental, blurring the lines between art and document, reality and fiction.

The presentation of a series of domestic gardens and their owners serves as the subject for Keith Arnatt's *Gardeners*. Through the systematic photographing of each individual, who often stands in the centre-ground looking at the camera, Arnatt presents the tended green spaces as a portrait of the sitters, one that is artfully constructed by their own hands and tools. By contrast, Masahisa Fukase's *From Window* depicts his wife Yoko acting out an array of poses, in a range of outfits, as she leaves for work each morning. Viewed together, the cumulative effect of her gestures ranging from happiness to sadness to frustration evokes the performed gestures of actors in a photo-studio. The ability of the snapshot to startle both subject and viewer was exploited in Ivars Gravlejs's *Scream and Flash*, in which new students at his school were taken into a dark room and shocked by the sudden flash of the camera. The resulting unexpected poses and gestures are unwitting performances that expose the impact that the camera can have on behaviour.

The potential ambiguity of the photograph and what might constitute real life and fantasy has been exploited by artists to draw the status and truth of photography into question. In 1982 Boris Mikhailov created *Crimean Snobbism*, a series of photographs documenting his wife and friends as they pretended to be on a leisurely holiday that they would not have been able to afford. While the performance involved the participants taking a real vacation, Mikhailov noted that the restrictive nature of the communist state meant that 'real' life was in effect more highly performative than these moments of temporary freedom. The photographs record this private performance and imitate the scale and sepia tone of old holiday snapshots that would be found in a family album. More recently, Swiss artist Romain Mader created the series *Ekaterina* to explore 'mail-order bride tourism' in Ukraine. Apparently documenting the artist's search for a wife, Mader frames each of his potential partners in an informal manner that reinforces the impression of reality. The images become both a performative exploration of photography as a record of reality, and the real documentation of a performance project.

With the rise of social media, the chronicling and instant broadcasting of people's day-to-day lives have transformed the personal act into a performative one. This has been cannily exploited in Amalia Ulman's four-month long performance *Excellences and Perfections* 2014 that existed solely on the photo-sharing platform Instagram. Structured in a manner similar to the paintings of William Hogarth, across three 'chapters', Ulman enacted the tale of an innocent blonde who moves to Los Angeles to have a breast enlargement, develops a drug addiction, and finally discovers yoga and healthy living. Bringing together questions surrounding the documentation of performance, the construction of identity and the dissemination of photo-media, Ulman's continued use of Instagram complicates an understanding of what is reality and what is a performance.

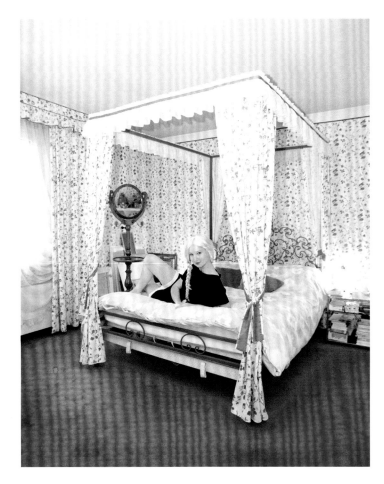

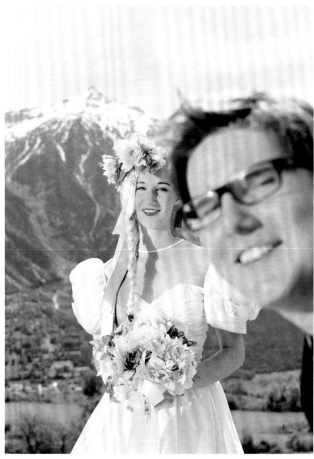

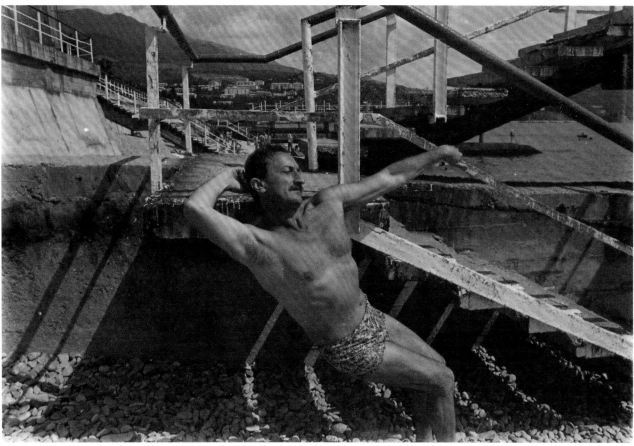

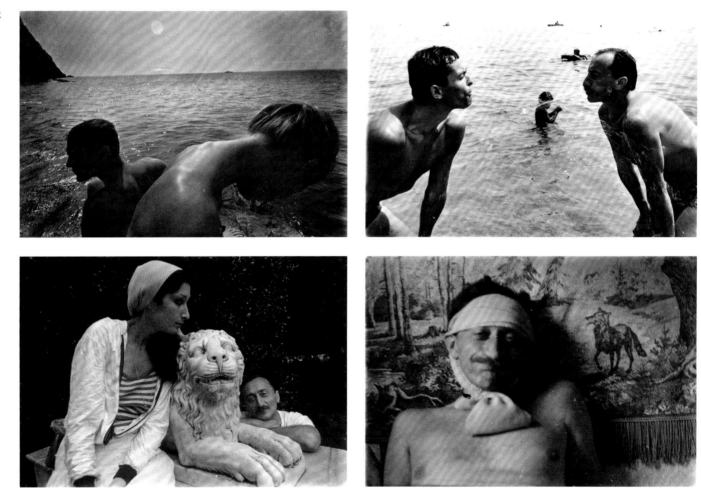

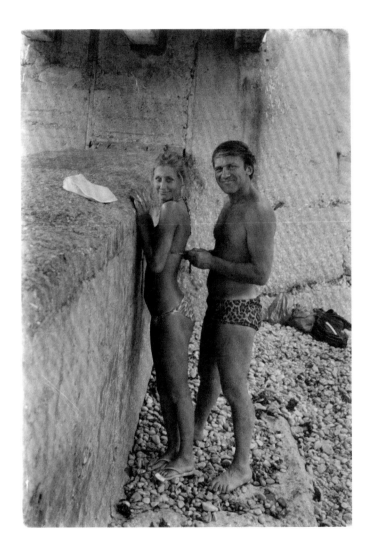

204

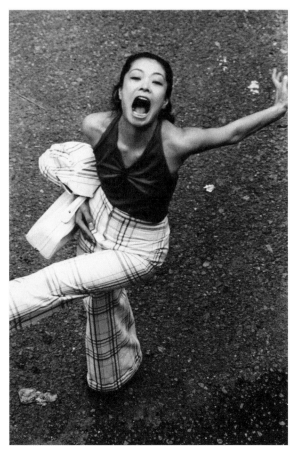

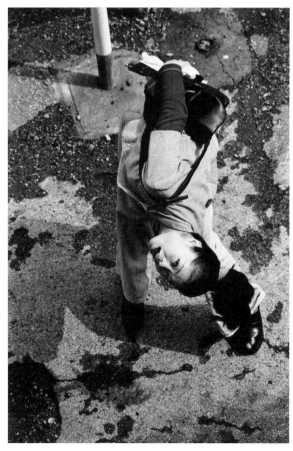

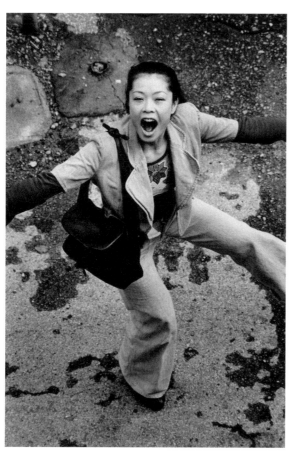
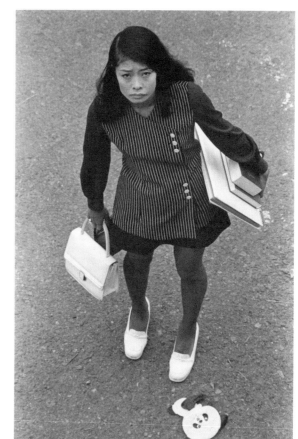

'The unofficial inauguration of newcomers in the gymnasium, I was hiding in the cellar in total darkness. I waited for the signal and when the door opened I screamed into the dark and with the flashlight photographed the person in front of me.' [Ivars Gravlejs]

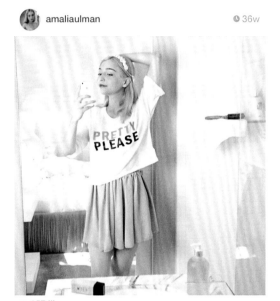

amaliaulman     🕐 36w

157 likes

amaliaulman Wearing the PRETTY PLEASE tshirt in retro print from @momotrapots ^•^ gotta lovethe unique design and striking prints! It comes in 2 other colors !! Quote "amalia10" and enjoy a 10% discount for any regular- priced item

kris_clairvoyance first

vacuumnoise PP

amaliaulman    🕐 31w

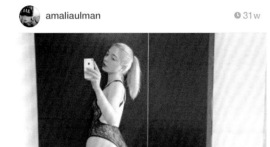

♡ 256 likes

**amaliaulman** #got #em #cakes
dun care bout all ur negativity #itsjustdifferent
less nervous today.... countdown
caitbowden @d3scribe
remlovee @samkrumw

amaliaulman    🕐 23w

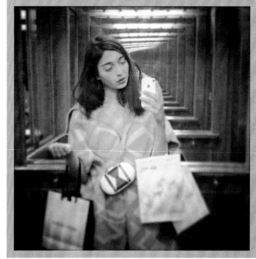

♡ 199 likes

**amaliaulman** Small presents are the best gifts.
Paying attention to details. ✨ #friends #family
#birthday #sister
amaliaulman @nataliauceda
nataliauceda 👏 💋 💕

212

SHUNK-KENDER, *'WORLD TOUR' SERIES* c.1960s

# Between You and Me: Photographs of Performance by Shunk-Kender 1960–77

FIONTÁN MORAN

I suppose one of the things I took from my wartime experiences was that reality was a stage set. The realities that you took for granted – the comfortable day-to-day life, school, the home where one lives, the familiar street and all the rest of it, the trips to the swimming pool and cinema – were just a stage set. They could be dismantled overnight … Nothing is as secure as we like to think it is.
J.G. Ballard[1]

## BETWEEN SCENES, BEHIND THE SCENES

Never was the concept of the world as a stage more acutely felt than after the Second World War. The erection of the Berlin Wall in 1961 provided a physical reminder of a war that physically and psychologically tore at the fabric of society to leave a world in pieces. In the mid-1960s János Kender and Harry Shunk, known as 'Shunk-Kender', created their *World Tour* series, in which they photographed the entire length of the wall in a carefully composed modernist style.[2] Depicting the abstract forms of the structure, the bricked-up doorways and remnants of buildings, only a few of the images include signs of human life. They are often solitary figures or guards looking over the edge of barriers, as though caught in the wings of a stage, waiting for a new scene to be configured that in many ways connects with Shunk-Kender's practice as photographers. For alongside projects such as *World Tour*, Shunk-Kender earned their living documenting a community of artists, who were expanding the limits of painting and sculpture by embracing mass media and performance. This placed the duo in the unique position of chronicling and helping to create some of the most exciting moments in the history of art. By always co-authoring their work, they rejected the singular authorial vision associated with the eye of photography, in favour of a pluralistic one; at the same time, they opened up the possibilities of what might constitute a performance.

Since the publication in 1979 of RoseLee Goldberg's *Performance Art: From Futurism to the Present*, interest in

understanding performance within a broader social and political context has increased, and with it, how that history is represented. In exhibitions and books on the subject, the photographic document is often used as an illustration of a performance, at times accompanied by associated set-designs, costumes and scripts. For Peggy Phelan, who believed that performance's 'only life is in the present', such remnants merely represented a poor imitation of an art form that was radical in its ephemerality and resistance to forms of commodification.[3] As many historians have noted, such a declaration ignores a number of elements that documentation can offer in the understanding and experience of performance: the intention of the artist who may conceive of documentation as part of the work, the reality that performance often becomes 'the material of its own documentation' and can subsequently be considered from an aesthetic point of view, and the contribution of the viewer or audience who witnesses and forms a memory of the event.[4] These are all concerns at play in the photographs of Shunk-Kender whose work, although familiar, has often been interpreted from the perspective of the artists that are depicted. Alice Maude-Roxby has highlighted that photographers in the darkroom can 'retrieve under-or-overexposed details which might be overlooked by technicians who were not present at the performance', which can subsequently affect the interpretation of a work in ways not anticipated by the artist.[5] By documenting such a diverse array of artists and events, Shunk-Kender provided a means to investigate the status of performance photography and the web of relations between subject, author, viewer and institution.

Throughout their career, Shunk-Kender approached performance in the same manner as their street photography. Working collaboratively, on the threshold between audience and performer, they presented multiple views of an action, and often manipulated their photographs in the darkroom, using cropping, dodging and blurring to draw out particular moments within a work. In one of the few contemporary commentaries on Shunk-Kender, their photographs are described as existing in 'the present tense, endowed as they are with a sort of freshness which never gives the impression of being an "historic document"'.[6] This suggestion of immediacy, and of a potential 'futurity' to be found in the photograph, can be related to José Esteban Muñoz's assertion that performance 'in its incompleteness, lingers and persists', is never completely settled or known, and in the process 'serves as a conduit for knowing and feeling other people'.[7] It is this connection to the social space of performance that offers a window through which to view Shunk-Kender's practice.

## NEW REALISMS, PARIS: 1957–67

Shunk-Kender began their careers in postwar Paris, where they were both émigrés from their homeland. Harry Shunk (originally Schunke) was born on 4 October 1924 in Reudnitz, Germany. Upon the outbreak of the Second World War he was conscripted, aged fifteen, and by 1946 was living as a prisoner of war at Chilbrook Farm, Cobham, in England. János (also known as Jean) Kender, was born in Baja, Hungary, on 6 July 1937 and emigrated to Paris after the Hungarian Revolution against Soviet occupation in 1956. At around the same time, Shunk moved to Paris and for two years worked for the Austrian photographer Dora Kallmus (otherwise known as Madame D'Ora) who, although reputed for her elegant society and fashion portraits, was at this time documenting the slaughterhouses of Paris.[8] Kallmus praised Shunk for his sense of framing and provided him with two important pieces of advice: to find a collaborator; and to work with artists; because then, she explained, 'if you make a mistake, they might even find the result interesting'.[9] In 1957 Shunk met Kender, who at around this time enrolled at the Institut Français de Photographie. The two men soon embarked on a professional and romantic relationship, living together at 19 quai aux Fleurs, near to Notre Dame Cathedral. In the few anecdotal accounts of Shunk-Kender and their work, they appear as quiet characters who shot simultaneously using different cameras, each sometimes accidentally capturing the other in the frame.[10] Together they

documented the dynamism and 'performative' social conventions of modern Parisian life, including scenes of street performers, markets and the dynamism of underground jazz clubs. Through Shunk's close friendship with Dutch artist Dora Tuynman and her gallerist Iris Clert, the couple found a group of artists who were ready collaborators; these artists were expanding the limits of painting, sculpture and performance and would later collectively be known as the 'nouveau réalistes' or 'new realists'.[11] Yves Klein was a founding member of the group and became the photographers' first important subject, commissioning them to document him variously at home, performing judo, presenting lectures and exhibiting his monochrome canvases painted in his trademark 'International Klein Blue'.

In 1960 Klein asked Shunk-Kender to cover the first public demonstration of his experimental painting technique that involved using the bodies of naked women to apply paint to canvas and which he would call 'living paintbrushes'. At 10pm on 9 March at the Galerie internationale d'art contemporain on rue Saint Honoré, Paris, Klein presented *Anthropometries of the Blue Period*. Standing in a tuxedo, in front of a specially invited audience dressed in evening wear, Klein directed three nude female models as they casually applied blue paint to their bodies and pressed themselves against the paper that lined the wall and floor (pp.28, 30–3). The white flooring reminded Klein, an expert at judo, of the mats that he would perform the martial art upon (very often for a camera). For others, witnessing the creation of abstract painterly forms (albeit using women's bodies) would have recalled Hans Namuth's by then well-known photographs of Jackson Pollock dynamically dripping paint across his large floor-based canvases. By having this performance documented, Klein not only ensured that there was evidence that would outlive it, but also placed the act of making and the complete *mise-en-scène* of audience, model and orchestra (who played Klein's *Monotone Symphony*) at the forefront of the work. The private space of the artist's studio was transferred to the public sphere, in a gesture

that has been interpreted as having 'dramatically shifted the terms of the Pollockian performative toward the overtly theatrical, the aristocratic, and the ironic'.[12] Shunk-Kender's photographs therefore formed an important part in the interpretation of Klein's work. Across a series of images, the deep black tones of the silhouetted audience perfectly frame the bodies of the models, and subsequently, in the dark room, a series of crops of the same image transforms a passing moment into a monumental gesture. Shunk-Kender's use of two perspectives – from behind the audience and from the side of the 'stage' – provides not only a sense of the environment and atmosphere, but also locates performance as a form that exists between the gallery setting and the social fabric of life.[13]

For their next collaboration, Klein called upon Shunk-Kender to realise *Leap into the Void* 1960, a conceptual photograph that would be the most theatrical statement of his career (p.10). The sight of Klein fearlessly and elegantly 'flying' into the open sky has become synonymous with his work and while he did actually leap from the stone pillar of the wall outside 5 rue Gentil Bernard, in the quiet Parisian suburb of Fontenay-aux-Roses, there was originally a group of men on the ground holding a tarpaulin to break his fall. Using a photomontage technique,

YVES KLEIN, *ANTHROPOMETRIES OF THE BLUE PERIOD*, GALERIE INTERNATIONALE D'ART CONTEMPORAIN, PARIS, 1960. PHOTO: SHUNK-KENDER

own persona that has inevitably met with suspicion.[17] However, many historians have attempted to explain that such strategies were an attempt to destabilise notions of truth in the mass-produced photographic medium, and that the artist deflated 'the spectacle of the culture industry by staging an even greater hoax'.[18] Instead of forming an external critique on the rise of mass media in cultural life, *Leap into the Void* used the same medium to communicate an idea that reality, and also photography, is nothing more than a construction. Shunk-Kender's collaboration with Klein indicates an acute awareness of performance and the documentary photograph as forms that can never be completely known or stable.

The street scene or disused site frequently recurs throughout the photographs of Shunk-Kender. As a marker of the everyday environment, it provided the ideal backdrop for events (either by street or 'fine' artists) that sought to collapse divisions between subject, viewer and author, manifested in photographs that resisted providing a definitive viewpoint. The move from the enclosed sphere of the art gallery to the street was epitomised in Marta Minujín's first solo happening, *The Destruction.* On 6 June 1963 at 7pm, the artist dragged her box relief sculptures composed of discarded objects and mattresses that she had been exhibiting to the disused site of Impasse Ronsin in the Montparnasse area of Paris, released cages of rabbits and birds and then asked her friends to destroy her art.[19] In their photographs Shunk-Kender avoided using a single viewpoint to record the event and instead shot from multiple angles, photographing over the shoulders of people, and treating the architecture of the space as a provisional stage-set, complete with figures peering out of windows from near-by buildings, as though seated in a loge at the theatre (p.44–7). Shunk-Kender's images not only accurately document the chaos of the happening, but complement Minujín's desire to create an art form that was a 'way of intensifying life, of impacting the viewer, shaking up, removing [them] from inertia'.[20]

Shunk-Kender erased these figures in the darkroom to replace the lower half of the negative with an unremarkable street scene. Drawing upon a reproduction of the sixteenth-century painting attributed to Pieter Bruegel, *Landscape with the Fall of Icarus*, which depicts figures oblivious to the demise of the mythic figure, Shunk suggested including an image of a solitary cyclist (who may have been Kender) and a speeding train in the final montage, to emphasise the extraordinary nature of Klein's leap.[14] To create a steady and consistent record of the two scenarios, Shunk used a Rolleiflex camera positioned on a tripod, while Kender (who can be seen in the lower left corner of the original photograph) documented Klein's descent using a 35mm Leica with a telephoto lens that served an evidentiary function closer to their previous photographs of performance (p.13).[15] This blurring of reality and fantasy was reiterated by Klein initially publishing the image in his own newspaper that he distributed to newsstands and at a press conference on 27 November 1960; and then later reproducing another version without the bicyclist for an exhibition catalogue (frontispiece and p.12).[16] Klein asked Shunk-Kender never to discuss how the image was created and it was this apparent desire to conflate transcendent ideology with the cultivation of his

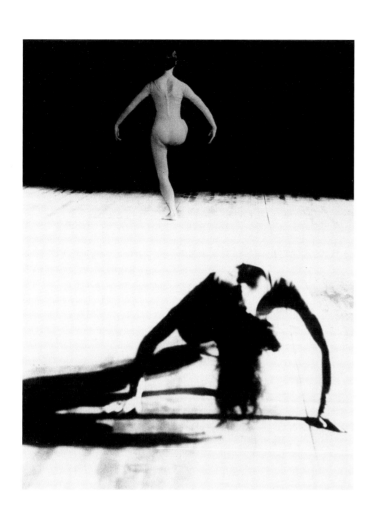

When Shunk-Kender worked inside a traditional performance venue like the Théâtre de l'est Parisien, their approach changed completely. In their photographs of a presentation of Merce Cunningham's ballets *Nocturnes* (1956), *Crises* (1960) and *Aeon* (1961) on 12 June 1964, the audiences and theatre architecture are omitted altogether. Instead, Shunk-Kender used the carefully poised and rehearsed gestures of the dancers to create a series of striking, poetic images (p.62). In many of the pieces the choreography had the dancers follow separate lines that at times intercepted to form duets and group compositions, which created a dynamism akin to Shunk-Kender's collaborative technique.[21] In a similar manner to their photographs of Klein's *Anthropometries* performance, they framed the event from two angles: one displaying a theatrical, frontal representation of the dance, with the bodies forming graphic lines against a pitch-black background; the other an intimate side-view from the wings that emphasises the dramatic lighting design by artist Robert Rauschenberg. This approach, combined with their extensive use of tonal gradation and empty space, served to complement Cunningham's own rejection of a classical conception of the stage that had been centred around perspective, in favour of one informed by the abstraction and chance procedures of modern painting.[22] In tune with Cunningham's ideas, Shunk-Kender escaped the restrictions of straightforward documentation, and later presented an alternate form of reality by developing the images into abstractions that blurred the dancers' bodies into each other to create forms that exist in a transitory liminal space (p.63).

## NEW YORK: 1967–71

In 1967 János Kender and Harry Shunk accompanied their good friend Niki de Saint Phalle and her partner Jean Tinguely to Montreal's World Fair, and afterwards settled in New York. In a city thriving with experimental activity, they immersed themselves in a new community of artists. Having photographed Andy Warhol during his trips to Paris in 1964 and 1965, they ended up working for his magazine *Interview*, which used an informal interview style and large-format photography to present portraits of superstars from Hollywood and Warhol's studio The Factory. The performative possibility to be found in the everyday actions of people reflected a recognition at the time that the personal could be political. In an era of civil rights movements and demonstrations against the Vietnam War, the personal gained a greater visibility that influenced a number of artists, notably Yayoi Kusama. In the midst of the presidential campaign in 1968, Kusama staged her own form of political protest on the Brooklyn Bridge and in the series *Anatomic Explosions*, performed outside the United Nations and on Wall Street, where (accompanied by a lawyer) a small group of men and women stripped and danced, while a clothed Kusama painted their bodies with her trademark polka dot motif. Shunk-Kender's photographs of the events are suggestive of an impulsive, fleeting moment, reiterated by the expressions of passers-by, but their proximity to the action and, at times, careful compositions of figures posing for the camera, direct our attention to the fact that these were performances conceived to be documented and publicised (pp.52–5). Kusama was well known in the art world for using photography to promote her projects and artistic persona, which led to many interpreting her *Explosions*

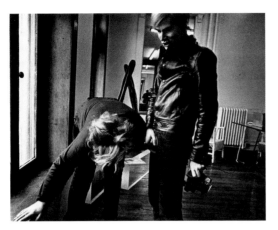

**218**

as another example of self-marketing. However, as Mignon Nixon has noted, in Kusama's use of naked bodies from 'New York's bohemia', and the writing of press releases that declared, 'The money made with this stock is enabling the war to continue … We protest this cruel, greedy instrument of the war establishment', she was making explicit a connection between desire, war and profit.[23] For Kusama, the documentary photograph was a means to transmit her message, stating that 'Publicity is critical to my work because it offers the best way of communicating with large numbers of people.'[24]

The documentary form has been described as 'half visual, half vocal … inquisitive and explanatory, it participates in the exchange of things but also freezes the relations between them within visual and conceptual still images', and it is this quality that Shunk-Kender effectively deployed in their work on the project *Pier 18*.[25] In 1971, the curator Willoughby Sharp invited twenty-seven male artists, including Vito Acconci, John Baldessari and Gordon Matta-Clark, to conceive a performance work to take place on pier 18 in downtown New York that would be exclusively documented by Shunk-Kender. As a deserted, post-industrial site, which had become known as a gay cruising spot and straddled the periphery of a rapidly changing city, the pier embodied a notion of in-between-ness that can be found throughout Shunk-Kender's practice. *Pier 18* provided the duo with the opportunity to use a range of photographic techniques that combined forms of performance documentation with objective, abstract representations of the pier. One of the most interesting iterations was Dan Graham's proposal, which he described as a 'spin-off' from his work *Body Press*.[26] Standing at the end of the pier, Graham placed the viewfinder of a camera against his body, and as he gradually moved it from his feet to his forehead, he took photos of the surrounding cityscape, including the construction of the World Trade Center's twin towers. At the same time, Shunk-Kender photographed Graham within the landscape of the pier, and then progressively moved around and closer to him

as his camera travelled skyward. Shunk-Kender's carefully framed images provide a panorama of the city, while Graham's embrace of an anti-aesthetic associated with accidental photography reduces the pier to abstract forms and lines (pp.56–7). When brought together – the documentation of the action and the performative photographing of the area – the work makes explicit the complicated relationship between photography and performance-related art. The significance of the project was instantly recognised by Kynaston McShine who, a few months after the photographs were developed, curated the exhibition *Projects: Pier 18* at the Museum of Modern Art, New York, with Jennifer Lich. All of the artists' actions were exhibited in a minimal display that consisted of rows of photographs hung across the gallery wall alongside each artist's statement of intent (which were photographed by Shunk-Kender). By presenting the bare 'facts' of performance, the exhibition ironically shifted attention towards the aesthetic decisions taken by the photographers. Described as 'the richest, most clearly defined and most meaningful show of conceptual art I have ever had the pleasure of seeing', it was to be the most explicit recognition of Shunk-Kender's practice during their lifetime.[27]

## COULISSE

Navigating the pathways between artwork, performance, street-scene and portrait, Shunk-Kender documented an astonishing variety of events that chronicle an important moment in art history, seen through their lives together. It was an intimate collaboration that reached its end in September 1973, when Harry Shunk and János Kender split professionally and personally, leaving the former with full control of their archive and copyright. They never worked together again. Kender went on to marry and have a child, only to leave the family in the late 1970s; he passed away in a hospice in Palm Beach, Florida in 2009. Shunk continued to work in the art world, often using the camera in a similar mode to many of the earlier projects. In 1977 he documented Eleanor Antin's performance *The Angel of Mercy* at the uptown M.L.D'Arc Gallery, which accompanied her exhibition of prints that imitated

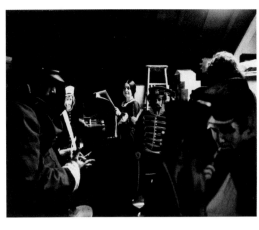

nineteenth-century photography and cast her as a Florence Nightingale figure tending to the wounded.[28] Despite now working alone, Harry Shunk continued to document the performance in an open-ended manner by moving around the gallery setting and capturing the moments before, during and after the performance (pp.50–1). Antin recalled Shunk comforting her before the audience arrived by taking a photograph as she read a newspaper, and that he 'liked to wander around on the periphery of things, silently choosing his shots'.[29] The final images effectively coalesce the relationship between theatre, authenticity and photography, and the intimate exchange between subject and author.

By the late 1980s and into the 1990s, Shunk mainly worked on fashion and advertising projects, and later became a recluse. Although Shunk-Kender's photographs were included in publications and exhibitions on the artists whose work they featured, Shunk appeared to have had little interest in promoting or selling his work. Upon his death on 26 June 2006, Shunk's New York apartment was found to be full of negatives, photographs, paintings and papers. The collection was saved in 2008 by the Roy Lichtenstein Foundation, which purchased the entire archive from the state of New York and later donated it jointly to the Getty Research Institute, Los Angeles, California; MoMA, New York; National Gallery of Art, Washington DC; Centre Pompidou, Paris, and Tate, London.

Viewing the vast collection of prints, transferred from the private space of a home to the archives of the museum, one is made aware of the specific formal and conceptual choices made by Shunk-Kender in order to draw out the essence of a performance. Those photographs, of which many have only been known in isolation in an exhibition vitrine or book, can now be seen as part of an open-ended series. They are a reminder of the collaborative, porous and temporal nature of performance that, like the photographers, can never be truly known or assimilated. From the streets of postwar Europe, at exhibition openings

and performances, and across to the piers of New York, the photographs of János Kender and Harry Shunk provide a context and form with which to understand performance that is embodied in an early photograph of the couple (p.220). Standing upright by a window, divided by the frame, the public street at night reflected in the glass and their private studio illuminated beyond, the image is evocative of their approach to photography and performance as a sense of being caught between absence and presence, between fantasy and reality, between you and me.

**219**

## NOTES

Many thanks are due to Iggy Cortez for reading an earlier draft of this essay and providing useful reference points.

1   J.G. Ballard to Travis Elborough, 'Reality Is a Stage Set', interview published in *The Drowned World*, 1962, revised edn, London 2006, p.5.
2   The earliest-known example of Shunk-Kender's collaboration can be found in their prints of the World's Expo 58 in Brussels, the back of which have a stamp listing their dual identity. From here on, I will refer to all projects that they worked on together under this name.
3   Peggy Phelan, 'The Ontology of Performance: Representation without Reproduction', in *Unmarked*, New York and London 1996, p.146.
4   Barbara Clausen, 'Performing Histories: Why the Point Is Not to Make a Point …', *Afterall*, no.23, Spring 2010. For more on the interpretation of performance documentation, please see Amelia Jones, '"Presence" in Absentia: Experiencing Performance as Documentation', *Art Journal*, vol.56, no.4, Winter 1997, pp.11–18; Philip Auslander, 'The Performativity of Performance Documentation', *PAJ: A Journal of Performance and Art* (PAJ84), vol.28, no.3, September 2006, pp.1–10; Alice Maude-Roxby, *Live Art on Camera*, exh. cat., John Hansard Gallery, Southampton 2007.
5   Alice Maude-Roxby, 'The Delicate Art of Documenting Performances', in *Art, Lies and Videotape: Exposing Performance*, exh. cat., Tate Liverpool 2003, p.70.
6   Claude Fournet, in *Harry Shunk – Projects: Pier 18*, exh. cat., Musée

d'Art Moderne d'Art Contemporain, Nice 1992, p.9.

7   José Esteban Muñoz, *Cruising Utopia: The Then and There of Queer Futurity*, New York 2009, pp.99–113.

8   Harry Shunk, in *Harry Shunk – Projects: Pier 18*, 1992, p.14.

9   Ibid.

10  Many thanks are due to Justin Brancato, archivist at the Roy Lichtenstein Foundation, for supplying a great deal of information on the lives of Shunk-Kender and their archive.

11  The nouveau réalistes were a loose group of artists based in Paris, who rejected the dominance of abstract expressionist and *art informel* painting in favour of a broader conception of art that often incorporated media from everyday life to create 'new perceptual approaches of the real'. The term was coined by the art critic Pierre Restany and officially inaugurated, and documented by Shunk-Kender, on 27 October 1960 in Yves Klein's apartment with a declaration that was signed by Restany, Arman, François Dufréne, Raymond Hains, Yves Klein, Martial Raysse, Daniel Spoerri, Jean Tinguely, and Jacques Villeglé. However, by the following year, many of the artists, including Klein, distanced themselves from the term, partly due to Restany's over-determined interpretation of their work.

12  Amelia Jones, *Body Art*, Minneapolis 1998, p.86.

13  Jonah Westerman's concept of performance as an 'inframedium' that brings together the realms of art and life has been a very useful frame of reference for this essay. See Westerman, 'Between Action and Image: Performance as "Inframedium"', *Tate Blog*, 20 January 2015, http://www.tate.org.uk/context-comment/articles/between-action-and-image-performance, accessed 2 August 2015.

14  Harry Shunk to Sidra Stich, 12 April 1991 and 20 August 1993, in Stich, *Yves Klein*, exh. cat., Hayward Gallery, London 1995, p.274, n.33.

15  Nan Rosenthal, 'Assisted Levitation: The Art of Yves Klein', *Yves Klein 1928–1962: A Retrospective*, exh. cat., Institute for the Arts, Houston 1982, p.127.

16  Harry Shunk stated to Sidra Stich that Klein drove with Shunk and a young Hans Haacke in the car to deliver the paper, which was 'on

SHUNK-KENDER, *HARRY SHUNK AND JÁNOS KENDER (SELF-PORTRAIT), PARIS*
1960s

display at only three newsstands and very few people responded
to it'; interview 10 September 1991, in Stich, *Yves Klein*, exh,cat.,
Hayward Gallery, London 1995, p.273.

17   Sacha Craddock, 'How I Caught a Falling Star', *Times*, 7 February
1995, p.31, in Mia Fineman, *Faking It: Manipulated Photography Before
Photoshop*, exh.cat. Metropolitan Museum of Art, New York 2012,
p.183.

18   Yve-Alain Bois, 'Klein's Relevance for Today', *October*, no.119, Winter
2007, p.93. For another productive analysis of Klein's work in relation
to media and performativity, see Kaira M. Cabañas, *The Myth of
Nouveau Réalisme: Art and the Performative in Postwar France*, London
2013.

19   The happening was the culmination of a week-long exhibition in
Minujín's studio, 30 May–6 June 1963, that included her cardboard and
mattress sculptures alongside works by Portuguese Lourdes Castro
and Venezuelan Alejandro Otero. The site was next to the studios
of Niki de Saint Phalle, Jean Tinguely and Larry Rivers. An extensive
description is included in *Marta Minujín: Obras 1959–1986*, exh. cat.,
Malba – Fundación Costantini, Beunos Aires 2010, p.253.

20   Marta Minujín, handwritten note, in ibid., p.241.

21   Merce Cunningham and David Vaughan, *Merce Cunningham: Fifty
Years*, New York 1997, pp.92–6.

22   Merce Cunningham, *The Dancer and the Dance: Merce Cunningham in
Conversation with Jacqueline Lesschaeve*, New York 1985, pp.17–18.

23   For more on Kusama and the political significance of her work, see
Mignon Nixon, 'Infinity Politics', in Frances Morris (ed.), *Yayoi Kusama*,
exh. cat., Tate Modern, London 2011; and Mignon Nixon, 'Anatomic
Explosion on Wall Street', *October*, vol.142, Fall 2012, pp.3–25.

24   Kusama, quoted in Alex Munroe, 'Obsession, Fantasy and Outrage:
The Art of Yayoi Kusama', in Bhupendra Karia (ed.), *Yayoi Kusama: A
Retrospective*, exh. cat., Center for Contemporary Arts, New York
1989, p.30.

25   Hito Steyerl, 'The Language of Things', *no-w-here*, 2006, http://no-w-
here.org.uk/thelanguageofthings.pdf, accessed 2 August 2015.

26   Dan Graham's *Body Press* 1970–2 featured a man and woman, both
naked, entering a mirrored cylindrical space and holding a Super8 film

camera to their skin, which they slowly circle around their bodies.
Graham now considers his contribution to the Pier 18 project an
oversimplification of *Body Press* (email conversation between the
author and Graham's representative, 2 October 2015).

27   Alfred Frankenstein in the *San Francisco Chronicle*, 4 July 1971,
p.30; quoted in Lynne Cooke, *Mixed Use, Manhattan*, Cambridge,
Massachusetts and London 2010, p.40.

28   *The Angel of Mercy* performance took the form of a two-act play, with
Antin performing the role of 'the Nurse', and using life-size cut-outs
on wheeled bases for the other characters, to 'tell the story of a
depraved capitalist aristocracy fighting an idiotic war with the lower
classes as their disposable toys'. Email conversation with the author,
27 October 2015.

29   'So I'm trying to read the Times, trying to cool out, trying not to cry.
I never felt so alone and unloved … I remember hearing a noise and
looking up. Harry Shunk had come in and was snapping my picture. I
was so happy to see him, I felt like kissing him. ''Well, Harry,'' I greeted
him, ''you're here, anyway.'' Then I heard sounds coming from the
gallery … The sounds got louder. There were voices. I peeked out.
They were still coming through the door. Crowds of them. I started
to cry … Harry gave me a victory sign and slipped out to get a seat.
Then I felt sick to my stomach. Stage fright.' Eleanor Antin, 'Stage
Fright', *Art in America*, no.9, October 2012, p.69.

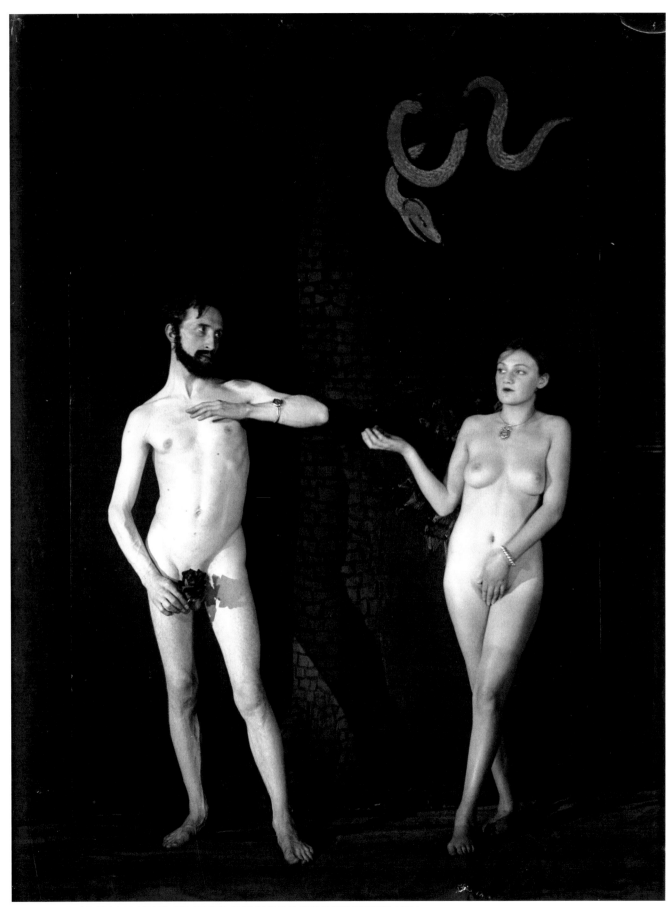

**MAN RAY** / *CINÉ-SKETCH: ADAM AND EVE (MARCEL DUCHAMP AND BRONIA PERLMUTTER)* / 1924

# Original Sin: Performance, Photography and Self-Knowledge

JONAH WESTERMAN

*Performing for the Camera* poses a question of origins. Usually, we think of photography as something that 'captures' or 'documents' a performance, that the relationship between the two entails a simple and sequential progression. Some kind of action happens, and an image is made of that activity. From this perspective, a performance and its photographic registration sit snugly on either side of a temporal and ontological divide: the live act on one side; its representation on the other. The prepositional phrase in the title, however, suggests another angle of approach. What is it to perform *for* the camera? And does thinking about performance and its 'documents' in these terms – with the camera placed on the seam between action and image – suggest an alternate origin, a different sequence of events? To foreground the role of the camera in performance is to reconceive not only the relationship between performance and photography, but also the nature and source of creativity itself.

Man Ray's photograph *Ciné-Sketch: Adam and Eve (Marcel Duchamp and Bronia Perlmutter)* 1924 stages this concern about origins front and centre. Its subjects, Duchamp and Perlmutter, pose as Creation's first couple at the moment of their fall from Grace into knowledge and mortality. The scene depicted approaches the beginning of human life, the Original Sin, with a wink. For this image of the beginning of history opens onto a palimpsest of accreted quotations. The source material, of course, is the book of Genesis; the photograph is a visual recapitulation of a textual representation. Further, the models have borrowed their own physical attitudes from an earlier pictorial rendering of the same story, Lucas Cranach the Elder's painting, *Adam and Eve* 1528. The state of nature, then, appears as a cultural artefact, a production of human artistry.

Such ironic commentary on naturalness could well be expected from any collaboration involving dada's dynamic duo. By 1924, Man Ray had harnessed photography's ability to produce images that did not automatically copy from nature

**224** by transcribing it, but produced whole new (fictive) realities. He had created abstract images from objects pressed against photosensitive paper, turned model Kiki de Montparnasse into a violin by painting on a print and re-photographing it (*Le Violon d'Ingres* 1924), and transformed the Marquise Casati into a four-eyed spectral gorgon (*Marquise Casati* 1924), to name but a few examples. And Duchamp had pioneered the readymade during the second decade of the twentieth century, skewering art's most sacred notions of originality, authorship, and technical quality, demonstrating the institutionally constructed, contingent nature of art itself in the process. The two of them together had even created a person *ex nihilo* – Duchamp's alter-ego, Rrose Sélavy – in a series of portraits from 1921 (pp.120, 124–5). Iterative processes of doubling, reframing, quotation and polysemy were key tactics for these artists, and mounting a tongue-in-cheek assault on an *ur*-text of western civilisation would seem only par for the course.

Approaching the subject of Eden, however, offered the opportunity for a focused engagement with the importance of cultural forms in the production of self-knowledge – not only how we come to know who we are through the ways we externalise ourselves in our environment, but also what significance such representations portend. While Man Ray made the photograph, and Duchamp played the role of the first man, the performance itself was conceived by neither. An announcement for *Ciné-Sketch* that appeared in the newspaper *Le Figaro* on 28 December 1924, describes it as a 'revue', a variety show, to be performed in Paris on one night only (31 December) at the Théatre des Champs-Elysées, organised and scripted by Francis Picabia, and directed by René Clair.[1] The *tableau vivant* that featured Duchamp and Perlmutter as Adam and Eve was only one among many scenes that comprised the show. Man Ray took the snapshot during a rehearsal; as he recalled in his memoir, *Self Portrait*, 'One would have liked to see a more prolonged vision of the tableau.'[2] It is tempting to assume that Man Ray's desire to freeze the fleeting moment for subsequent inspection would stem from his habitual vocation, that it would naturally occur to a photographer to make a photograph. Yet it is more accurate to say that *Ciné-Sketch* demanded this kind of attention from all its viewers. It wanted to be seen photographically – as though it were somehow intrinsically *for* or *of* the camera – and could only be fully appreciated as a process of mechanical replication and observation from a mediated remove.

*Ciné-Sketch* positioned itself as hybrid production, reversing the ordinary temporality of mechanical vision: rather than using the camera to capture and represent life, it offered a live theatrical presentation designed as though it were a film. In relating how he wanted to prolong the image's duration, Man Ray described its initial appearance during the performance in terms redolent of the experience of seeing a movie: 'the theater was in complete darkness, then a few flashes gave one the impression that he saw a living tableau of Adam and Eve in the garden of Eden'.[3] The staging itself sought the look of a sequence of still film frames given motion by the projection of light.

In this way, *Ciné-Sketch* – in both its guises as photographed performance and performed photograph – can be seen as a condensation of fraught contemporaneous debates about the futures of theatre and dance in relation to the burgeoning fields of technical, mechanical arts in the early twentieth century. During the same week in which *Ciné-Sketch* took the stage, the Théatre des Champs-Elysées also featured another Picabia–Clair production, this one a ballet entitled *Relâche*, designed and performed in concert with the Ballets Suédois. According to performance historian Felicia McCarren, the dance company, headed by impresario Rolf de Maré and lead dancer and choreographer Jean Börlin, took formal 'collaboration with the cinema' to unprecedented levels, even to the point of the 'erasure of dancers'.[4] This manifested itself in what McCarren calls an 'emphasis on the pictorial … The absorption of dancers

into sets and costumes, into full-scale stage-pictures'. She asserts that the aim of this subsumption of individual bodies to collective, scenographic tableaux was that 'cinematic references and cinematic form facilitated the staging of ballets of technological modernity'.[5] Dance, according to the Ballets Suédois, would have to adapt to the changing media ecology of modern life in order to stay relevant.

It is worth noting, moreover, that the spectre of dancers' erasure at the hands of technological advance similarly rears its mediated regard in Shunk-Kender's solarised pictures of Merce Cunningham dancers from 1964–6 (p.63). In these images, photographic process winnows bodies and blurs their borders, echoing the fully mediated choreographies they enacted. Describing the singular level of intermediality Cunningham sought in works like *Variations V* 1965, theatre historian Roger Copeland writes, 'the dancers moved through a series of electromagnetic fields, triggering bleeps and blurts of electronic sound as they darted in and around antennae-like poles'.[6] Provocatively, Copeland asserts that such commingling of the electronic and organic, coupled with the use of projections by Stan VanDerBeek and video by Nam June Paik made such works by Cunningham 'utterly unlike the garden variety (the ''got-to-get-ourselves-*back*-to-the-Garden'' variety) multimedia … of the period'.[7]

In *Relâche*, however, the mediated body appeared less as a generative method for performance than a precarious organism under existential threat. The ballet took its title at least in part from this anxiety – 'relâche' translates roughly to 'theatre closed' or 'no performance today'. Its combination of devices and innovations, designed in concert with those dada *aides-de-camp* Picabia and Clair, represented the Ballets Suédois's most radical attempt at intermedial integration and reconciliation; also, in a poetic and unintentional historical flourish, its last. The stage set mimicked a cinematic palette, rendered in colours ranging only from black to white.[8] But more than this, the ballet included in

its composition a film in two parts. Directed by Clair, *Entr'Acte* ('Intermission'), served as both prologue and intermission. The first part of the film, roughly two minutes long, features a seemingly autonomous cannon, spinning and rolling across a Paris rooftop as though suddenly sentient and running amok. This stop-motion animation comes to a halt as Picabia and Erik Satie (who provided the music for both *Relâche* and *Entr'Acte*) bound into the frame in slow motion, before loading the cannon. The prologue ends with the camera looking down the barrel; the round emerges from the depths as though being fired at us, the watching audience. This machine threatens the viewer with annihilation, just as mechanical vision menaces theatre. The film visualises the potential erasure of dance, dancers and the audience, and thus enunciates the stakes of the entire production.

The second part of the film, which ran during the 'intermission' for about eighteen minutes, further elaborates this relationship between automation and human disappearance. Near the start of the film, Picabia shoots and kills Börlin (the ballet's lead dancer). Picabia sports the urban uniform of suit and tie while Börlin is kitted out in traditional Alpine dress; on being shot, Börlin plummets from an urban rooftop into a hearse waiting on the street below. Modernity extinguishes tradition; this is only the chronicle of a death foretold. Mourners follow Börlin's hearse, their own movements strangely attenuated by mechanical artifice. Leaping in slow motion, their funeral procession looks to contemporary eyes more like astronauts bounding across the surface of the moon – gravity appears to have lost its grip. The hearse then careers out of control and races through the streets among speeding automobiles and cyclists, its inexorable progress portrayed by shots of its rapidly turning wheels intercut with footage filmed from the front seat of a rollercoaster. The coffin spills from the back of the carriage and rolls into a field – we have left the urban landscape and returned to a 'natural' one. The lid rattles; Börlin emerges not just unharmed, but revivified, resurrected. He holds a magic wand, which he points

first at the coffin, then at the mourners, and, finally, at himself to make everything and everyone disappear. The wheel of life and death keeps spinning in the last frames as Börlin bursts through a paper screen announcing the film's *'Fin'* ('End'), only to be sent back through as the sequence runs in reverse, the end reinstated before a final fade to black.

Death, resurrection, and disappearance – depicted with what were at the time cutting-edge film techniques – demonstrate over and again how the camera, as the alienated power of human vision and artistry, both kills and creates. It is the automaton cannon that assaults the audience; this overture prefigures how Picabia's modernist rifle will fell the pastoral Börlin. Yet it is also the uncontrolled speed of a horseless carriage that resurrects Börlin; and when he awakes, he is forever changed. He is reborn invested with the camera's power to reshape the human figure, even to make it disappear. Is he still human? Is it really Börlin at all? Or has he been made to disappear himself, his naturalness replaced with, or annihilated by, a new knowledge of cultural artifice and the power technology exerts over both him and the world at large? Is the technological subject any longer human, or have we long ago left nature and our essential selves behind?

These are the questions condensed in *Ciné-Sketch*, and especially by Man Ray's gesture of photographing the tableau of Adam and Eve in order to prolong its duration. The story of Adam and Eve's expulsion from Eden centres on the transformative power of rationality, just as does *Entr'Acte*. In the latter parable, however, rather than being seduced by knowledge, Börlin's character, along with the audience, is assaulted by it. Or, as Walter Benjamin put it, 'art of the Dadaists became an instrument of ballistics. It hit the spectator like a bullet'.[9] The knowledge transmitted along that ballistic arc was that the world had already been seduced by its own investments in reason, that technology had already transformed life. We had long ago committed the Original Sin of falling in love with our own rationality and,

like a disappearing dancer or a closed theatre, whatever now constituted our creative capacities would comprise a collaboration between ourselves and the seemingly alienated products of our intellect. *Ciné-Sketch*, then, appears as both a wishful intervention and a knowing commentary. It is a fantasy of freezing the moment before Adam and Eve eat the fruit of the tree of knowledge, of repeating it indefinitely (as a photographic performance) or suspending it in time (as a performed photograph); but such a gesture is only imaginable in hindsight, from the standpoint of reasoned reflection and only rendered sensible by its continued exercise.

By reaching back to the metaphorical beginning of human history in this way, *Ciné-Sketch* suggests a paradox. We are only able to see what makes us human insofar as we can escape it, insofar as we can see it as though from the outside, from some place beyond ourselves. This, of course, is the fate that befalls Adam and Eve – their acceding to knowledge results in judgment from on high. At the same time, however, this drive to self-knowledge (from an exteriorised position) is what makes us human and what makes art possible. The 'sin' is original because it is the beginning of the human condition, not the end. If we are changing somehow, the only way we can come to know it is through a representation of that process – whether it's a film about ballet, or a ballet about film – and, in the end, we find ourselves back in nature, though what it means and what we can do there have been altered by the process of our arrival. The notion of technology advanced here is not one of a degradation of experience or a threat to embodied, natural reality, but rather an admixture of the two that yields a dialectically consummated, newly articulated form of life.

When it comes to the question of performance's relation to photography, of the human body to its mediated representation, this dada take on Edenic logic suggests that we misapprehend when we posit an original state that precedes the camera and a

corrupted copy that issues from it. Neither should we conceive of photography as serving a mere evidentiary role in 'documenting' that something has taken place, as this entails the same temporality and presumption of degradation: a reality transmuted into representation, a plenitude rendered partial. Rather than this kind of rupture, the photographic activity of performance creates continuity. Man Ray's *Ciné-Sketch* amplifies what was already at stake in the performance, creating another situation in which the human activity of self-examination comes into focus. Each version, albeit in its own way, offers the opportunity to reflect on the nature of human creativity as though from the outside. In that interaction of artwork and viewer, in the exercise of observation and judgment, subjectivity is not mirrored, captured or documented, but enacted as a process. That is, the photograph is not an object of knowledge (i.e. a witness to an extant state of affairs), but a catalyst for the production of self-knowledge.

The photograph's role as the beginning of a process of reflection and, therefore, a spur to self-knowledge, obtains equally across the works included here (not just those explicitly concerned with mechanisation or technological vision). This mode of analysis is especially instructive in describing the many works that feature repetitive practices of 'self'-portraiture. The works by Nadar, from relatively early in the history of photography, participated in a complex economy of self-fashioning. Far from offering keepsakes or sentimental *aides-mémoires* to his subjects, Nadar sold social and spiritual aspirations. Historian of photography Elizabeth Anne McCauley has written at length about how Nadar eschewed usual conventions of dress, set design and lighting, positioning 'the sitter outside bourgeois society and canons of proper ("idealizing") portraiture'.[10] Nadar's direct lighting could be harsh, and his penchant for tumbling folds of velvet precluded sitters from showing off fancy clothes or posing with the tools of their trade (in the style of more conventional portrait photography, and of painting beforehand), but he offered membership of a cultural elite, the chance to see oneself as a

Bohemian hero possessed of a rich inner life.[11] As such, careful brand management was central to Nadar's strategies. McCauley writes, 'Whereas other studios assiduously courted theatrical personalities for celebrity cartes, Nadar invited only a few members of the Comédie Française and the Opéra.'[12] The images Nadar made of actress Sarah Bernhardt or Jean-Charles Duburau as the mime Pierrot – both fixtures of the nineteenth-century Parisian A-list – contributed to his studio's aura of exclusivity (pp.19, 68–9, 70, 72–5). Getting one's photograph taken by Nadar was to breathe the rarified air of cultural greatness, to become the image one had consumed and participate in its elaboration. Further, historian Geoffrey Batchen has pointed out that people could and did place these celebrity images in personal photo albums alongside their own likenesses, concretising these conceptual links of filiation.[13] Nadar's photographs pointed toward a cultural ideal, and, as objects bound for domestic consumption, authorised new modes of self-construction.

This notion that one's innermost self somehow resides in or stems from participation in widely circulated social codes and conventions has always been a subject of photographic investigation (as well as exploitation). Over a hundred years after Nadar bent the camera's capacity for direct and automatic transcription to the production of personal and epochal mythologies, Cindy Sherman made such machinations the self-conscious subject of her work. Her series of *Untitled Film Stills*, made between 1977 and 1980, only comprise self-portraits in the most oblique sense (pp.130–1). She is the sitter in each of these, and has designed the look of every photograph exactingly. She appears, however, only in order to encapsulate and recreate a stereotypical role, a 'type' of woman circulated through mass-mediated representations. As critic Craig Owens puts it, 'Sherman's women are not women but images of women, specular models of femininity projected by the media to encourage imitation, identification; they are, in other words, tropes, figures.'[14] While Sherman is in these pictures, she is also not really there.

**228** The cultural ideal of personhood (that photographic branding operation) operates in these images not as a co-authored, constructive fantasy, but as a regulating inscription impressed without permission.

This is the usual way we have come to see Sherman's non-self-portraits: hegemonic representations threaten the living individual with erasure; Sherman disappears into the two-dimensional mesh of her black, white and silver doll's house, endlessly replicated but ever elusive. In Owens's words, 'disguise functions as parody; it works to expose the identification of the self with an image as its dispossession'.[15] For Owens, Sherman (as subject) precedes Sherman (as image). This sequential temporality – in which there is first a self that can then be dispossessed – however, falls into the trap of the Original Sin. It misses how it is the act of copying the copy that creates a kind of minimal distance between social stereotype and authorial consciousness. That is, to the extent that Sherman appears at all in these photographs, it is in her will to replicate, to assert herself in the seam between action and image. The photographic gesture freezes and isolates the moment of mediated becoming and cultural inscription, making possible and palpable the difference between an individual person and an ideological vision of one. Sherman repeatedly drives a wedge between a signifying surface and its presumed signified depth, between image and subject, and every insistent schism announces: I am not here; therefore, I am. Only in that activity, in that enunciation, does the person Cindy Sherman appear. In this way, the *Untitled Film Stills* and Martin Parr's *Autoportrait* series 1996–2005 (pp.182–3) occupy two sides of the same coin. Every one of the fifty-seven portraits of Parr (taken at different portrait studios all over the world) delivers a different vision of this same person. Teleported by green screens, supported by props, or zealously 'retouched', Parr is subjected to a catalogue of millennial photographic effects from each of these 'vernacular' portraits to the next. Yet he is always there, looking very much like himself. Rather than disappearing into photographic processes

of reproduction (and negatively asserting himself as a present absence – or absent presence), Parr emerges from the aggregate of these disparate images, as what persists across them. No matter where he goes, there he is.

Adrian Piper's series *Food for the Spirit* 1971 elevates this repetitive action of making a photograph (as a way to both conjure and affirm personhood) into a life-sustaining ritual (pp.172–3). Piper made these photographs during a period of intensive study of Immanuel Kant's *Critique of Pure Reason* of 1781. In a reflection written ten years after she produced the series, Piper describes how her immersion in the life of the mind was so complete that she worried she 'was on the verge of abdicating [her] individual self on every level'.[16] The photographs were an attempt to stave off her growing sense of disconnection from the physical world, which was exacerbated, according to her, by a coincident 'two-month juice-and-water fast'.[17] She worried she was disappearing.

As she puts it, 'To anchor myself in the physical world, I ritualised my frequent contacts with the physical appearance of myself in the mirror'. Driven to her reflection to 'make sure [she] was still there', she would also take a photograph to 'record [her] physical appearance objectively'.[18] Tempting though it might be to see here the evidentiary role of the image, that the photograph simply captures and proves the shape of reality, the series – as a ritual performance – bears out the same logic as the dada works described above. Taken repeatedly and from belly-button perspective, the images not only show Piper (to herself and to us) but enact the desire to see from a perspective not her own – no longer God's omniscient vertical gaze, but the Brownie camera's disembodied horizontal one. By then encountering this other vantage onto herself from her own perspective, as an object of continued contemplation, Piper could be satisfied that she did indeed still exist. Her subjective persistence, her sense that she was 'still there', stemmed from the collision of these perspectives – that is, her own process of making sense of the notionally objective, alienated image.

That Piper would have hit on this particular solution to the existential anxieties produced by her reading *The Critique of Pure Reason* attests to how deeply engaged with Kant's thought she must have been, and not just because of the strength of her reaction. Five years after the *Critique* was published, Kant wrote an essay entitled 'Conjectural Beginning of Human History', which offers a retelling of the story of Eden and the fall from Grace. In his version, neither God nor the Devil appears as dramatis personae; there is only the human discovery of reason and its consequences. In Kant's account, the apple represents a new experience in analogical thinking: 'Perhaps it was only a fruit, the sight of which invited [one], through its similarity with other agreeable fruits … already tasted, to experiment'.[19] Such a thought experiment, provoked by and exteriorised in the figure of this enticing fruit, seeded profound revelations. Adam and Eve became aware that their actions could be the result of contemplation and choice.

From then on, human history would be defined by this constant crushing freedom, by having to imagine what others might do in our shoes and vice versa. The moment of self-recognition, achieved through the externalised activity of rationality, simultaneously precipitated an awareness of existing 'as a member of a whole (the species)'.[20] 'Humanity' is thus not only the ability to see oneself, but a mode of understanding what one sees. Self-knowledge, therefore, is not the quasi-magical effect of the forbidden fruit's ingestion, but a process of comprehension. This is why Piper could only verify her own existence when she could imagine viewing it from elsewhere. She had to objectify herself as a vision seen by another person in order to assure herself that she still belonged to humanity.

All these works imagine their origin not as a state, but a process of continual mediation. In each case, this derives from an attempt to picture a way of seeing – technological rationality, cultural ideals (whether constructive or constricting), and even species-level self-awareness. As such, each carries an implicit argument about what is most important about how one should envision oneself in the world. Despite these different outlooks, however, they share an approach to art as a generator of worldly self-knowledge. As performances *for* the camera, they seek to produce a vision of life from the outside, which then functions as the ground of contemplative interaction that produces self-understanding. They locate the work of art not in the live, not in the mediated, and not even in the amalgamation of the two, but rather in the continually unfolding processes of reception that put people into relation with each other and their understandings of a shared reality. Art becomes a situation not unlike the state of freedom Kant described as 'at once honorable and perilous', in which we find ourselves at the origin of our world, and have to imagine what new futures we might make.[21]

**230** NOTES

1  'Figaro-Théatre', *Le Figaro*, 28 December 1924, p.3.

2  Man Ray, *Self Portrait*, London 1963, p.238.

3  Ibid.

4  Felicia McCarren, *Dancing Machines: Choreographies of the Age of Mechanical Reproduction*, Stanford, CA 2003, p.112.

5  Ibid., p.113.

6  Roger Copeland, *Merce Cunningham: The Modernizing of Modern Dance*, London 2004, p.41.

7  Ibid.

8  McCarren 2003, p.118.

9  Walter Benjamin, 'The Work of Art in the Age of Mechanical Reproduction' (1936), reprinted in *Illuminations*, trans. Harry Zohn, New York 1969, p.165.

10  Elizabeth Ann McCauley, *Industrial Madness: Commercial Photography in Paris, 1848–1871*, New Haven 1994, p.134.

11  Ibid., p.137.

12  Ibid., p.146.

13  Geoffrey Batchen, 'Dreams of Ordinary Life: Cartes-de-visites and the Bourgeois Imagination', in J.J. Long, Andrea Noble and Edward Welch (eds.), *Photography: Theoretical Snapshots*, New York 2009, p.91.

14  Craig Owens, 'The Allegorical Impulse: Toward a Theory of Postmodernism Part 2', *October*, no.13, Summer 1980, p.77.

15  Ibid., p.78.

16  Adrian Piper, 'Food for the Spirit (1981)', in *Out of Order, Out of Sight, Volume 1: Selected Writings on Meta-Art 1968–1992*, Massachusetts 1996, p.55.

17  Ibid.

18  Ibid.

19  Immanuel Kant, 'Conjectural Beginning of Human History' (1786), in Pauline Kleingeld (ed.), *Toward Perpetual Peace and Other Writings on Politics, Peace, and History*, trans. David L. Colclasure, New Haven and London 2006, p.26.

20  Ibid., p.30.

21  Ibid., p.28.

## LIST OF WORKS

This list includes all works shown in the exhibition. Any works illustrated in the publication that do not appear below are not exhibited.

All works lent to Tate from ARTIST ROOMS are: Acquired jointly with the National Galleries of Scotland through The d'Offay Donation with assistance from the National Heritage Memorial Fund and the Art Fund 2008

**Ai Weiwei** born 1957
*Dropping a Han Dynasty Urn* 1995, printed 2015
3 photographs, digital prints on paper
199.9 × 180 each
Courtesy Ai Weiwei Studio
[pp.98–9]

**Eleanor Antin** born 1935
Photos: **Harry Shunk** 1924–2006
*Eleanor Antin exhibition, 'Adventures of a Nurse', The Clocktower, New York* 1975
Photograph, print on paper 20.3 × 25.4
Centre Pompidou – Musée national d'art moderne, Paris – Fonds Shunk-Kender.
Gift of the Roy Lichtenstein Foundation in memory of Harry Shunk and János Kender

*Eleanor Antin performance, 'The Angel of Mercy', M. L. d'Arc Gallery, New York* 1975
9 photographs, prints on paper 20.3 × 25.4 each
Centre Pompidou – Musée national d'art moderne, Paris – Fonds Shunk-Kender.
Gift of the Roy Lichtenstein Foundation in memory of Harry Shunk and János Kender
[pp.50–1]

**Keith Arnatt** 1930–2008
*Gardeners* 1978–9
12 photographs, gelatin silver prints on paper 40.4 × 30.4 each
Tate. Purchased 2010
[pp.204–5]

**Hippolyte Bayard** 1801–1887
*Self-Portrait as a Drowned Man* 1840, printed 2015
Autoportrait en noyé
Facsimile print on paper 29 × 20.9
Collection Société française de photographie, Paris
[p.20]

**Lynda Benglis** born 1941
*Lynda Benglis advertisement, Artforum, April 1974* 1974
Magazine, print on paper 26.5 × 26.5
Tate Archive. TGA 200610

*Lynda Benglis advertisement, Artforum, November 1974* 1974
Magazine, print on paper 26.5 × 26.5
Tate Archive. TGA 200610
[pp.148–9]

**Hicham Benohoud** 1968
*The Classroom* 1994–2000
La Salle de Classe
6 photographs, gelatin silver print on paper 40 × 30 each
Tate. Presented anonymously 2015
[pp.100–1]

**Joseph Beuys** 1921–1986
*Joseph Beuys: Drawings, Kunsthalle Kiel 1971*
Joseph Beuys. Zeichnungen Kunstahlle Kiel
Print on paper 80.2 × 59.3
ARTIST ROOMS
[p.144]

*We Can't Do It Without the Rose, Because We Can No Longer Think* 1972
Ohne die Rose tun wir's nicht, da können wir gar nicht mehr denken
Lithograph on paper 80.4 × 56.8
Tate. Purchased 1982
[p.144]

*We Are the Revolution* 1972
La Rivoluzione siamo noi
Screenprint on paper 191.5 × 100.3
Tate. Purchased 1982

*Dillinger. He Was the Gangster's Gangster* [film poster] 1974
Print on paper 82.3 × 114.1
ARTIST ROOMS

*Meeting with Beuys, Galleria Lucrezia De Domizio, Pescara* 1974
Incontro con Beuys, Galleria Lucrezia De Domizio, Pescara
Print on paper 89.2 × 67.5
ARTIST ROOMS

*Joseph Beuys: I Like America and America Likes Me (Documentation of a Performance at the René Block Gallery, New York, May '74), Richard Demarco Gallery, Edinburgh* 1974
Print on paper 80.4 × 53.4
ARTIST ROOMS

*(Poster without text)* 1975
(Plakat ohne Textaufdruck)
Print on paper 61.7 × 85.7
ARTIST ROOMS

*Joseph Beuys for the cover of Wirtschaftswoche [Business Week] 43/76* 1976
Joseph Beuys als Titelbild de *Wirtschaftswoche* 43/76
Print on paper 59.5 × 42.1
ARTIST ROOMS

*Joseph Beuys: Drawings, Watercolours, Collages, Oil Paintings, Municipal Museum of Contemporary Art, Ghent* 1977
Joseph Beuys. tekeningen, aquarellen, collages, olieverven, Stad Gent Museum van Hedendaagse Kunst
Print on paper 99.7 × 54.9
ARTIST ROOMS

*Beuys, Galleria Santoro, Rome* 1978
Print on paper 99.5 × 68.4
ARTIST ROOMS
[p.145]

*Artist Beuys: The Greatest – World Fame for a Charlatan?* 1979
Künstler Beuys: Der Größte – Weltruhm für einen Scharlatan?
Print on paper, from magazine *Der Spiegel*, no.5, 5 November 1979, 67.8 × 30.4
ARTIST ROOMS

*Beuys by Warhol: Paintings + Prints, Schellmann & Klüser, Munich* 1980
Print on paper 42 × 29.7
ARTIST ROOMS

*Andy Warhol. Joseph Beuys, Lucio Amelio [Gallery], Naples 1980* 1980
Print on paper 68.4 × 47
ARTIST ROOMS

*Joseph Beuys, Galleria Delta* 1980
Print on paper 69.9 × 47.3
ARTIST ROOMS

*Beuys in the Office* 1981, printed 1989
Beuys im Arbeitsraum
Print on paper 42.9 × 60.8
ARTIST ROOMS

*Must One Really Wear a Hat as a German Artist Nowadays?* 1984
Print on paper 97.4 × 68.2
ARTIST ROOMS
[p.145]

*Ute Klophaus: The Language of Movement – Photographs of Joseph Beuys, Atelier & Galerie-Kollektiv, Wuppertal* 1986
Ute Klophaus: sprache der Bewegung – Photographie zu Joseph Beuys, Atelier-und Galerie-Kollektiv, Wuppertal
Print on paper 68.7 × 49.7
ARTIST ROOMS

**Stuart Brisley** born 1933
Photos: **Leslie Haslam** 1946–2002
*Moments of Decision/Indecision* 1975
18 photographs, prints on paper on card 54.6 × 42.5 each
Tate. Purchased 1981
[pp.92–3]

**Trisha Brown** born 193
Photos: **Harry Shunk** 1924–2006, **János Kender** 1938–2009
*Trisha Brown rehearsal, unidentified studio after 1960*
6 photographs, prints on paper 20.3 × 25.4 each
Centre Pompidou – Musée national d'art moderne, Paris – Fonds Shunk-Kender.
Gift of the Roy Lichtenstein Foundation in memory of Harry Shunk and János Kender

**Claude Cahun** 1894–1954
*Self-Portrait* 1927
Photograph, vintage gelatin silver print on paper 25.5 × 20.1
Wilson Centre for Photography, London
[p.161]

**Merce Cunningham** 1919–2009
Photos: **Harry Shunk** 1924–2006, **János Kender** 1938–2009
*Merce Cunningham performance, Théâtre de l'est Parisien, Paris, 12 June 1964, featuring the ballets: 'Nocturnes' (1956), music by Erik Satie, decor and costumes by Robert Rauschenberg; 'Crises' (1960), music by Conlon Nancarrow, costumes by Robert Rauschenberg; 'Aeon' (1961), music by John Cage, decor and costumes by Robert Rauschenberg* 1964
14 photographs, prints on paper 25.4 × 20.3 each
Centre Pompidou – Musée national d'art moderne, Paris – Fonds Shunk-Kender.
Gift of the Roy Lichtenstein Foundation in memory of Harry Shunk and János Kender
[p.62]

*Merce Cunningham performance, Théâtre de l'est Parisien, Paris, 12 June 1964: 'Solarized' series* 1964–6
13 photographs, prints on paper 20.3 × 25.4 each
Centre Pompidou – Musée national d'art moderne, Paris – Fonds Shunk-Kender. Gift of the Roy Lichtenstein Foundation in memory of Harry Shunk and János Kender
[p.63]

Judy Dater born 1941
*Imogen and Twinka at Yosemite, mock-up of book layout for 'Imogen Cunningham: A Portrait'* 1979
Photograph, print on paper, on paper 32 × 43.5
Wilson Centre for Photography, London
[pp.150–1]

F. Holland Day 1864–1933
*The Seven Words* 1898, printed c.1898
7 photographs, platinum prints on paper 13.34 × 10.8 each
Courtesy of Bruce Silverstein Gallery, New York
[pp.122–3]

Jimmy DeSana 1949–1990
*Gauze* 1979
Photograph, vintage C-print on paper 33 × 48.3
Courtesy Jimmy DeSana Trust and Wilkinson Gallery, London

*Extension Cord* 1979
Photograph, vintage C-print on paper 48.8 × 32.3
Courtesy Jimmy DeSana Trust and Wilkinson Gallery, London
[p.111]

*Untitled (Suit)* 1980
Photograph, vintage C-print on paper 32.3 × 48.8
Courtesy Jimmy DeSana Trust and Wilkinson Gallery, London
[p.110, top]

*Coat Hanger* 1980
Photograph, vintage C-print on paper 48.8 × 37.4
Courtesy Jimmy DeSana Trust and Wilkinson Gallery, London

*Toothpaste* 1980
Photograph, cibachrome print on paper 33.2 × 48.3
Courtesy Jimmy DeSana Trust and Wilkinson Gallery, London
[p.110, bottom]

*Marker Cones* 1982
Photograph, C-print on paper 33 × 48.3
Courtesy Jimmy DeSana Trust and Wilkinson Gallery, London
[p.110, middle]

Hans Eijkelboom born 1949
*With My Family* 1973
4 photographs, prints on paper 60 × 48 each
Hans Eijkelboom
[p.184–5]

VALIE EXPORT born 1940
*Action Pants: Genital Panic* 1969
Aktionshose: Genitalpanik
6 screenprints on paper 65.8 × 45.9 each
Tate. Presented by Tate Patrons 2007
[pp.142–3]

Samuel Fosso born 1962
*African Spirits* 2008, printed 2009
14 photographs, gelatin silver prints on paper 101.6 × 76 each
Tate. Purchased with funds provided by the Africa Acquisitions Committee 2013
[pp.136–7]

Lee Friedlander born 1934
*Self-Portraits* 1963–2009:
    *New York City* 1963, printed 2009
    *Chicago* 1966, printed c.2011 [p.189]
    *Haverstraw, NY* 1966, printed 2007
    [p.188]
    *New York* 1966, printed 2005
    *Chicago* 1967, printed 2008
    *New City, New York* 1967, printed 2005
    *New City, New York* 1967, printed 2009
    *Buffalo, New York* 1968, printed 2008
    *New York City* 1968, printed c.2007
    *Provincetown, Massachusetts* 1968, printed 2011
    *Tallahassee, FL* 1969, printed 2008
    *Route 9W, New York* 1969, printed c.2012
    *Rochester, New York* 1971, printed 2006
    *Lafayette, Louisiana* 1972, printed 1980s
    *Milwaukee, Wisconsin* 1974, printed 2007
    *Mexico City* 1975, printed c.2010
    *New York City* 1985, printed c.1994
    *Tel Aviv* 1985, printed before 2010
    *Tokyo* 1994, printed 2013 [p.190]
    *Tokyo, Japan* 1994, printed c.1994
    *Santa Fe* 1995
    *Boston* 1996, printed c.1996
    *Florida* 1997, printed 2005 [p.191]
    *New City, New York* 1997, printed c.2000
    *Oregon* 1997
    *Paris* 1997
    *Tuscon* 1997
    *Canada Rockies* 2005, printed 2006
    *New Mexico* 2006
    *New York City* 2009
30 photographs, gelatin silver print on paper, various dimensions
Tate. Lent by the Tate Americas Foundation 2014

Masahisa Fukase 1934–2012
*From Window* 1974, printed 2015
17 photographs, prints on paper 30 × 19.5 each
Masahisa Fukase Archives
[pp.206–7]

*Bukubuku (Bubbling)* 1991
79 photographs, prints on paper 25.4 × 20.3 each
Masahisa Fukase Archives, courtesy Michael Hoppen Gallery, London
[pp.26, 192–5]

Dan Graham born 1942
*Pier 18, New York* 1971
18 photographs, silver gelatin prints on paper various dimensions
Centre Pompidou – Musée national d'art moderne, Paris – Fonds Shunk-Kender. Gift of the Roy Lichtenstein Foundation in memory of Harry Shunk and János Kender
[p.57]

Ivars Gravlejs born 1979
*Scream and Flash* 1995, printed 2009
15 photographs, prints on paper 18 × 13 each
Ivars Gravlejs
[pp.208–9]

Minoru Hirata born 1930
*Hi Red Center's Dropping Event at Ikenobo Hall, Tokyo, 10 October 1964* 1964, printed 2011
8 photographs, gelatin silver prints on paper 33.5 × 22.2 each
Tate. Purchased with funds provided by the Photography Acquisitions Committee 2012
[pp.40–1]

*Kyushu Faction Street Happening at the Tenjin Intersection of Fukuoka, 26 February 1970* 1970, printed 2011
16 photographs, gelatin silver prints on paper 22.2 × 33.5 each
Tate. Purchased with funds provided by the Photography Acquisitions Committee 2012
[pp.42–3]

Eikoh Hosoe born 1933
*Dance Experience* 1961, printed 2012
Book, print on paper 24.1 × 24.7
Courtesy of Eikoh Hosoe and Akio Nagasawa Gallery | Publishing (Tokyo)
[pp.76–7]

Eikoh Hosoe born 1933
Tatsumi Hijikata 1928–1986
*Kamaitachi* 1969
Book, print on paper 37.5 × 31
Martin Parr Collection

*Kamataichi* 1969, printed 2010
48 photographs, silver gelatin prints on paper 47 × 37 each
Private collection
[pp.78–81]

Eikoh Hosoe born 1933
Simmon Yotsuya born 1944
*Simmon: A Private Landscape* 1971, printed 2012
36 photographs, prints on paper 40.6 × 50.8 each
Courtesy Eikoh Hosoe, Akio Nagasawa Gallery | Publishing, Tokyo, and Jean-Kenta Gauthier, Paris
[pp.18, 82–5]

Norio Imai born 1946
*Time Clothing* 1978
39 photographs, Polaroid prints on paper 10.7 × 8.8 each, 62.5 × 85 overall
Courtesy of Yumiko Chiba Associates
[pp.174–5]

Yves Klein 1928–1962
Photographer unknown
*Yves Klein, Judo demonstration, Tokyo, Japan, and La Coupole, Paris* 1953–4
Printed by Shunk-Kender
6 photographs, prints on paper 20 × 26 each
Centre Pompidou – Musée national d'art moderne, Paris – Fonds Shunk-Kender. Gift of the Roy Lichtenstein Foundation in memory of Harry Shunk and János Kender
[p.34]

*Yves Klein realising an 'Anthropometry' in his studio, 14 rue Campagne Première, Paris* 1960
Artistic action of Yves Klein. Collaboration: Harry Shunk 1924–2006, János Kender 1938–2009
Photograph, print on paper 30 × 40
Centre Pompidou – Musée national d'art moderne, Paris – Fonds Shunk-Kender. Gift of the Roy Lichtenstein Foundation in memory of Harry Shunk and János Kender
[Inside front and back covers]

*Yves Klein realising an 'Anthropometry' in his studio, 14 rue Campagne Première, Paris* 1960
Artistic action of Yves Klein. Collaboration: Harry Shunk 1924–2006, János Kender 1938–2009
Photograph, print on paper 20 × 43
Centre Pompidou – Musée national d'art moderne, Paris – Fonds Shunk-Kender. Gift of the Roy Lichtenstein Foundation in memory of Harry Shunk and János Kender
[p.16]

*'Anthropometries of the Blue Period', Galerie internationale d'art contemporain, Paris, France, 9 March 1960* 1960
Artistic action of Yves Klein. Collaboration: Harry Shunk 1924–2006, János Kender 1938–2009
21 photographs, prints on paper, various dimensions
Centre Pompidou – Musée national d'art moderne, Paris – Fonds Shunk-Kender. Gift of the Roy Lichtenstein Foundation in memory of Harry Shunk and János Kender
[pp.28, 30–3]

*Leap into the Void* (Saut dans le Vide), Fontenay-aux-Roses, France 1960
Artistic action of Yves Klein. Collaboration: Harry Shunk 1924–2006, János Kender 1938–2009
Photograph, print on paper 36 × 28
Centre Pompidou – Musée national d'art moderne, Paris – Fonds Shunk-Kender. Gift of the Roy Lichtenstein Foundation in memory of Harry Shunk and János Kender and Tate
[p.10]

Preparatory images for *Leap into the Void*, Fontenay-aux-Roses, France 1960
Artistic action of Yves Klein. Collaboration: Harry Shunk 1924–2006, János Kender 1938–2009
4 photographs, prints on paper 28 × 36 each
Centre Pompidou – Musée national d'art moderne, Paris – Fonds Shunk-Kender. Gift of the Roy Lichtenstein Foundation in memory of Harry Shunk and János Kender
[p.13]

Preparatory image of Yves Klein's *Leap into the Void*, Fontenay-aux-Roses, France 1960, printed 2015
Artistic action of Yves Klein. Collaboration: **Harry Shunk** 1924–2006, **János Kender** 1938–2009
2 photographs, print on paper 36 × 28 each
Private collection
[Frontispiece, p.12]

*Dimanche (le journal d'un seul jour)*, 27 November 1960
Newsprint on paper 55.6 × 37.9
Private collection

Preparatory image of Yves Klein's *The Dream of Fire* (Le Rêve du feu) 1960
Artistic action of Yves Klein. Collaboration: **Harry Shunk** 1924–2006, **János Kender** 1938–2009
Photograph, print on paper 20 × 25
Centre Pompidou – Musée national d'art moderne, Paris – Fonds Shunk-Kender.
Gift of the Roy Lichtenstein Foundation in memory of Harry Shunk and János Kender
[p.35]

**Komar and Melamid**
**Vitaly Komar** born 1943
**Alexander Melamid** born 1945
*A Catalogue of Superobjects: Supercomfort for Superpeople – VI. Auto-Probes: 15. Dikliotik* 1975, published 1976
C-print and text on paper 25.4 × 20.3
Tate. Presented by Ronald and Frayda Feldman 2015

*A Catalogue of Superobjects: Supercomfort for Superpeople – VI. Auto-Probes: 16. Charog –15* 1975, published 1976
C-print and text on paper 25.4 × 20.3
Tate. Presented by Ronald and Frayda Feldman 2015
[pp.102–3]

*A Catalogue of Superobjects: Supercomfort for Superpeople – VI. Auto-Probes: 17. Udam* 1975, published 1976
C-print and text on paper 25.4 × 20.3
Tate. Presented by Ronald and Frayda Feldman 2015
*A Catalogue of Superobjects: Supercomfort for Superpeople – VI. Auto-Probes: 18. Khudam* 1975, published 1976
C-print and text on paper 25.4 × 20.3
Tate. Presented by Ronald and Frayda Feldman 2015

*A Catalogue of Superobjects: Supercomfort for Superpeople – VI. Auto-Probes: 19. Tyairp* 1975, published 1976
C-print and text on paper 25.4 × 20.3
Tate. Presented by Ronald and Frayda Feldman 2015
[pp.104–5]

*A Catalogue of Superobjects: Supercomfort for Superpeople – VI. Auto-Probes: 20. Ovyorly* 1975, published 1976
C-print and text on paper 25.4 × 20.3
Tate. Presented by Ronald and Frayda Feldman 2015

**Jeff Koons** born 1955
*Art Magazine Ads (Arts, Art Forum, Art in America, Flash Art)* 1988–9
4 lithographs on paper 91.5 × 71.2 each
ARTIST ROOMS
[pp.156–7]

**Les Krims** born 1942
Caption for all works, by the artist: 'Printed By Les Krims, in a Basement in Buffalo, New York – a Failed Border Town Where the Stank of Government Cheese Meets the E.coli Scented Lake Erie Breeze.'.

*Masked Pregnant Woman with Giant Soap Bubble, Rochester, New York* 1968
Photograph, vintage Kodalith print on paper 17 × 23
Paci Contemporary Gallery, Brescia, Italy
[p.109, bottom]

*On Point Pussy Leap, Buffalo, New York* 1969
Photograph, vintage Kodalith print on paper 16 × 22
Paci Contemporary, Brescia, Italy
[p.109, middle]

*The Nostalgia Miracle Shirt, West Avenue, Buffalo, New York* 1970
Photograph, vintage Kodalith print on paper 16 × 22
Paci Contemporary, Brescia, Italy
[p.108]

*Feminist with Wedding Cake, Buffalo, New York* 1970
Photograph, vintage Kodalith print on paper 16.5 × 21.5
Paci Contemporary, Brescia, Italy

*The Painter Paul Wiesenfeld, Performing String Breast Distortion, Buffalo, New York* 1970
Photograph, vintage Kodalith print on paper 16 × 23
Paci Contemporary, Brescia, Italy

*Local Magician Levitating Oversize Wand and Young Woman, Kitchen, 198 Fargo Avenue Buffalo, New York* 1970
Photograph, vintage Kodalith print on paper 16 × 23
Paci Contemporary, Brescia, Italy

*Local Magician Levitating Fanned Deck of Cards and Woman, Bedroom, 198 Fargo Avenue, Buffalo, New York* 1970
Photograph, vintage Kodalith print on paper 16 × 23
Paci Contemporary, Brescia, Italy

*Nude Airflow Test Area (with a Remnant of Chocolate Syrup Fake Blood Pool, from The Incredible Case of the Stack o'Wheats Murders). Buffalo, New York* 1970
Photograph, vintage Kodalith print on paper 16 × 23
Paci Contemporary, Brescia, Italy
[p.109, top]

**Yayoi Kusama** born 1929
Photos: **Harry Shunk** 1924–2006, **János Kender** 1938–2009
*'Anti-War' Naked Happening & Flag Burning at Brooklyn Bridge, New York* 1968
7 photographs, prints on paper 20.3 × 25.4 each
Centre Pompidou – Musée national d'art moderne, Paris – Fonds Shunk-Kender.
Gift of the Roy Lichtenstein Foundation in memory of Harry Shunk and János Kender
[p.53, top]

*Happening, unidentified location, New York* 1968
3 photographs, prints on paper 25.4 × 20.3
Centre Pompidou – Musée national d'art moderne, Paris – Fonds Shunk-Kender.
Gift of the Roy Lichtenstein Foundation in memory of Harry Shunk and János Kender
[p.53, bottom]

*Happening, at The Anatomic Explosion, Wall Street, New York* 1968
3 photographs, prints on paper 25.4 × 20.3
Centre Pompidou – Musée national d'art moderne, Paris – Fonds Shunk-Kender.
Gift of the Roy Lichtenstein Foundation in memory of Harry Shunk and János Kender
[p.52]

*Happening/Body Painting, Kusama Studio, New York* 1968
5 photographs, prints on paper 20.3 × 25.4
Centre Pompidou – Musée national d'art moderne, Paris – Fonds Shunk-Kender.
Gift of the Roy Lichtenstein Foundation in memory of Harry Shunk and János Kender

*Happening/Fashion Show with 'Compulsion Furniture (Accumulation)', Kusama Studio, New York* 1968
Photograph, print on paper 20.3 × 25.4
Centre Pompidou – Musée national d'art moderne, Paris – Fonds Shunk-Kender.
Gift of the Roy Lichtenstein Foundation in memory of Harry Shunk and János Kender

*Happening/Fashion Show, Kusama Studio, New York* 1968
2 photographs, prints on paper 20.3 × 25.4
Centre Pompidou – Musée national d'art moderne, Paris – Fonds Shunk-Kender.
Gift of the Roy Lichtenstein Foundation in memory of Harry Shunk and János Kender
[p.54]

*Kusama happening, Body Painting, Kusama Studio, New York* 1968
3 photographs, prints on paper 20.3 × 25.4
Centre Pompidou – Musée national d'art moderne, Paris – Fonds Shunk-Kender.
Gift of the Roy Lichtenstein Foundation in memory of Harry Shunk and János Kender
[p.55]

**David Lamelas** born 1946
*Rock Star (Character Appropriation)* 1974, printed 2015
7 photographs, prints on paper 40.5 × 30.5 each
Courtesy of the artist, Sprueth Magers & Jan Mot
[pp.128–9]

**Linder** born 1954
*She/She* 1981, printed 2007
14 photographs, silver bromide prints on paper 74 × 61 each
Tate. Purchased with funds provided by Wendy Fisher 2009
[pp.168–9]

**Sarah Lucas** born 1962
*Fighting Fire with Fire* 1996
Photograph, digital print on paper 76 × 56.5
Tate. Purchased 2001
[p.165]

**Romain Mader** born 1988
*Ekaterina* 2012
Photograph, print on paper 40 × 50
Romain Mader

*Ekaterina* 2012
Photograph, print on paper 50 × 33
Romain Mader

*Ekaterina #1* 2012
Photograph, print on paper 24 × 30
Romain Mader

*Ekaterina #12* 2012
Photograph, print on paper 50 × 40
Romain Mader
[p.199, left]

*Ekaterina #16* 2012
Photograph, print on paper 30 × 24
Romain Mader

*Ekaterina: Soon* 2012
Ekaterina: Bientôt
Photograph, print on paper 40 × 50
Romain Mader
[p.198]

*Ekaterina: Marriage Proposal* 2012
Ekaterina: Demande en marriage
Photograph, print on paper 40 × 50
Romain Mader
[p.196]

*Ekaterina: Marriage in Leukerbad* 2012
Ekaterina: Mariage à Loècheles Bains
Photograph, print on aluminium 140 × 100
Romain Mader
[p.199, right]

*Moraliste #1* 2012
Photograph, print on paper 30 × 24
Romain Mader

**Thomas Mailaender** born 1979
*Gone Fishing* 2015
Tree, flatscreen, audio recording, variable dimensions
Courtesy the artist
[pp.186–7]

**Man Ray** 1890–1976
*Marcel Duchamp as Rrose Sélavy* 1921, printed 2002
Photograph, gelatin silver print on paper after original glass negative 12 × 9
Musée national d'art moderne, Centre Pompidou, Paris
[p.125]

*Rrose Sélavy* 1921
Photograph, gelatin silver print on paper
13.8 × 9.9
Private collection, USA
[p.120]

*Ciné-Sketch: Adam and Eve (Marcel Duchamp and Bronia Perlmutter)* 1924, printed 2016
Photograph, facsimile from digital file
18 × 13.2
© Man Ray Trust/ADAGP, Paris and DACS, London / Print by Telimage 2016
[p.222]

*Erotique Voilée* 1933
Photograph, gelatin silver print on paper
61 × 50.8
Wilson Centre for Photography, London
[p.88]

**Mike Mandel** born 1950
*The Baseball Photographer Trading Cards* 1974
133 prints on card 8.9 × 6.4 each
Martin Parr Collection
[pp.152–3]

**Babette Mangolte** born 1941
*Yvonne Rainer, Rehearsal of 'Performance', Hofstra University, NY, March 19, 1972*
*Performers: Yvonne Rainer, Valda Setterfield, John Erdman, Shirley Soffer*

*Three Satie Spoons with Yvonne Rainer* 1972
Photograph, vintage print on paper
20.3 × 25.4
Courtesy the artist and BROADWAY 1602, New York

*In the Box* 1972, printed 1997
Photograph, vintage print on paper
27.9 × 35.6
Courtesy the artist and BROADWAY 1602, New York
[p.64, middle]

*'Box Sequence': Shirley and John looking at Valda looking at Yvonne in the Box* 1972, printed 1997
Photograph, print on paper 20.3 × 25.4
Courtesy the artist and BROADWAY 1602, New York

*'Box Sequence': Yvonne Rainer shows to Valda and Shirley how to do 'Walk She Said'* 1972, printed 1997
Photograph, print on paper 20.3 × 25.4
Courtesy the artist and BROADWAY 1602, New York

*'Box Sequence': Valda looking at Yvonne in the Box* 1972, printed 1997
Photograph, print on paper 27.9 × 35.6
Courtesy the artist and BROADWAY 1602, New York
[p.64, bottom]

*Contact Sheet 31972-1* 1972, printed 2007
Photograph, digital C-print from unique contact sheet, on paper 50.8 × 40.6
Courtesy the artist and BROADWAY 1602, New York

*Yvonne Rainer, 'Lives of Performers' Performance at the Whitney Museum, 21 April 1972*

*Medium shot Box with Shirley, Epp, Valda and Jim and Yvonne in the foreground facing the audience* 1972
Photograph, vintage print on paper
20.4 × 25.4
Courtesy the artist and BROADWAY 1602, New York

*Extreme long shot from left to right Fernando, Box with Epp and Jim, Shirley, Valda and Yvonne* 1972
Photograph, vintage print on paper
20.4 × 25.4
Courtesy the artist and BROADWAY 1602, New York

*Scene Printed from 42172-1-26A* 1972, printed 2007
Photograph, print on paper
27.9 × 35.6
Courtesy the artist and BROADWAY 1602, New York

*Box and John, Valda and Shirley* 1972, printed 2007
Photograph, print on paper 2
0.3 × 25.4
Courtesy the artist and BROADWAY 1602, New York

*Box and Fernando* 1972, printed 2007
Photograph, print on paper 27.9 × 35.6
Courtesy the artist and BROADWAY 1602, New York

*Jim and Epp in the box, Valda's arm in foreground* 1972, printed 2007
Photograph, print on paper
20.4 × 25.4
Courtesy the artist and BROADWAY 1602, New York
[p.64, top]

*Yvonne Rainer, 'Lives of Performers' film*

*Shooting of Yvonne Rainer's film 'Lives of Performers'* 1972, printed 2007
Photograph, print on paper
27.9 × 35.6
Courtesy the artist and BROADWAY 1602, New York

*'The Letter', frame enlargement from 16mm film: Fernando's hand comes into frame to handle the letter (Valda has eye shade)* 1972
Photograph, vintage print on paper
20.4 × 25.4
Courtesy the artist and BROADWAY 1602, New York

*'The Letter', frame enlargement from 16mm film: Close-up Valda's hands holding the chair* 1972
Photograph, vintage print on paper
20.4 × 25.4
Courtesy the artist and BROADWAY 1602, New York

*'Valda's solo', frame enlargement of the 16mm film: Valda extending her left arm with the ball* 1972
Photograph, vintage print on paper
20.4 × 25.4
Courtesy the artist and BROADWAY 1602, New York

*'Boxes', Yvonne Rainer performance: Rehearsal shots at Hofstra University, March 19, 1972, Dancers: Valda Setterfield, Shirley Soffer, John Erdman and Yvonne Rainer* 1973, printed 2007 1973, printed 2007
Photograph, gelatin silver print on paper
25.4 × 20.32
Courtesy the artist and BROADWAY 1602, New York
[p.65]

*Trisha Brown, 'Roof Piece' 1973, 53 Wooster Street to 381 Lafayette Street, New York City* 1973, printed 2003
Photograph, gelatin silver print on paper
40.7 × 50.8
Courtesy the artist and BROADWAY 1602, New York
[pp.61–2]

*Trisha Brown, 'Roof Piece' 1973, Soho NYC, Contact Sheet 71173* 1973, printed 2007
Digital C-print from unique contact sheet on paper 40.64 × 50.8
Courtesy the artist and BROADWAY 1602, New York

*Trisha Brown, 'Woman Walking Down a Ladder', Feb 25, 1973, 130 Greene Street, New York* 1973, printed 2007
Photograph, digital C-print from unique contact sheet on paper 40.64 × 50.8
Courtesy the artist and BROADWAY 1602, New York
[p.58]

*Trisha Brown, 'Woman Walking Down a Ladder', Feb 25, 1973, 130 Greene Street, New York, diptych* 1973, printed 2007
Photograph, print on paper 20.4 × 25.4
Courtesy the artist and BROADWAY 1602, New York
[p.59]

**Robert Mapplethorpe** 1946–1989
*Self-Portrait* 1983, printed 2005
Photograph, gelatin silver print on paper
38.2 × 38
ARTIST ROOMS. Tate and National Galleries of Scotland. Lent by Artist Rooms Foundation 2014
[p.163]

**Dora Maurer** born 1937
*Seven Twists I–VI* 1979, printed 2011
6 photographs, gelatin silver prints on paper
20 × 20 each
Tate. Purchased with funds provided by the Russia and Eastern Europe Acquisitions Committee 2015
[pp.170–1]

**Paul McCarthy** born 1945
*Face Painting – Floor, White Line* 1972, printed 1994
2 photographs, gelatin silver prints on paper
101.6 × 76.2 each
Collection of the artist
[pp.94–5]

**Boris Mikhailov** born 1938
*Crimean Snobbism* 1992
55 photographs, gelatin silver prints on paper, sepia toned 17.8 × 14
Tate. Purchased with funds provided by the Russian and Eastern European acquisitions committee 2015 and the Photography Acquisitions Committee 2015
[pp.24, 200–3]

*I Am Not I* 1992
Photographs, prints on paper 143 × 93 each; exhibited version: prints mounted on 3 sheets of paper, 40 × 50 each
Courtesy of the artist and Sprovieri gallery, London
[pp.106–7]

**Marta Minujín** born 1943
Photographs: **Harry Shunk** 1924–2006, **János Kender** 1938–2009
*The Destruction (La Destrucción), exhibition and happening, Impasse Ronsin, Paris* 1963
13 photographs, prints on paper 25.4 × 20.3 each
Centre Pompidou – Musée national d'art moderne, Paris – Fonds Shunk-Kender. Gift of the Roy Lichtenstein Foundation in memory of Harry Shunk and János Kender
[pp.44–7]

**Yasumasa Morimura** born 1951
*A Requiem: Theater of Creativity / Self-Portrait as Yves Klein* 2010
Photograph, silver gelatin print on paper
120 × 90
Juana de Aizpura Collection, Madrid
[p.138]

**NADAR STUDIO AND FAMILY**
Gaspard-Félix Tournachon (Nadar)
1820–1910
**Adrien Tournachon** 1825–1903
*Pierrot with Fruit Basket (mime Charles Deburau)* 1854
Photograph, salt print on paper 28.7 × 21.2
Musée d'Orsay, Paris. Gift of Mr and Mrs André Jammes, 1991

*Pierrot Laughing (mime Charles Deburau)* 1854
Photograph, salt print on paper 28.6 × 21.2
Musée d'Orsay, Paris. Gift of Mr and Mrs André Jammes, 1991
[p.68, right]

*Pierrot Surprised (mime Charles Deburau)* 1854
Photograph, salt print on paper 28.6 × 21.4
Musée d'Orsay Paris. Gift of Mr and Mrs André Jammes, 1991
[p.68, left]

*Pierrot Suffering* (mime Charles Deburau) 1854
Photograph, salt print on paper 28.5 × 22.2
Musée d'Orsay, Paris. Gift of Mr and Mrs André Jammes, 1991

*Pierrot Pleading* (mime Charles Deburau) 1854
Photograph, salt print on paper 29 × 20.8
Musée d'Orsay, Paris. Gift of Mr and Mrs André Jammes, 1991
[p.69, left]

*Pierrot Running* (mime Charles Deburau) 1854–61
Photograph, salt print on paper 24.9 × 20.1
Bibliothèque nationale de France, Estampes et photographie, Paris

*Pierrot Surprised* (mime Charles Deburau) 1854–5
Photograph, salt print on paper 26.8 × 20.3
Bibliothèque nationale de France, Estampes et photographie, Paris

*The Mime Charles Deburau* 1854–5
Photograph, salt print on paper 29 × 21.2
Bibliothèque nationale de France, Estampes et photographie, Paris

*Portrait of a Mime (Paul Legrand)* 1854–5
Photograph, salt print on paper 31.2 × 23.3
Bibliothèque nationale de France, Estampes et photographie, Paris
[p.69, right]

**Paul Nadar** 1856–1939
*Sarah Bernhardt in 'Pierrot Assassin'* c.1883, printed c.1900–10
Photograph, gelatin print on paper 35 × 25
Bibliothèque nationale de France, Estampes et photographie, Paris
[p.75]

*Sarah Bernhardt in 'Macbeth'* 1884, printed c.1900–10
Photograph, gelatin silver print on paper 37 × 27.8
Bibliothèque nationale de France, Estampes et photographie, Paris

**Paul Nadar and Studio**
*Dailly and gil Naza in 'l'Assommoir' by Émile Zola* 1879
Photograph, albumen print on paper mounted on cardboard 16.5 × 11
Bibliothèque nationale de France, Estampes et photographie, Paris

*Hélène Petit in 'l'Assommoir' by Émile Zola* 1879
3 photographs, albumen print on cardboard 16.5 × 11
Bibliothèque nationale de France, Estampes et photographie, Paris
[p.72, top left and right]

*'Madame Sans-Gêne' by Victorien Sardou and Émile Moreau* 1895
Photograph, albumen print on paper mounted on cardboard 16.5 × 11
Bibliothèque nationale de France, Estampes et photographie, Paris
[p.72, bottom left]

*Léa Piron – Opéra* 1917
3 photographs, gelatin silver prints on card 16.5 × 11 each
Bibliothèque nationale de France, Estampes et photographie, Paris
[pp.66, 71]

*Regnard and Sérier* c.1880–90
Photograph, albumen print on paper mounted on cardboard 16.5 × 11
Bibliothèque nationale de France, Estampes et photographie, Paris
[p.73, right]

*Sarah Bernhardt in 'Macbeth'* 1884, later print
Photograph, albumen print on paper mounted on cardboard 16.5 × 11
Bibliothèque nationale de France, Estampes et photographie, Paris
[p.74]

*Sarah Bernhardt in 'La Tosca' by Victorien Sardou* 1887
2 photographs, albumen prints on paper mounted on cardboard 16.5 × 11 each
Bibliothèque nationale de France, Estampes et photographie, Paris
[p.72, bottom right; p.73, left]

*Sarah Bernhardt 'Théodora' by Victorien Sardou* 1884
1 photograph, albumen print on paper mounted on cardboard, 1 photograph, gelatin silver print on paper mounted on cardboard, printed 1899 16.5 × 11 each
Bibliothèque nationale de France, Estampes et photographie, Paris

*Sarah Bernhardt in 'Pierrot Assassin'* 1883
Photograph, albumen print on paper mounted on cardboard 16.5 × 11
Bibliothèque nationale de France, Estampes et photographie, Paris

*Nadar Studio print reference album* c.1894
32 photographs, albumen prints and ink on paper mounted on paper 75 × 63.3 × 4 overall
Bibliothèque nationale de France, Estampes et photographie, Paris
[p.70]

**Kiyoji Otsuji** 1923–2001
*Gutai Photographs* 1956–7, printed 2012
Performances: Saburo Murakami, *Passage* (Tsūka) / ; Atsuko Tanaka, *Electric Dress* (Denkifuku)
10 photographs, gelatin silver prints on paper 27.8 × 35.5 each
Taka Ishii Gallery, Tokyo
[pp.36–9]

**Paul Outerbridge** 1896–1958
*Self-Portrait* 1927
Photograph, gelatin silver print on paper 38.3 × 28.5
Wilson Centre for Photography, London
[p.158]

**Martin Parr** born 1952
*Autoportraits* 1996–2015
    *Dhaka, Bangladesh* 1996 [p.183, right]
    *Strasbourg, France* 1996
    *Pyongyang, North Korea* 1997
    *Benidorm, Spain* 1997 [p.183, middle left]
    *Ocho Rios, Jamaica* 1997 [p.182, top left]
    *Funchal, Madeira, Portugal* 1998
    *Abu Dhabi, United Arab Emirates* 1999
    *Scarborough, England* 1999 [p.182, bottom left]
    *Paris, France* 1999
    *Porto, Portugal* 1999
    *Rimini, Italy* 1999
    *New York, USA* 1999 [p.183, top left]
    *Odessa, Ukraine* 2000
    *Vienna, Austria* 2000
    *Amsterdam, The Netherlands* 2000
    *Havana, Cuba* 2001 [p.183, middle right]
    *Tbilisi, Georgia* 2002 [p.182, top right]
    *Singapore, China* 2003
    *Nuwara Eliya, Sri Lanka* 2004
    *Darjeeling, India* 2005
    *Porto, Portugal* 2007
    *Dubai, United Arab Emirates* 2007 [p.183, bottom left]
    *Mexico City, Mexico* 2008
    *Fortaleza, Brazil* 2008
    *Yalta, Russia* 2008
    *Delhi, India* 2009 [p.182, bottom left]
    *Dubai, United Arab Emirates* 2009
    *Beidaihe, China* 2010
    *Atlanta, Georgia, USA* 2010
    *Nairobi, Kenya* 2010
    *Singapore* 2010
    *Amsterdam, The Netherlands* 2012 [p.183, bottom right]
    *Wolverhampton, England* 2012
    *Wisconsin, USA* 2013
    *Lausanne, Switzerland* 2013
    *Lima, Peru* 2015
36 photographs, prints on paper various dimensions
Martin Parr Collection / Magnum Photos

**Adrian Piper** born 1948
*Food for the Spirit* 1971, printed 1997
14 photographs, silver gelatin prints on paper 38.1 × 36.8 each; 44 original book pages of a paperback edition of Immanuel Kant's *Critique of Pure Reason*, torn out and annotated by Adrian Piper
Collection of Thomas Erben, New York
[pp.172–3, 228]

**Charles Ray** born 1953
*Plank Piece I–II* 1973
2 photographs, prints on paper on board 101 × 68
ARTIST ROOMS
[p.15]

**Tokyo Rumando**
*Orphée* 2012, printed 2015
25 photographs, gelatin silver prints on paper 27.9 × 35.6
Courtesy of Tokyo Rumando 'Orphée' 2015
[pp.22, 134–5]

**Niki de Saint Phalle** 1930–2002
Photographs: **Harry Shunk** 1924–2006, **János Kender** 1938–2009
*Niki de Saint Phalle shooting and exhibition opening, 'Fire at Will' (Feu a Volonté), Galerie J, Paris* 1961
2 photograph, prints on paper 20.3 × 25.4 each
Centre Pompidou – Musée national d'art moderne, Paris – Fonds Shunk-Kender. Gift of the Roy Lichtenstein Foundation in memory of Harry Shunk and János Kender
[p.49]

*Niki de Saint Phalle shooting, Impasse Ronsin, Paris* 1961
3 photographs, prints on paper 20.3 × 25.4
Centre Pompidou – Musée national d'art moderne, Paris – Fonds Shunk-Kender. Gift of the Roy Lichtenstein Foundation in memory of Harry Shunk and János Kender
[p.48]

*Niki de Saint Phalle shooting, Impasse Ronsin, Paris* c.1960
Photograph, print on paper 20.3 × 25.4
Centre Pompidou – Musée national d'art moderne, Paris – Fonds Shunk-Kender. Gift of the Roy Lichtenstein Foundation in memory of Harry Shunk and János Kender

**Tomoko Sawada** born 1977
*ID400* 1998
100 photographs, prints on paper 127 × 100 overall
Wilson Centre for Photography, London
[pp.180–1]

**Carolee Schneemann** born 1939
*Eye Body: 36 Transformative Actions* 1963, printed 1973
30 photographs, gelatin silver prints on paper 35.9 × 28.3 each
Hirshhorn Museum and Sculpture Garden, Smithsonian Institution, Washington, DC. Joseph H. Hirshhorn Bequest and Purchase Funds and Holenia Purchase Fund, in memory of Joseph H. Hirshhorn, 2007
[pp.90–1]

**Rudolf Schwarzkogler** 1940–1969
*3rd Action* 1965, printed early 1970s
Photograph, gelatin silver print on paper 60 × 50
Tate. Purchased 2002
[p.86]

**Cindy Sherman** born 1954
*Untitled Film Still #17* 1978, printed 1998
Photograph, gelatin silver print on paper 74.5 × 95
Tate. Presented by Janet Wolfson de Botton 1996
[p.131]

*Untitled Film Still #27* 1979, printed 1998
Photograph, gelatin silver print on paper 97.5 × 68.3
Tate. Presented by Janet Wolfson de Botton 1996
[p.130]

*Untitled Film Still #53* 1980, printed 1998
Photograph, gelatin silver print on paper
69.5 × 97
Tate. Presented by Janet Wolfson de Botton
1996
[p.21]

*Untitled #97* 1982
Photograph, print on paper 115 × 76
Tate. Purchased 1983
[p.128, left]

*Untitled #98* 1982
Photograph, print on paper 115.2 × 76
Tate. Purchased 1983
[p.128, right]

*Untitled #99* 1982
Photograph, print on paper 115.8 × 76
Tate. Purchased 1983
[p.129, left]

*Untitled #100* 1982
Photograph, print on paper 114.7 × 76
Tate. Purchased 1983
[p.129, right]

**Aaron Siskind** 1903–1991
*Pleasures and Terrors of Levitation* 1956–65
9 photographs, gelatin silver prints on paper
35.1 × 27.9 each
Aaron Siskind Foundation courtesy of Bruce
Silverstein Gallery, New York
[p.14]

**Jemima Stehli** born 1961
*Strip* 1999–2000
56 photographs, C-prints on paper on
aluminium 32 × 27 each, 242 × 390 overall
Courtesy the artist
[pp.176–9]

**Keiji Uematsu** born 1947
*Wave Motion IV* 1973
Photograph, gelatin silver print on paper
73 × 103
Keiji Uematsu, Courtesy of Yumiko Chiba
Associates
[p.97]

*Stone/Rope/Man II* 1974
Photograph, gelatin silver print on paper
120 × 89
Keiji Uematsu, Courtesy of Yumiko Chiba
Associates
[p.96]

**Amalia Ulman** born 1989
*Excellences & Perfections* 2014
Performance on Instagram, archived: http://
webenact.rhizome.org/excellences-and-
perfections
Courtesy the artist and Arcadia Missa,
London
[pp.210–11]

*Excellences & Perfections (Instagram Update,
1 June 2014)* 2015
Photograph, C-print dry mounted on
aluminium, mounted on black edge frame
125 × 125
Courtesy the artist and Arcadia Missa,
London

*Excellences & Perfections (Instagram Update,
8 July 2014), (#itsjustdifferent)* 2015
Photograph, C-print dry mounted on
aluminium, mounted on black edge frame
125 × 125
Michael Xufu Huang (M WOODS
MUSEUM)

*Excellences & Perfections (Instagram Update,
5 September 2014)* 2015
Photograph, C-print dry mounted on
aluminium, mounted on black edge frame
125 × 125
Courtesy the artist and Arcadia Missa,
London

**Andy Warhol** 1928–1987
*The Art of Giving* 1981
Lithograph on paper 70.8 × 55.8
ARTIST ROOMS
[p.154]

*Andy Warhol* 1982
Lithograph on paper 73.8 × 50.9
ARTIST ROOMS

*Grace [ Jones] Being Painted by Keith [Haring]*
1986
6 photographs, gelatin silver prints on paper
and thread 69.5 × 80.5 overall
ARTIST ROOMS
[p.89]

*New York, New York* 1987
Screenprint on paper 56.4 × 44.4
ARTIST ROOMS

*JM Magazine* c.1985
Lithograph on paper 81.7 × 61.4
ARTIST ROOMS

*LeRoy Neiman and Andy Warhol* c.1977–8
Lithograph on paper 49.5 × 68.6
ARTIST ROOMS

*Andy Warhol's BAD* 1977
Lithograph on paper 75.7 × 101
ARTIST ROOMS

*Pop Tarts! Andy Warhol & Debbie Harry Slip
a Floppy Disk with Cynthia Rose, NME,* 11
January 1986
Magazine, print on paper 52.4 × 34
Fiontán Moran Collection
[p.140]

**Hannah Wilke** 1940–1993
*Portrait of the Artist in his Studio* 1971
Photograph, exhibited archival pigment print
on paper, printed 2015, 30.5 × 40.6
Performalist Self-Portrait with Claes
Oldenburg
Hannah Wilke Collection & Archive, Los
Angeles. Courtesy Alison Jacques Gallery,
London
[p.166]

*Hannah Wilke Super t-Art* 1974
From a three-minute performance at the
Kitchen, New York, November 1974
20 prints on paper framed together
16.5 × 11.4 each, 102.9 × 82.5 overall, artist's
proof
Hannah Wilke Collection & Archive, Los
Angeles. Courtesy Alison Jacques Gallery,
London
[p.167]

*Having a talent isn't worth much …* 1976
Proposed subway ad for the School of Visual
Arts
Photograph with text on paper 114.3 × 76.2
Exhibited archival pigment print on paper,
printed 2015
Hannah Wilke Collection & Archive, Los
Angeles. Courtesy Alison Jacques Gallery,
London
[p.146, left]

*Philly* 1976–8
Photograph with text on board 69.2 × 101.6
Exhibited archival pigment print on paper,
printed 2015
Hannah Wilke Collection & Archive, Los
Angeles. Courtesy Alison Jacques Gallery,
London
[p.147]

*Marxism and Art: Beware of Fascist Feminism*
1977
Lithograph on paper 29 × 23
Tate. Purchased 2008
[p.146, right]

**David Wojnarowicz** 1954–1992
*Arthur Rimbaud in New York* 1978–9, printed
2004
   (bar terminal) [p.126, top right]
   (diner)
   (Duchamp) [p.127]
   (hole in wall) [p.126, bottom right]
   (kissing) [p.126, bottom left]
   (mask)
   (motorcycle, pride 79)
   (movie house)
   (Nathan's)
   (pier, shooting up mural)
   (pissing)
   (subway)
   (target)
   (tile floor, gun)
   (times square) [p.126, top left]
15 photographs, gelatin silver prints on paper
27.9 × 35.6 each
Courtesy the Estate of David Wojnarowicz
and P.P.O.W Gallery, New York

**Francesca Woodman** 1958–1981
*Self-Portrait, Providence, Rhode Island* 1976
Photograph, gelatin silver print on paper
12.7 × 12.5
Wilson Centre for Photography, London

*From Angel Series, Roma, September 1977*
1977
Photograph, gelatin silver print on paper
9.3 × 9.3
ARTIST ROOMS
[p.116, bottom]

*Untitled, Providence, Rhode Island* 1975–8
Photograph, gelatin silver print on paper
14.5 × 14.5
Wilson Centre for Photography, London

*Eel Series, Roma, May 1977 – August 1978*
1977–8
Photograph, gelatin silver print on paper
21.9 × 21.8
ARTIST ROOMS

*Space², Providence, Rhode Island* 1975–8
Photograph, gelatin silver print on paper
14 × 14
ARTIST ROOMS
[p.117, top]

*Space², Providence, Rhode Island* 1975–8
Photograph, gelatin silver print on paper
13.9 × 13.9
ARTIST ROOMS
[p.117, bottom]

*Untitled* 1975–80
Photograph, gelatin silver print on paper on
ink on paper 10.9 × 10.9
ARTIST ROOMS

*Untitled* 1975–80
Photograph, gelatin silver print on paper
14.1 × 14
ARTIST ROOMS

*Untitled* 1975–80
Photograph, gelatin silver print on paper
12.8 × 12.9
ARTIST ROOMS

*Untitled* 1975–80
Photograph, gelatin silver print on paper on
ink on paper 14.4 × 14.6
ARTIST ROOMS

*Untitled* 1975–80
Photograph, gelatin silver print on paper
14 × 14
ARTIST ROOMS

*Untitled* 1975–80
Photograph, gelatin silver print on paper
15.6 × 15.6
ARTIST ROOMS

*Untitled* 1975–80
Photograph, gelatin silver print on paper
10.9 × 10.9
ARTIST ROOMS

*Untitled* 1975–80
Photograph, gelatin silver print on paper
15.2 × 15.2
ARTIST ROOMS
[p.116, top]

*Untitled* 1975–80
Photograph, gelatin silver print on paper
13.5 × 13.3
ARTIST ROOMS

*Untitled* 1975–80
Photograph, gelatin silver print on paper on
ink on paper 14.3 × 14.4
ARTIST ROOMS

*Untitled, New York* 1979–80
Photograph, gelatin silver print on paper
13.6 × 11
Wilson Centre for Photography, London

*Untitled, New York* 1979–80
Photograph, gelatin silver print on paper
14.5 × 14.3
Wilson Centre for Photography, London
[p.118]

*Untitled, New York* 1979–80
Photograph, gelatin silver print on paper
14 × 14
Wilson Centre for Photography
[p.119]

*Untitled, MacDowell Colony, Peterborough, New Hampshire* 1980
Photograph, gelatin silver print on paper
11.4 × 11.2
Wilson Centre for Photography, London

*Untitled (FW crouching behind umbrella)*
c.1980
Photograph, gelatin silver print on paper
17.1 × 16.5
ARTIST ROOMS

**Erwin Wurm** born 1954
*One Minute Sculptures* 1997
7 photographs, C-prints on paper 45 × 30 each
Courtesy the artist and Lehmann Maupin, New York and Hong Kong
[pp.112–13]

*Untitled (Claudia Schiffer series)* 2009
2 photographs, C-prints on paper 144 × 114
Courtesy the artist and Lehmann Maupin, New York and Hong Kong
[pp.114–15]

# SELECT BIBLIOGRAPHY

## Artists

Antonio d'Avossa, *Joseph Beuys: Every Man Is an Artist: Posters, Multiples and Videos*, Milan 2013

Gordon Baldwin, Judith Keller, *Nadar/Warhol: Paris/New York*, exh. cat., J. Paul Getty Museum, Los Angeles 1999

Jennifer Blessing, *Francesca Woodman*, exh. cat., Guggenheim Museum, New York 2011

Chris Boot, Clare Grafik, *I'm a Real Photographer: Photographs by Keith Arnatt*, London 2007

John P. Bowles, *Adrian Piper: Race, Gender and Embodiment*, Durham and London 2011

Sabine Breitwieser, *Carolee Schneemann: Kinetic Painting*, exh. cat., Museum der Moderne Salzburg, Munich 2015

Claude Cahun, *Disavowals: Or Cancelled Confessions*, Paris 1930, English ed. London 2008

Cynthia Carr, *Fire in My Belly: The Life and Times of David Wojnarowicz*, New York 2012

Bob Colacello, *Holy Terror: Andy Warhol Close Up* (1990), London 2014

Roger Copeland, *Merce Cunningham: The Modernizing of Modern Dance*, New York 2004

Amanda Cruz, Amelia Jones, Elizabeth A.T. Smith, *Cindy Sherman: Retrospective*, London 1997

Merce Cunningham and David Vaughan, *Merce Cunningham: Fifty Years*, New York 1997

Jennifer Doyle (ed.), *Pop Out: Queer Warhol*, Durham 1996

*Hans Eijkelboom: Photoworks*, exh. cat., Museum of Modern Art, Arnhem 1999

Peter Eleey (ed.), *Trisha Brown: So That the Audience Does Not Know Whether I Have Stopped Dancing*, exh. cat., Walker Art Center, Minneapolis 2008

Mia Fineman, *Faking It: Manipulated Photography before Photoshop*, New Haven and London 2012

Howard N. Fox, *Eleanor Antin*, exh. cat., Los Angeles County Museum of Art, California 1999

Lee Friedlander, *In the Picture: Self-Portraits, 1958–2011*, exh. cat., Yale University Art Gallery, New Haven 2011

Lena Fritsch, *The Body as a Screen: Japanese Art Photography of the 1990s*, Hildesheim, Zurich, New York 2011

Masahisa Fukase, *Yoko*, Tokyo 1978

Masahisa Fukase, *Solitude of Ravens*, Tokyo 1986

Masahisa Fukase, *Bukubuku*, Tokyo 2012

Jason Fulford, Sharon Gallagher, Mike Mandel (eds.), *Mike Mandel: Good 70s*, New York 2015

Ivar Gravlejs, *Early Works*, Prague 2014

David Hopkins, *Dada's Boys: Masculinity after Duchamp*, New Haven 2009

Eikoh Hosoe, *Dance Experience 1 & 2* (July 1960 and September 1961), facsimiles published by Akio Nagasawa, Tokyo 2012

Eikoh Hosoe, *Kamaitachi* (1969 artist book), New York 2009

Eikoh Hosoe, *Simmon: A Private Landscape*, Tokyo 2012

Kai Itoi, Filippo Maggia, Marinella Venanzi, *Yasumasa Morimura: Requiem for the XX Century: Twilight of the Turbulent Gods*, exh. cat., Galerie Juana de Aizpura, Madrid, Milan 2008

Alex Kitnick (ed.), *Dan Graham (October Files)*, Cambridge, MA 2011

Yves Klein, *The Foundations of Judo* (1954), London 2009

Yves Klein, Dominique de Menil, Dominique Bozo, Thomas McEvilley, Pierre Restany, Nan Rosenthal, *Yves Klein 1928–1962: A Retrospective*, exh. cat., Institute for the Arts, Houston 1982

Yayoi Kusama, *Infinity Net: The Autobiography of Yayoi Kusama*, London 2013

Carrie Lambert-Beatty, *Being Watched: Yvonne Rainer and the 1960s*, Cambridge, MA and London 2011

Emily Liebert, *Multiple Occupancy: Eleanor Antin's 'Selves'*, exh. cat., Wallach Art Gallery, New York 2014

Thomas Mailaender, *Extreme Tourism* (artist book), Paris 2011

Thomas Mailaender, *Gone Fishing* (artist book), Paris 2012

Man Ray, *Self-Portrait* (1963), London 2012

Claudia Mesch, Viola Michely (eds.), *Joseph Beuys: The Reader*, London and New York 2007

Boris Mikhailov, *Crimean Snobbism*, exh. cat., Rat Hole, Tokyo 2006

Boris Mikhailov, *Krymskaja FotoManija (Photomania in Crimea)*, Cologne 2013

Boris Mikhailov, *I Am Not I*, London 2016 (forthcoming)

Marta Minujín, *Marta Minujín: Happenings and Performances*, Buenos Aires 2015

Frances Morris (ed.), *Yayoi Kusama*, exh. cat., Tate Modern, London 2011

Maria Morris Hambourg et al., *Nadar*, exh. cat., Metropolitan Museum of Art, New York 2013

Gaspard-Felix Nadar, *When I Was a Photographer* (1900), Cambridge, MA and London 2015

Dan Nadel, Laurie Simmons (eds.), *Jimmy DeSana: Suburban*, New York 2015

Michael Newman, *Erwin Wurm*, exh. cat., Photographers Gallery, London 2000

Victoria Noorthoorn, *Marta Minujín: Obras 1959–1986*, exh. cat., Malba – Fundación Costantini, Beunos Aires 2010

Klaus Ottman, *Yves Klein: Works / Writings / Interviews*, Barcelona 2009

Martin Parr, Marvin Heiferman, *Martin Parr: Autoportrait*, new ed. 2016 (forthcoming)

Nancy Princenthal, *Hannah Wilke*, Munich, Berlin, London, New York 2010

Yvonne Rainer, *Feelings Are Facts: A Life*, Cambridge, MA and London 2006

Eva Respini (ed.), *Cindy Sherman*, exh. cat., Museum of Modern Art, New York 2012

Shelley Rice (ed.), *Inverted Odysseys: Claude Cahun, Maya Deren, Cindy Sherman*, Cambridge, MA 1999

Scott Rothkopf, *Jeff Koons: A Retrospective*, exh. cat., Whitney Museum of Art, New York 2014

Tokyo Rumando, *Orphée*, Tokyo 2014

Tokyo Rumando, *Rest 3000 Stay 5000*, Tokyo 2014

Gabriele Schor, *Cindy Sherman: The Early Works 1975–1977. Catalogue Raisonné*, exh. cat., Sammlung Verbund, Vienna 2012

Carolee Schneemann, *Imagine Her Erotics: Essays, Interviews, Projects*, Cambridge, MA and London 2003

Cindy Sherman, *Cindy Sherman: The Complete Untitled Film Stills*, exh. cat., Museum of Modern Art, New York 2003

Harry Shunk, *Harry Shunk – Projects: Pier 18*, exh. cat., Musée d'Art Moderne et d'Art Contemporain, Nice 1992

Bennett Simpson, Chrissie Iles (eds.), *Dan Graham: Beyond*, exh. cat., Whitney Museum of American Art, New York 2009

Aaron Siskind, *Pleasures and Terrors*, Boston 1982

Aaron Siskind, *Harlem Document: Photographs 1932–1940*, Rhode Island 1981

*Aaron Siskind: Photographer*, exh. cat., George Eastman House, Rochester 1965

Cherise Smith, *Enacting Others: Politics of Identity in Eleanor Antin, Nikki S. Lee, Adrian Piper, and Anna Deavere Smith*, Durham and London 2011

Sidra Stich, *Yves Klein*, exh. cat., Hayward Gallery, London 1995

John Szarkowski, *Self Portrait: Photographs by Lee Friedlander* (1970, 1998), New York 2005

Anna Telgren, *Francesca Woodman: On Being an Angel*, exh. cat., Moderna Museet, Cologne 2015

Charles Traub, Gilles Mora, *Aaron Siskind: Another Photographic Reality*, Texas 2014

Andy Warhol, Pat Hackett, *The Andy Warhol Diaries*, New York 1991

David Wojnarowicz, *Brush Fires in the Social Landscape* (1994), New York 2015

Catherine Wood, *Yvonne Rainer: The Mind Is a Muscle*, London 2007

Erwin Wurm, *Gurke*, Cologne 2009

Lydia Yee, *Laurie Anderson, Trisha Brown, Gordon Matta-Clark: Pioneers of the Downtown Scene, New York 1970s*, exh. cat., Barbican, London 2011

## General

Philip Auslander, 'The Performativity of Performance Documentation', *PAJ: A Journal of Performance and Art* (PAJ84), vol.28, no.3, September 2006, pp.1–10

Simon Baker, 'For the Camera', *Aperture: Performance* Issue, Winter 2015

Jack Bankowsky, Alison M. Gingeras, Catherine Wood (eds.), *Pop Life: Art in a Material World*, exh. cat., Tate Modern, London 2009

Geoffrey Batchen, *Burning Desire: The Conception of Photography*, London 1997

Jennifer Blessing, *Rrose is a Rrose is a Rrose: Gender Performance in Photography*, exh. cat., Guggenheim Museum, New York 1997

Susan Bright, *Auto Focus: The Self-Portrait in Contemporary Photography*, London 2010

Judith Butler, *Gender Trouble: Feminism and the Subversion of Identity*, London 2006

Kaira M. Cabañas, *The Myth of Nouveau Réalisme: Art and the Performative in Postwar France*, London 2013

Mia Fineman, *Faking It: Manipulated Photography before Photoshop*, exh. cat., Metropolitan Museum of Art, New York 2012

Adrian George (ed.), *Art, Lies and Videotape: Exposing Performance*, exh. cat., Tate Liverpool 2003

Gianni Jetzer, Chris Sharp, *Le Mouvement: Performing the City*, exh. cat., Berlin 2014

Amelia Jones, *Body Art*, Minneapolis 1998

Amelia Jones, '"Presence" in Absentia: Experiencing Performance as Documentation', *Art Journal*, vol.56, no.4, Winter 1997, pp.11–18

Danielle Knafo, *In her own Image: Women's Self-Representation in Twentieth-Century Art*, Teaneck, NJ 2009

Natalya Lusty, *Surrealism, Feminism, Psychoanalysis*, Aldershot 2007

Alice Maude-Roxby, *Live Art on Camera*, exh. cat., John Hansard Gallery, Southampton 2007

Peggy Phelan, *Unmarked*, New York and London 1996

Joan Riviere, 'Womanliness as Masquerade', *International Journal of Psychoanalysis* 1929

Helena Rickett and Peggy Phelan, *Art and Feminism*, London 2006

Arthur Rimbaud, *Illuminations*, New York 1957

Julia Robinson (ed.), *New Realisms: 1957–1962: Object Strategies Between Readymade and Spectacle*, exh. cat., Reina Sofia, Madrid 2010

Paul Schimmel, *Out of Actions: Between Performance and the Object, 1949–1979*, exh. cat., Museum of Contemporary Art, Los Angeles 1998

Susan Sontag, *On Photography*, London 1979

Catherine Wood (ed.), *A Bigger Splash: Painting after Performance*, exh. cat., Tate Modern, London 2012